THE LAST LAUGH

THE LAST LAUGH

Strange Humors of Cinema

Edited by Murray Pomerance

Wayne State University Press Detroit

17 16 15 14 13 5 4 3 2 1

Library of Congress Cataloging-in-Publication Data

The last laugh : strange humors of cinema / edited by Murray Pomerance.

pages cm. — (Contemporary approaches to film and media)

Includes bibliographical references and index.

ISBN 978-0-8143-3513-0 (pbk. : alk. paper) — ISBN 978-0-8143-3855-1 (e-book)

1. Laughter in motion pictures. 2. Wit and humor in motion pictures.

I. Pomerance, Murray, 1946– editor of compilation.

PN1995.9.L39L37 2013

791.43'617—dc23 2012040676

Designed by Maya Whelan
Typeset by E.T. Lowe Publishing Company
Composed in Warnock Pro

An earlier version of Thomas Leitch's essay "Noir at Play"
appeared in *Studia Filmoznawcze* 31 (2010), 83–93.
The author and editor are grateful for the permission to
reprint this material.

To Ariel

Laugh once again, and laugh heartily, but it's the last time—because you're laughing at the death of laughter.

André Bazin, *The Cinema of Cruelty*

Contents

ACKNOWLEDGMENTS

This book was inspired by a panel on dark humor at the 2010 Society for Cinema and Media Studies conference in Los Angeles. Organizing and participating in that panel, besides Thomas Leitch and the editor of this volume, both of whom offer contributions herein, were two insightful and articulate scholars whose work, centrally about television, could not fit the parameters of the collection: Lester D. Friedman and Martha P. Nochimson. The hunt for screen laughter in unexpected places originated with them in some vital way, so I hope that this anthology does service to their hopes and intent, and also expresses my gratitude to them for involving me in the project.

To Nick White and Matt Thompson, my sincere thanks for affable and brilliant research assistance. Wheeler Winston Dixon has been a generous colleague. I am grateful as well to my colleagues at Wayne State University Press, including Barry Keith Grant, Jane Hoehner, Annie Martin, Kristin Harpster, and Maya Whelan and also to freelance copyeditor Eric Schramm. My cherished friend and collaborator Barton Palmer has been of invaluable assistance throughout. And for maintaining my own good humor while at work on all this variegated darkness, my love to Nellie Perret and Ariel Pomerance.

Toronto
October 2012

MURRAY POMERANCE

Introduction

The Great Corrective

Wandering through one of the great screen spectaculars of the 1950s, Cecil B. DeMille's *The Greatest Show on Earth* (1952), is Buttons the clown (James Stewart). Sporting whiteface and a great grease-painted red maw at all times, inside the ring and out, Buttons is forced to dramatically amplify a grin so that it becomes visible at a great distance. Like many circus clowns, he is the very embodiment of facial expression. Only at a critical juncture in the story do we learn that the reason he never removes his makeup is that he is using it to cover another identity, that of a medical practitioner in flight from the police because of a murder. Implicit with Buttons, beyond the obscuration of his biographical past inside the envelope of his dramaturgical present, is the capacity of his expressive smile or laugh to hide darker, socially problematic undertones: grief, fear, remorse, confusion. This painted smile—even at middle distance it replaces the clown's actual mouth— does not signify comedy or happiness; it is a telltale wound of pain and despair.

That the laughing face can indicate not mirth or release but secrecy, darkness, surrender, derision, and improbability is at the core of our considerations in this book. We seek to understand cinema's treatment of the "dark" laugh, a phenomenon which is either expressly non-comedic, intended for an edification of the audience that is far from light-hearted in origin or structure; or else comedic only at its surface, built upon stress and torment instead of the vertiginous thrills

of confusion, disorientation, and suspended expectation that riddle "comedy" as we conventionally label it. We may think of the relation between humor and play in the terms Roger Caillois invokes when he notes "the case of a monkey which took pleasure in pulling the tail of a dog that lived with it, each time that the dog seemed to be going to sleep" or the child, who "loves to play with his own pain, for example by probing a toothache with his tongue" (28). Even as we read about and contemplate whatever agonized chuckles may be produced in them, these are moments of "dark" laughter. We learn from Northrop Frye that comedy is a kind of "oracular repetition," a form with "so much repetition that, . . . as in music, even a vague and woolgathering listener is bound to get some sense of design" (25–26), but the design need not be one that produces what we would call fun or lightheadedness, inebriation, release. What it produces is a loss of self, and this can be both delirious and obscure. Thus, in these pages the word "comedic" comes to have a much more destabilizing sense than it has when we use it flippantly to describe the films of Harold Lloyd, Buster Keaton, Jerry Lewis, the Marx Brothers, Steve Martin, Ben Stiller, or Judd Apatow.

Film is filled to the limit with conventional smiles and laughter that can be interpreted more or less fully at face value. Richard Widmark's grinning (and idiotic) Dauphin/King Charles in *Saint Joan* (1957); Cary Grant's gentle smile into Eva Marie Saint's face as, hanging with her from the crags of Mount Rushmore, he says he's making a "proposal, sweetie" (*North by Northwest*, 1959); Katharine Hepburn's smile of perfect graciousness as she makes the decision not to marry James Stewart in *The Philadelphia Story* (1940); John Barrymore's mad smiles of genius whenever he comes up with a new stratagem for outwitting the hypercompetitive Carole Lombard in *Twentieth Century* (1934); Diane Keaton's grinning "La di da" in *Annie Hall* (1977); and a legion more. And the open laugh (or the broad smile, which is its index) has long been a staple of the genre we call comedy—Charlie Chaplin singing and dancing in *Modern Times* (1936), Joe E. Brown in the motorboat conclusion of *Some Like It Hot* (1959), Jim Carrey's (frustratingly) irrepressible cable guy (1996)—not to mention a means of polishing and authenticating the expression of feeling in romance: the grinning charm of Alec Baldwin in *Prelude to a Kiss* (1992), the smile of awed bewilderment on Judy Holliday's face when William Holden impresses her with his intelligence in *Born Yesterday* (1950). Even in animation

and fantasy films (that generally reference genre films through imitation) we find the expressive laugh serving conventional needs of expression: Mickey Mouse grinning to cover over his delinquency in the "Sorcerer's Apprentice" section of *Fantasia* (1940), or grinning obsequiously at Leopold Stokowski; the Tramp grinning with pride as he brings his Lady for dinner at Tony's in *Lady and the Tramp* (1955).

But if the laugh or smile polishes conventional expression, highlighting the tone of "everyday" action by prolonging diegetic moments (Jerry Lewis's lunatic grin as in *The Nutty Professor* [1963] he tinkers in his laboratory to transform himself) or by drawing attention to the characteristic and beautified features of the actorly face (Ingrid Bergman grinning radiantly at Bogart in *Casablanca* [1942] or at Grant in *Notorious* [1946]), it also has the capacity to function negatively, making visible and thus bringing into play a psychological warping and obscurity, a disconnected solipsism, a painful self-withdrawal, or even some confrontation with forces cosmic and overwhelming. The smiling face can thus be horrific. It is in this context of otherness that we find the smile of guilt, the laugh of superiority, the grin of exaltation; an effusion of feeling that betrays villainy or strangeness or the depths of depravity, or the high climes of sanctity. This is laughter dramatically positioned where convention would not lead us to find it, "unconventional" or "dark" laughter because it is disconnected from humor, from giddy play, from simple joy, from an overflow of the happiest quotidian feeling.

Even worse is the denigration, finally the elimination, of pleasure itself, a hopeless and all-comprehending despair at the human condition. The idea of the "last laugh" in a conclusive and summative sense—not arising from mere situational one-upmanship or the metacomedic joke upon a joke, but indicating instead the culmination of one's capacity for ironic appreciation and emotional expression—is what André Bazin invokes when he encourages us to "laugh once again, and laugh heartily, but it's the last time—because you're laughing at the death of laughter" (47). When both our laugh and our ability to laugh have died away, what remains is a stoic and joyless life of the mind, what the diseased Prince is suffering from, and what all the sages in the land have seemed incapable of providing remedy for, in Prokofiev's opera *The Love of Three Oranges*; or what Murnau's debilitated and rehabilitated hotel doorman experiences in *Der letzte Mann* (1924).[1] Bazin is

commenting on a transformation in cinema toward a quotidian realism that transcends or replaces, and thus destroys, the idea of pleasure at the act of watching taken in itself.

One bleak possibility of dark humor is the smile or laugh of schadenfreude, spreading across the face of a person malevolently taking pleasure in the promise or actuality of someone else's pain and defeat. Another is the hopeless smile of resignation, as when life seems a great joke told by a raconteur of superhuman proportion, who dwarfs, even trivializes the human experience and condition. There is the sadistic smile of torturous expectation, that we see on the face of the powerful brute who is about to negate another man's reality. There is the sharply aggravating smile of innocent abusiveness, that expression we see plastered across the face of young Georgie Amberson (Tim Holt) in that wrecked Orson Welles masterpiece, *The Magnificent Ambersons* (1942); how superior he believes himself to be, how glorious, how deserving!—until the moment when his world falls apart and he gets the "come'uppance" we have all been prescribing since the film began.

Some poignant cases are to be found in the work of Alfred Hitchcock. In *Blackmail* (1929), the coy and only half-innocent Alice (Anny Ondra), escorted one night to a debonair artist's garret, sees there a canvas he has just finished. The camera swoops in upon it. The picture is of a plump harlequin, squinting at the viewer with either merriment or jibing sarcasm (the ambiguity of the freeze makes it impossible to tell). The clown is pointing out of the canvas, as though to indict. Bazinian laughter, to be sure, with the indictment gelid and formal, is a terminal statement as well as an artful provocation. Alice is immediately taken aback, but not long later, after she has killed the artist in self-defense, the image of this figure returns to haunt her: the eyes have come alive, have witnessed, will speak. In *North by Northwest*, at a deliciously precarious moment, the beleaguered hero, Roger Thornhill (Cary Grant), is trapped in a gilded elevator at the Plaza Hotel with his domineering mother (Jessie Royce Landis), two assassins bent on killing him (Adam Williams, Robert Ellenstein), and a crowd of uninformed bourgeois. As the cage descends in silence, Mrs. Thornhill suddenly looks past her son at the two agents and asks, "You gentlemen aren't *really* trying to kill my son, are you?" Everyone in the elevator—except one—bursts into hilarious laughter: in such an august venue, brutality is unthinkable (apparently); and so perfectly accommodated an example of bourgeois

culture as Mrs. Thornhill could not possibly have raised a child anyone would want to kill. The delinquent is Roger, who doesn't find this funny at all—since, as the audience now too painfully knows—killing him is precisely the business at hand, and what is laughable, yet horrific, is the blithe disattention attendant upon the "propriety" of those who visit this place.

One especially elegant and protracted example of unhappy laughter, demonstrating not only its essentially hollow character but also its attachment to context, is Tallulah Bankhead's outburst toward the conclusion of Hitchcock's *Lifeboat* (1944). Her Connie Porter, a hardboiled journalist who has fallen upward into a life of classy style, is suffering the agonies of being lost at sea, all the while frantically trying to cling to the accoutrements of her professional high life: her typewriter, gone into the water; her camera, ditto; her suitcase, the same again. She has less and less left to her as the picture winds on, and is finally the possessor of only a diamond bracelet, the "ladder," it turns out, upon which—originally a waif from the South Side of Chicago—she made her successful climb into the perfumed upper chambers of high society. The fellow survivor she has been admiring, and has now set her sights upon, a seaman and former meat packer (John Hodiak), doesn't like this kind of frippery at all, but nevertheless the bracelet, glimmering in the sunlight, is the one object with which Connie absolutely will not part. Finally, however, starvation falls upon the little boat, and one by one the survivors are dropping into debility and toward death. They must have something to eat: fish would be good, raw fish has water and nutritious oils. But what to fish with? The only possible bait is the shiny bracelet, and so—ultimately the hero we always suspected her to be—Connie pulls it off and hands it over. We see the thing dropped into the water and then, thanks to Hitchcock's carefully placed camera beneath the waves, watch it descend sparkling in shafts of sunlight. A huge fish meanders near it, gives it the once over, thinks twice, but is finally unable to resist. The fishers are ecstatic and tug on the line. But someone cries out that a ship is on the horizon, and, in the desperate excitement to see, whoever is holding that line lets go. The fish disappears, and with it the bracelet. Now we cut to Connie's face as she realizes the fulsomeness of nothingness, that she has no ticket, no riches, no career, perhaps no life, since that ship is the German supply vessel and it will haul them all to a concentration camp. She breaks into a

laugh, growing in size until it is of operatic proportion and prolonged so that it verges on an act of delirium. Her head cast back, her face showing radiance and relief but also an ultimate expression of surrender, she laughs as though there is no tomorrow, as though the world exists only to hear her. This is a last laugh, tailored for when culture has been lost, for when hope has evaporated, for when all of one's biography and future collapses into an imperceptible point of vacuity and irony and conviction. The opposite of despair, Connie's mood is a pure existential openness, and the laugh says to the forces above, "Do what you will!"

As a prototype for the kinds of laughter discussed here, Connie's laugh has the elements of pungency, dramatic weight, sharpness of expression, and personal character. It does not cue the audience for a joke's punch line—unless the joke is utterly cosmic. It does not license us for ironic mockery or protected superiority. This "dark" laugh, this cold laugh, this religious laugh is a way of seeing the world in extremis, and is as full of meaning as a Shakespearean soliloquy. The challenge to the contributors in this book was to find some example in cinema of "dark" laughter, if not exactly as summary as Connie's then at least located where one would not expect, and to address it through some scheme of analysis that made sense and offered clarity. As a result, we have a group of essays from numerous theoretical fields and reflecting anything but a uniform point of view, essays no one of which intends—any more than does the collection as a whole—to bring a definitive statement about strange humor onscreen. A definitive statement is beyond the scope of a single volume, and a collection is especially prone to the vagaries of individual interpretations and personal choices of material. There are plenty of films that could have found their way here and did not, only because the authors felt impelled to discuss something else instead, and that seems an entirely reasonable basis for making a collection. Here we can at least, and with some real power, give a taste of the issues that come up in a serious consideration of serious laughter: a taste, a sketch of the territory, and an idea of where questions remain and insights make their place. The one restricted ground to which no one was permitted access was comedy itself. In comedy, laughter is both motor and rationale, and about its working sufficiently illuminating books—such as those by Noël Carroll, Andrew Horton, William Paul, Ed Sikov, Lisa

Trahair, and others—already exist. We wanted to go into a territory that has not been explored with particular focus before, to look at the laughter that does not mean pleasure, fun, delight, or simple ironic inversion but calls up instead a more buried, more painful, and more problematic world.

Whilst dark laughter—often spontaneous, pointed, multivalenced, and explosive—is not, in and of itself, a topic that can logically be shaped into a linear order of investigations, there is nevertheless a loose structure to the arrangement of essays that follows. Bookended by two temporally based explorations, one dealing with very early narrative cinema and the second addressing a twenty-first-century statement of a futuristic theme, are two clusters. First are five considerations of dark laughter as invoked by certain well-known classical filmmakers or in particular genre contexts. Next come six analyses focused on particular films or groupings of film. As might be proper for a study of laughter, a vocal production, the order of presentation within each group derives from the more or less musical intonations of the authorial voices.

We begin with Matthew Solomon's exploration of the somewhat ironic case of laughter without sound. His essay "Laughing Silently" introduces some intriguing features of the laugh as a social performance, since in silent film we see it and decode its situated meaning without direct sonic cues. Solomon notes that in the earliest days of cinema, laughter had been understood by Charles Darwin and his followers as an unmediated expression of a bodily state that is partly instinctual, thus not something that could be performed through artifice or fakery. Actors laughed if they felt mirthful, until performance codes for laughter from theater, photography, and sound recording were imported to cinema. With a detailed exploration of Thomas Edison's *Laughing Gas*, Herbert Brenon's *Laugh, Clown, Laugh!* and Paul Leni's *The Man Who Laughs*, Solomon traces the development of silent performances of laughter from Bertha Regustus's naturalistic body pantomime through Lon Chaney's more carefully "framed" stage laughter to Conrad Veidt's astonishing use of facial musculature to develop a virtual language of pain and suffering through his grin. For Solomon, Veidt's landmark performance evidences Expressionist acting, a performance form that was prevalent in the late silent period but that, already by the time of *The Man Who Laughs*, was heading for obsolescence.

With the much celebrated case of Orson Welles, we have not only a filmmaker of the greatest importance in the history of American cinema but also a showman, raconteur, and public personality of great repute, a man often iconized through his sonorous voice and his robust and energetic laughter. (The filmmaker both indicates and parodies his own joviality in *F for Fake* [1974].) In Welles's filmic works, the laugh, always bearing dramatic and social meaning, is a force of nature evoked in "gusts" and "thunder," as we learn from James Morrison's "Wellesian Laughter." That the shadow of Falstaff is never too far from Welles's self-image onscreen we see in examining abject laughter in *Citizen Kane* and *The Magnificent Ambersons* and deluded laughter in *The Trial* and *Chimes at Midnight*. For Welles's characters, we learn, laughter is frequently a last resort, at once surrendering to powerful domination and mocking it. Further, the Wellesian moment of laughter is prone to having an uncanny or eerie quality, as when the laugh approximates to a scream, a wail, or a caustic vituperation, or as when it is emphatically unshared.

Jean-Michel Frodon's "Jerry Made His Day" is an in-depth study of a film that was never completed, Jerry Lewis's *The Day the Clown Cried*. But this author's deeper subject, like that of the film, is laughter in relation to the Holocaust, morally and historically a phenomenon of such immeasurable magnitude that we have had no language for coming to terms with it. As editor of *Cinema and the Shoah*, one of the most profound explorations of the Shoah in print, Frodon views the Lewis film with exceptional sensitivity and thoughtfulness, noting that the filmmaker has struggled to make his film a nightmare. The Lewis character is far from sympathetic, caught up in the Nazi plans for extermination and co-opted to lure children to the death chambers by his clowning. One of the many reasons *The Day the Clown Cried* was never finished, suggests Frodon, was the unresolved central issue of how morally pure the central character should be. Writers of the original script were upset when Lewis made significant changes in order to improve the character. Lewis's very specific style of non-realism was the saving gesture, since any step toward realism would have been, as Frodon sees it, "despicable" while also throwing the film off key for the viewing audience. Finally the film is seen as a radical culmination of Lewis's lifelong professional quest, to capture what is tragic about life and what is corrupted about filmmaking.

Thomas Leitch's "Noir at Play" is in part occasioned by his students' laughter at films that aren't supposed to be funny. Focusing too intensively on the thematic seriousness of (what are now called) noir films, conventional commentary has minimized a quality that keeps them from being depressing to watch no matter their plotty gravity and visual darkness. The critical view has thus limited our understanding of noir, has given us an incomplete vision of its possibilities. That noir is playful and gamey we see in a discussion of such films as *Criss Cross* and the "clownishly philosophical" *Kiss Me Deadly*, the wisecrack-crammed *Out of the Past*, and the playful and serious *Blood Simple*. Frequently, noir intensifies playfulness to be found in its source material, and even limitations placed on characters' freedom work in such a way that they can be read as playful. Further, gender duality is played with continually, as is the audience's ability to stand at one moment both within and without what they are watching. What makes many noir films disconcerting in their playfulness is a deep-seated ambivalence toward their subjects.

In "'So Bad It's Good': Critical Humor in Science Fiction Cinema," Christine Cornea looks on sci-fi cinema of the 1950s, and especially its popular reception, as an occasion and provocation for critically derisive laughter. Writing about films such as *The Day the Earth Stood Still, Forbidden Planet, Invasion of the Body Snatchers*, and *Mesa of Lost Women*, critics of the time pointed to films' "absurd assumption" and "amusing creatures" or suggested they were "for laughs only." It was more by willing, predominantly young audiences than by professional critics that the conventions of this form had been appropriated. An affective gap—one that can be filled by laughter—is left for viewers of the films by their consistently apparent failure to seem credible or fearsome; and producers such as American International Pictures actually strove for unbelievability, which was recognized and appreciated by teenagers while adults missed the joke. A detailed analysis is offered of the mechanism by which critical laughter is produced by Ed Wood's *Plan 9 from Outer Space*, focusing on Kantian "frustrated expectation" and on the significance of incongruity; and the relationship between parody and bad film is discussed in relation to *Abbott and Costello Meet Frankenstein, Abbott and Costello Go to Mars*, and other films, including the recent and notable object of critical laughter, *Battlefield Earth*.

David Sterritt's "Wrenching Departures: Mortality and Absurdity in Avant-Garde Film" is a penetrating study of three works of art: Bruce Conner's *A Movie* (1958), Michael Snow's *Wavelength* (1967), and Ken Jacobs's *Two Wrenching Departures* (1990). All three films, as this essay shows, foreground the filmmakers' aesthetic choices and modes of cinematic play as they extend a range of meaning by invoking laughter structurally. Conner, for example, was inspired by a sequence from *Duck Soup* but eventually complicated his project by editing together such improbable companion pieces as a 1953 newsreel compilation, pieces of a Hopalong Cassidy western, and a *samizdat* girlie-movie clip, including in his work the countdown numbers and codes usually edited out of film. In this film, comedy and horror come very close together. Snow, by comparison, is fascinated with cinematic time and space and produces a forty-five-minute one-shot work that excludes movie viewers' suspension of disbelief. In this film, laughter is everywhere, Sterritt argues, if, following philosopher John Morreall, we mean by laughter "an expression of pleasure at a psychological shift." *Wavelength* works to transcend an entire sensory apparatus. *Two Wrenching Departures*, a film that is at once nonsensical and deeply touching, addresses the mortality of Jack Smith, bringing us a kind of echo of what Hermann Hesse called the "frightful laughter of the hereafter."

The idea of universal humor subtends George Toles's "Time's Timing and the Threat of Laughter in Nicolas Roeg's *Don't Look Now*." This 1973 film remains one of the greatly chilling horror stories in American cinema, filmed with intrepid poetry and a razor-sharp vision by a leading cinematographer-turned-filmmaker at an important moment in his career. For Toles, beyond the fact that this film is rich with meaning and allusion, its "stifled" comedy demands investigation precisely because criticism has ignored its pressure. *Don't Look Now* gives us a story of misconnections, bad timing, misperceptions, misunderstandings, a father's failure to save his child from drowning, and his persistent search for her form afterward a long way away: in short, horrific themes, here couched in an envelope of aesthetic sensitivity and shifting time, since, as Toles reminds us, the sole tense of film is the "electric present." The laughter Toles describes in relation to this dark and brooding film is divine, a Nietzschean laughter that permeates sympathetic understanding. In engaging with our central

character, we must finally come to the conclusion that he is the butt of an immense and evanescent joke.

My own "The Gangster Giggles" examines special cases of screen laughter produced by the dark protagonists of gangster films—James Cagney's performance in *White Heat*, Richard Widmark's in *Kiss of Death*, Roman Polanski's in *Chinatown*, Joe Pesci's in *Goodfellas*, and Marlon Brando's in *The Godfather*, among others—in order to reveal a latent pattern of class-based disapprobation that subtends the typical gangster plot. Hollywood cinema works strictly to presume the unquestionable dominance of rational-bureaucratic propriety over the (purportedly obvious) feudal moral poverty of gangster life; gangsters are treated with natural immediacy as moral outsiders, as living lives that cannot be adequately accounted according to the principles of rational capitalism. As such, gangsters are foils for higher interests—interests the viewer automatically accepts as honorable. The gangster's laugh onscreen must always be turned inward, as self-mockery or as impotent social critique.

Adrienne McLean is fascinated by the idea of a film that fails, and subjects itself to receptive laughter, by entirely lacking self-consciousness about its material and weaknesses and a corresponding awareness of its viewers' expectations. Darren Aronofsky's *Black Swan* is a film that was promoted to audiences as a definitive treatment of the ballet dancer's personality and trauma. Comparing it with *Center Stage*, *Waterloo Bridge*, *The Red Shoes*, and *The Company*, McLean shows how even beyond being a pretentious and systematically flawed depiction *Black Swan* is kitsch without being self-aware as such. Thus, it is the film's own failure to understand its subject matter that makes it funny. The film shows a certain pomposity, for one reason because of the much-touted press releases about Natalie Portman's personal sacrifices while preparing for her role: numerous actors preparing for dance films have gone into rigorous training, this actor no more than others. A careful study of philosophies of humor production illuminates the key question of how clichéd and pretentious exaggeration can provoke laughter, beyond provoking viewers to feel superiority in expressing ridicule.

The laughs in Hal Hartley's *Henry Fool* are markedly scatological, unsettling, and revolutionary. David Martin-Jones's post-Rabelasian study, "Foolish Bum, Funny Shit: Scatologial Humor in Hal Hartley's Not-so-comedic *Henry Fool*" reveals that Hartley's toilet comedy is

a vehicle by which the filmmaker mediates on marriage, childhood, family, and society more generally. Hartley's dirty setups are therefore intended to make us look and think twice, reconsider our assumptions about the body and the body politic, about family life and biological imperatives. In a key scene in *Henry Fool*, for example, where Fay kneels in front of Henry on the toilet and proposes to him, laughter comes not only in response to a character's onscreen act of defecation but by its bold alignment with the traditionally romantic marriage proposal—an alignment that turns the situation upside-down. Hartley is only apparently fiddling with our mechanisms for body management and control, then, while much more deeply engaging with social conventions, processes, and repressions.

R. Barton Palmer considers the eclipsing and philosophically deeply stirring phenomenon of Homeric laughter, focusing on the case of a man often depicted as mirthful yet whose work contains very little laughter indeed. "Homeric Laughter in *The Treasure of the Sierra Madre*" shows that at issue in this film is possession, greed, control, and attachment of the self to the material world, all contrasting with a certain resignation and surrender that become possible when forces of nature take over and the material wealth of a group of hungry men is suddenly dissolved away. The explosive "laughing death" articulated by Howard when he sees that he has no value in his gold makes him seem insane to the natives who watch. For Palmer, spasms such as Howard's explode the decorum that separates the dignified elevation of the tragic from the baseness of the viscerally comedic. This film reaches a height of sublimity by offering a particular "cosmic" joke: that when its utility is exhausted, for all its glimmer gold counts as nothing when it cannot help men survive. In extremis, our supreme object and talisman of value won't keep us alive, won't succor us, and thus reflects our rapacious collectivity back upon us. The Homeric laugh that centers this narrative can be understood only in radical separation from the humor of physical comedy or social satire.

Looking garish or silly is often a cause for distancing laughter. As Dominic Lennard shows in "'Why So Serious?': Battling the Comic in *The Dark Knight*," a central problem can stem from a hero's precarious appearance: laughter can compromise the architectural structure of a story by undercutting the protagonist's position in it. We are introduced to unseriousness through buffoonery here; but as we come to

know the villain in a complex way, the ambiguity and edginess are developed with real gravity: he is nothing less than a manifestation of the danger lurking behind costumery, foolishness, and artifice. This turns the character of Batman comic—comic in the sense of silly; comic also in the sense of deriving from comic books—and runs the very serious risk of diminishing the serious dramatic potential of the character (and the film itself). Yet Batman's comic origins are irrepressible. *The Dark Knight* must therefore work hard to promote "seriousness," continually negotiating its own seriousness against the comic-book premise on which it is poised.

Finally, Linda Ruth Williams's "The Laughter of Robots" uses an intensive focus on one particular scene to show how Steven Spielberg's *A.I. Artificial Intelligence* (2001) raises issues of the very greatest profundity regarding the place of laughter in both society and the family bond. The mecha David's outlandish and shocking outburst of laughter at the dinner table is here seen as both socially inappropriate—thus, perfectly characteristic of the robot as an only partially sentient mechanical formation—and, on closer inspection, perfectly appropriate, characteristic of the robot as virtually human. Since the robot in this film is an analogue for the child, what is at issue with David's laugh, and the infectious response of his human parents, is far more than his curious and chilling android nature, now inhabiting a human family context: given that he does not "feel" or "recognize" a situation as mirthful or joyous, he can only be laughing as a cold signal of recognition. The laugh is thus his first step toward what will become almost full socialization, a point at which he can begin to acknowledge openly that he recognizes the subtleties of human interaction and can detect when something has gone "wrong": in short, he has not only intelligence but a capacity for irony and critique. In this light, as Williams beautifully shows, far more attention than has typically been paid is due to Spielberg's canny sentimentality, his ability to catch tiny nuances of performance, his skill with child actors, and his sensitivity to the family bond. And more attention is due, as well, to the rigors of performance, notably for such subtle, and swiftly telling, effects as "imitative" and "genuine" laughter.

Our collective intent in these pages is to open for inspection a number of ways in which laughter works entirely, or at least to an important degree, outside of pleasure, hilarity, joking, and what we officially

like to call comedy. In its flexibility and multivalence, the laugh is perhaps a sign of transformation, metaphor, plasticity, poetry, and mystery. But of course, as with all very serious books, we become laughable in our seriousness. Laughter, Bergson offered, is a corrective for a certain rigidity in social attitude and conduct. If, dear reader, you should find in these pages, devoted as they are to shedding light on improbable laughs and unexpected humor, yet another—and bleaker—form of rigidity, which is the formality of a book and the essays it contains; if in reading you are moved to think the seriousness of our approaches hilarious in itself, even so much as to break into laughter as you move your eyes across our provocative grammar, so much the better, so much the truer will be our relation and our act.

NOTE

1. A film whose title is translated in English, with some ineptness, as *The Last Laugh*. The original German referred not to the "last man on earth" or "last man who could experience" but to the man who came before. The film is about superannuation, and how from the point of view of a new employee the person he replaces was the "last man" on the job.

Matthew Solomon

Laughing Silently

The sound of laughter is, in many respects, the *sine qua non* of laughter itself, and so laughter would seem to pose special challenges for the ostensibly visual medium of silent film. Yet laughter—like other forms of sound—was, of course, never excluded from the profilmic universe of silent cinema and is seen (if not heard) in countless films made before synchronized sound recording became standardized. The word "laugh" even figures prominently in the titles of such films as *The Last Laugh* (F. W. Murnau, 1924), *Laugh, Clown, Laugh* (Herbert Brenon, 1928), and *The Man Who Laughs* (Paul Leni, 1928). Although laughter itself is not crucial for *The Last Laugh*—which, we should note, was titled *Der letzte Mann* (The Last Man) for its original German release—it is for the other two. At the level of narrative, *Laugh, Clown, Laugh* and *The Man Who Laughs* ask the viewer to remember that externalized, bodily signs of laughter (broadly smiling face, knee-slapping hands) do not always or necessarily correspond to an inner state of mirth or enjoyment. Indeed, both films are about clowns whose intense and unremitting sadness is masked not only by their profession but also by their appearance. In *Laugh, Clown, Laugh*, a famous clown, Tito (Lon Chaney), known as Flik, entertains circus crowds, seeming to laugh as he performs his antics for spectators. Yet

The author thanks David Mayer for his useful comments on laughter as performed on the nineteenth-century stage and to Michael Maslankowski for his research assistance.

Tito cannot himself truly laugh—much less smile—offstage because he cannot tell the woman he loves how he feels (she is much younger than he, and he has raised her from orphaned girlhood very much as a daughter). In *The Man Who Laughs*, Gwynplaine (Conrad Veidt), known as "The Man Who Laughs," wears a hideous grin that has been surgically inscribed on his face. Even though his wide and unflinching smile provokes continual laughter in others, the disfigurement that gives him a jovial appearance for others is the cause of tremendous grief for Gwynplaine himself. The sad clown is a longstanding cliché of literature and drama, not to mention of song and film. *Laugh, Clown, Laugh* and *The Man Who Laughs*, both of which are ostensibly based on theatrical sources—David Belasco and Tom Cushing's 1923 *Laugh, Clown, Laugh!* and Victor Hugo's 1869 *L'Homme qui rit*, respectively— make productive use of this cliché, showcasing both the repression and the expression of laughter as a particular (and particularly demanding) kind of performance.

Because during the nineteenth century the phenomenon of laughter had been understood by Charles Darwin and others as a direct and relatively unmediated expression of a quasi-instinctual bodily state, constructed performances of laughter posed problems for actors of the time. (One indicator of laughter's problematic status for performers, according to Jacob Smith, is its exclusion from many turn-of-the-century acting manuals [27–28].) If one had to be feeling mirthful to laugh, an actor serious upon his business might be forgiven for not being able to conjure laughter out of thin air. Laughter was nevertheless simulated in various kinds of photographs, phonograph recordings, and stage productions; performers in these respective media drew upon a well-established set of behavioral and performance codes, such as "standing with hands on hips, so that shoulders visibly shake or [with] arms crossed and wrapped around [the] middle, . . . postures allowing the body to rock or swivel on the hips" (David Mayer, personal communication, 1 March 2011). While filmmakers working in the early twentieth century certainly borrowed elements of nineteenth-century theatrical performance styles in representing laughter cinematically, they also modified these styles to exploit cinema's unique expressive possibilities. This can be seen clearly in the star turns by Chaney and Veidt in *Laugh, Clown, Laugh* and *The Man Who Laughs*, performances that are carefully calibrated to camera distance—tailored to

the closer views of the hands and face, respectively, which the more frequent use of medium shots and close-ups afforded audiences. Subtler gestures and expressions by an actor might well have gone unnoticed on large stages (which, not coincidentally, are replicated in the mise-en-scène of *Laugh, Clown, Laugh* and *The Man Who Laughs*), but these micro-movements are entirely legible on the cinema screen. While Chaney and Veidt had extensive prior experience in theater, their performances of noiseless laughter in these two films are highly congruent with Hollywood cinema's classical découpage. These performances of laughter and its discontents (which include a number of attending and sometimes contrasting emotions and expressions) thus provide an instructive locus for examining how the finer nuances of bodily movement were employed during the late silent period—even in large-scale films that are a far cry from the intimate explorations of a *kammerspiel* (chamber-drama) like *The Last Laugh*.

Performances of Authenticity in Photography and Phonography

In his 1872 book *The Expression of the Emotions in Man and Animals*, Darwin posited that the physical manifestations of human emotions were deep-rooted responses that corresponded to those seen in animals experiencing analogous affective states. For Darwin, laughter was an "expression of mere joy or happiness" (196) defined by its sound, "produced by a deep inspiration followed by short, interrupted, spasmodic contractions of the chest, and especially of the diaphragm" (200), though it also had a set of typical facial expressions—and, to a lesser extent, convulsive body movements—that could be seen in similar forms across different species of primates. As Darwin concluded, "Although we can hardly account for the shape of the mouth during laughter, which leads to wrinkles being formed beneath the eyes, nor for the peculiar reiterated sound of laughter, nor for the quivering of the jaws, nevertheless we may infer that all these effects are due to some common cause. For they are all characteristic and expressive of a pleased state of mind in various kinds of monkeys" (206).

While the bodily expressions of animals are depicted in engravings in the book, Darwin chose to illustrate many expressions of human emotion with photographs—a pair of which were taken by the early

art photographer Oscar Rejlander. Unlike the conventionalized mannerisms seen in painting and sculpture, Rejlander's heliotype photographs seemed to offer a more reliable index of the outward signs of human emotion on the countenance; as Rejlander explained to a group of photographers shortly after Darwin's book was published, "What he [Darwin] wanted he could find nowhere else but in photography, and photography supplied him with . . . [the] expressions which could not be found in the stereotyped forms on which the artist relied" (qtd. in "South London Photographic Society Annual Meeting," *Photographic News*, 6 December 1872, 587, qtd. in Spencer 120–21).

Darwin illustrated his discussion of laughter in *The Expression of the Emotions* with six photographs, one taken by George Charles Wallich, two by Rejlander, and three credited to Guillaume-Benjamin Duchenne (they had already appeared in Duchenne's 1862 book *Mécanisme de la physionomie humaine*). The six photographs show "different degrees of moderate laughter and smiling." In at least one photograph (taken by Wallich), "the expression was a genuine one," as Darwin put it, while in another (taken by Duchenne), the subject had been electrically stimulated by the "galvanization of the great zygomatic muscles of the face" (200–201). Most of the other photographs of smiling and laughing people are not so clearly glossed, and thus it can be difficult to determine to what extent these pictures are performances—a difficulty that is compounded by the often performed smile for the camera. In sharp contrast to the blurring of spontaneity and performance seen in the close-up photographs of laughter in the book are the photographs of Rejlander himself taken from medium-shot distance in its last few chapters, looking every bit like a Victorian actor posing during performance. Among these is a photograph of "helplessness" in which, Darwin says, "Mr. Rejlander has successfully *acted* the gesture of shrugging the shoulders" (264, my emphasis).

Laughter was subject to simulation not only in photography but also in other forms of mechanical reproduction—not to mention ostensibly spontaneous performances of everyday life—where it retained an aura of apparent authenticity. Human laughter was an important part of late nineteenth- and early twentieth-century recorded sound culture. During the 1870s, demonstrations of the Edison phonograph often included recordings of coughing, sneezing, and laughing (Feaster 100). Such non-linguistic but nevertheless distinctively human sounds

were a favorite choice for early phonograph demonstrations, reminding listeners of the human presence at the source of the disembodied processes of sound recording and reproduction. Auditors seem to have been even more surprised to hear a machine laughing than talking or singing. The popularity of laughing records, a genre of early phonograph recordings comprising "almost entirely the sound of unrestrained and unaccompanied laughter" (Smith 19), shows the continued appeal of mediated laughter.

The African American entertainer George Washington Johnson recorded *The Laughing Song*, "perhaps the first blockbuster of the emerging market for entertainment phonograph records [and] . . . one of the (if not *the*) best-selling records in the country during the 1890s" (Smith 18–19). Smith notes, "Johnson's laugh certainly carried with it racist stereotypes of the minstrel show." Actually it was widely marketed as authentic, specifically a recording of "'authentic' blackness" (19). The racial impersonations of blackface minstrels were proffered for their ostensible comedy (as well as for their performances of song, music, and dance), but laughter was generally supposed to come from the audience rather than onstage performers. As Robert C. Toll writes, "Minstrel audiences obviously wanted to laugh at Negro characters and to enjoy their 'peculiar' music and dance" (38). Minstrel comedy was both visual, with an emphasis on slapstick, and verbal, premised on dialect and malapropisms both delivered by the stump speaker and exchanged between the endmen and the interlocutor in the classic nineteenth-century minstrel program and stage arrangement (Toll 53–57). As during the mid-nineteenth century the minstrel show became increasingly specialized—like variety theater and burlesque—its format expanded to accommodate a range of specialty acts, one of which was the so-called Laughing Darkey (Mahar 37–38).

BREAKING OUT LAUGHING

Smith treats Edison's *Laughing Gas* (1907), directed by Edwin S. Porter and J. Searle Dawley, as an analog to laughing records in contemporaneous visual culture. Here, the sound of recorded laughter is replaced by "broad physical gestures: opening the mouth, slapping the knee, throwing the arms up overhead, rhythmically swaying back and forth, and generally presenting a loose and relaxed posture" (26). Theater

historian David Mayer explains that performances of laughter gained amplitude for lower-class characters: "The lower the class, the more physically evident the laughter. Upper-class people cock their heads back and sneer or again sneer behind their hands." In *Laughing Gas*, Mandy Brown (Bertha Regustus) is administered the eponymous anesthetic before having a painful tooth removed. But, once the tooth is removed, Mandy awakens in the dentist's chair and collapses onto the floor in a seemingly uncontrollable paroxysm of laughter that proves contagious; both the dentist and his assistant are seized by laughter that prevents them from staying on their feet as Mandy leaves the office. Succeeding scenes show the effects of Mandy's infectious full-bodied laughter as she moves through a number of different locations over the course of a day: her laughter sends everyone she comes into contact with into fits of hilarity. *Laughing Gas* is a "linked vignette film, [which] features the same character in a series of shots/settings engaged in corresponding actions" (Stewart 44). As with a number of other early films structured by linked vignettes, "repetition with slight variation is the basis for their comedy" (Musser 354).

Although the laughter that Mandy's laughter induces in others is what gets repeated with variations in the film, Regustus adeptly performs not just the act of laughing but that of *breaking out* laughing, and she performs these with slight variations in different scenes. Regustus is a large and demonstrative woman and she dominates the frame not only because she is larger than anyone else in the film but also because of the way she throws her weight around with the seeming effortlessness and self-assurance of an experienced physical comedian. Regustus's performances exceed both the simple structure of linked vignettes and the performances of laughter by other actors in the film, inasmuch as Mandy tries again and again without success to contain her laughter in a series of places where uncontrolled laughter would seem inappropriate (on a crowded public conveyance, during a hearing at a police station, in the domestic workplace, in a place of worship). In a number of vignettes, Mandy stifles her laughter before being overwhelmed by it: she puts her hand to her mouth and attempts to check the swaying of her body as it undulates in a series of increasingly intense wave-like movements. Ultimately, she cannot hold it in and her body either collapses onto the floor or is launched careening into others. Lest we have any doubts about the

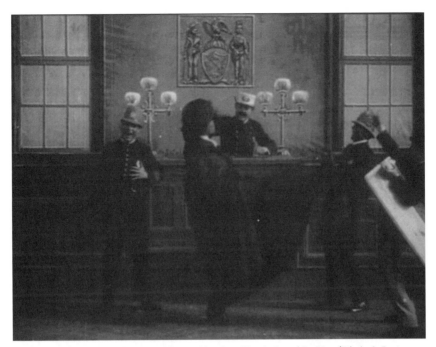

Mandy (Bertha Regustus) twirls before exiting laughing in *Laughing Gas* (Edwin S. Porter, Edison, 1907). Digital frame enlargement.

bodily control required for these performances of seemingly uncontrolled laughter, we need only look to Mandy's exit from the police station, where she strides purposefully past the officer who has just discharged her, extends one leg into the air, and then gracefully twirls 180 degrees, walking past him again in the opposite direction before exiting frame-left, smiling. The film is populated with a range of racial and ethnic stereotypes—the large African American female domestic servant, as well as several unnamed characters described in a published synopsis of the film as a "Dago image seller" on a street corner and two construction workers engaged in "an Irish argument" (*Moving Picture World*, 14 December, 1907, 671). Yet, with their dancer-like grace, Regustus's performances of rippling, quaking laughter cannot be reduced to iterations of a minstrel stereotype.

However, *Laughing Gas* is bookended by emblematic close-up shots of Mandy, at the beginning with her jaw bandaged as she grimaces in pain and at the end laughing ecstatically with her mouth wide open.

As the film begins, Mandy is completely static, with her head turned slightly to one side to show her swollen cheek—the impetus for the film's skeletal narrative. Only after a few seconds does she move from this pose, lolling her head slowly to one side against her palm as she winces in pain. In the final shot, she is fully in motion, head rolling quickly from side to side as she quivers with laughter and opens her eyes from time to time. While the effect of the laughing gas is made visible in the contrast between these two respective shots, the close-up further amplifies Regustus's unrestrained facial performances. Her laugh seems excessive both in its duration and in its expression, and in this final shot one can perhaps see traces of minstrelsy's eye-rolling "laughing darkey."

LON CHANEY: EMOTIONAL QUICK-CHANGE

In *Laugh, Clown, Laugh,* Count Luigi Ravelli (Nils Asther) is afflicted with (as an intertitle puts it) "spells of uncontrollable laughter" due to a life of self-indulgence. A neurologist tells him that he can be cured only if he truly falls in love with a woman. Coincidentally, Tito (Lon Chaney), a famous clown, is there to see the neurologist on the same day: this man who makes thousands laugh suffers from crying spells due to an unrequited love. The doctor tells him that the only cure for his unrelenting sadness is to win the love of the woman he desires. Walking out of the doctor's office together, the two patients realize that they can help one another given their symmetrical problems. They begin spending time together and form a ready trio with Simonetta (Loretta Young), the wire-walker whom Tito and fellow clown Simon (Bernard Siegel) have raised since she was an orphan girl. But both Tito and Luigi are in love with Simonetta, and a bizarre love triangle ensues that can be resolved only when one man is cured and not the other.

Tito often acts out laughter as part of his clowning, but his performances of laughter are not always confined to a stage or a circus ring. When he finds Simonetta crying backstage after he finishes a show, he implores her to stop before launching into a private performance of comic mimicry just for her benefit, one that also involves Simon and includes wildly exaggerated imitations of laughter in which he throws his head back and leans forward, placing his hands on his knees. In

the theater, as Mayer points out, "[the] clown's shrieking laughter is one of the times that pantomime is notably audible," but of course here Chaney must pantomime laughter without benefit of his voice. The degree to which Tito's laughter is marked as a performance within the film is indicated in a subsequent scene in which he performs the same series of gestures on the stage of a vaudeville theater as "Flik" the clown, just after he sees Simonetta and Luigi kissing backstage. Although the show is over (having concluded with Flik's slide from an elevated platform down a tightrope stretched above the audience to the stage—while standing on his head), Simon urges Tito to prolong his performance onstage with an encore (despite being completely crushed by what he has just seen): "Laugh, clown, laugh. . . . even though your heart is breaking!" While a packed house gives him a raucous standing ovation, Flik doubles himself over with laughter as he claps and points in two frontal full shots, seemingly unable to control his mirth until the curtain is drawn—at which point he immediately collapses sobbing into Simon's arms.

Sequences like this are evidence of what Joël Magny has described as the "formidable malleability" of both Chaney's body and face, as well as his ability to change his facial expressions rapidly: "In a single shot of scarcely several seconds, Chaney is capable of running through an astonishing gamut of contradictory emotions" (77, my translation). Earlier in *Laugh, Clown, Laugh*, when Tito discovers an expensive pearl necklace Luigi has sent to Simonetta's dressing room (and begins to suspect that his friend wants to seduce her), Chaney's performance of emotional quick-change is even more extended and wide-ranging. Stuart Rosenthal notes, "Chaney would often progress from amusement to puzzlement to surprise and then through anger into a state of rage in a single close shot" (20–21). This is precisely the series of emotions Chaney performs in this scene (although they span a number of successive shots), as he moves quickly from amusement with his own clowning to puzzlement and surprise over the pearl necklace and then into anger and rage when Simon confronts him with the implications of the gift.

Tito becomes despondent. Even though Simonetta has told him that she loves him and will marry him instead of Luigi, he believes she has lied to spare his feelings. As Tito and Simon begin what will be their final rehearsal (with Tito dressed in full motley and Simon

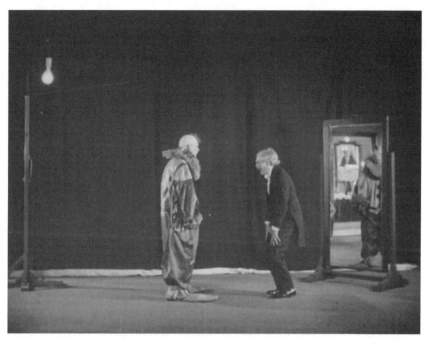

Tito as Flik (Lon Chaney) rehearses with Simon (Bernard Siegel) in *Laugh, Clown, Laugh* (Herbert Brenon, MGM, 1928). Digital frame enlargement.

in formal dress), their movements mirror one another, although Tito moves more slowly and without much energy. The symmetry of their performances breaks down completely, however, when the time comes for the clowns to laugh together. While Simon crouches over and slaps his hands on his knees, Tito stands with a forlorn look, no longer able even to go through the motions of the routine, his unhappy face reflected in a full-length mirror behind Simon. Simon continues vigorously slapping his hands on his knees, but Tito looks aside and wrings his hands while Simon implores him to laugh and "be Flik." Chaney's facial expressions are partly masked by the clown makeup he wears, but it is his hands—more than his face—that convey the emotions of the scene. The film's director, Herbert Brenon, claimed to have "passed more time in directing the hands of his players than in any other phase of the huge spectacle. . . . Brenon holds that Chaney has the most expressive hands of any actor of either stage or screen. 'Chaney,' he says, 'can speak volumes with his eloquent hands'" ("Hands").

Matthew Solomon

In *The Man Who Laughs*, set in seventeenth-century England, King James II punishes Gwynplaine, the son of a rebel leader, by having him surgically disfigured. The gruesome operation takes place offscreen, but an intertitle explains, "A Comprachico surgeon carved a grin upon his face so that he might forever laugh at his fool of a father." (The Comprachicos are a gypsy band that kidnaps children and surgically renders them "Monstrous Clowns and Jesters.") The orphan Gwynplaine falls in with Ursus (Cesare Gravina), who makes him part of a traveling show with another orphan, the blind girl Dea (Mary Philbin), whom he takes into his caravan. The three travel together: Gwynplaine becomes a famous clown and Dea acts in the show.

In a brief sequence that crystallizes the gap between smiling and happiness, Gwynplaine looks in a mirror while Dea, in profile, rubs his shoulder. She is smiling although—Gwynplaine believes *because*—she cannot see his face, happy in love. Their eyelines are triangulated by the gaze of Hardquanonne (George Siegmann), the surgeon who disfigured Gwynplaine and now seeks to exploit him as a sideshow attraction. He is peering unseen through a window at Gwynplaine and Dea. Dea strokes Gwynplaine's shoulder, smiling and speaking, as Hardquanonne raises his eye-patch to get a better look. Her gentle smile is in sharp contrast to Gwynplaine's absurdly exaggerated grimace (as well as to the expressionless face of Hardquanonne). Although she cannot see, the film suggests that her vision is actually more penetrating than that of anyone else. Gwynplaine looks intently at a polished mirror but sees only the grotesque clown whom the public finds hilarious (rather than the compassionate and caring individual whom Dea adores.) Hardquanonne's gaze through the dusty, smudged window pane at the reflection in the mirror is only long enough for identifying the grown-up Gwynplaine with certainty; at this point, Hardquanonne doesn't directly glimpse Gwynplaine's face, nor does he apparently even see Dea.

As Gwynplaine looks into the mirror, he closes his eyes and furrows his eyebrows while raising the corners of his mouth. The subtle movement of Veidt's lips further bares his teeth, making Gwynplaine's wide, surgically produced smile seem even wider, yet his closed eyes and furrowed brow show the emotional anguish he is experiencing.

He reaches up and closes the doors on the small cabinet enclosing the mirror, which are each mirrored on the inside. For a split second, the viewer sees Philbin's beatific smile doubled, as the right profile of her face and the reflection of her left profile bracket Veidt's tortured grin. The closing of the cabinet doors begins in medium shot but is completed in a succeeding close-up, which shows the classical masks of comedy and tragedy painted on the outside of the cabinet's doors. But, importantly, the placement of Veidt's hands on the mouths of the masks as he pushes the doors closed makes it very difficult to determine which one of the two masks represents comedy and which one represents tragedy. This intersection of set design and performance in the mise-en-scène of this shot underscores a central theme of the film as a whole, which turns on the ways that tragedy can be mistaken for comedy.

Our first introduction to Gwynplaine as a child (Julius Molnar, Jr.) centers on just such a mistake. After bringing the abandoned baby Dea to Ursus's wagon from a driving snowstorm, the boy removes his scarf but holds his hands to his mouth, warming them. When Ursus glances over at Gwynplaine, it appears to him that the boy is smiling and is thus quite insensitive to his sad discovery of the baby girl's blindness. He demands that Gwynplaine stop laughing, but only when he orders him to stop laughing a second time, to which the boy responds that he is not laughing, does Ursus take a closer look at Gwynplaine's face. He brings the boy's face close to his own, runs his fingers over his mouth, and only then realizes that the young Gwynplaine's apparent smile is not what it had seemed at a glance. Throughout the rest of the film, the adult Gwynplaine often conceals his facial disfigurement by holding his hands in front of his face or otherwise shielding his mouth from view. Generally, it is only in the sightless Dea's presence that he lets his guard down and lowers his hands from his face.

Veidt's performance in *The Man Who Laughs* is thus structured by an oscillation between concealing and revealing his mouth within and across specific scenes. Yet the gestural movements of his arms and hands take on meaning only in relation to facial expressions. Veidt's acting combines larger gestures of his upper body and careful articulations of his mouth (which must remain contorted in fixed expressions to simulate disfigurement) that are often independent of precise movements of his cheeks, eyes, eyebrows, and forehead. The

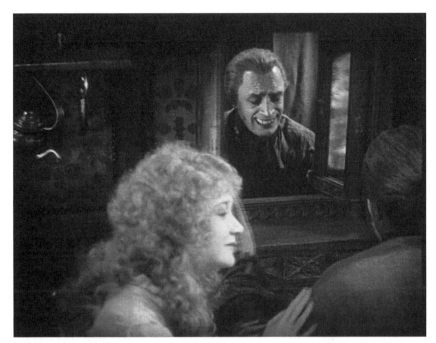

The face of Dea (Mary Philbin) beside the mirror image of Gwynplaine (Conrad Veidt) in *The Man Who Laughs* (Paul Leni, Universal, 1928). Digital frame enlargement.

remarkable facial acting Veidt does in close-up was further highlighted by an innovative approach to makeup that was purportedly based on the actor's prior medical studies in Germany. According to studio publicity, "Conrad Veidt . . . can distort the muscles of his face in any manner and control them in any particular position for a reasonable length of time. It is due not alone to muscular training but to . . . a remarkable system of making up his face. . . . He divided his face, not according to its exterior appearance, but according to the muscles, into segments and columns. . . . A surgical knowledge of the muscles in his face enabled him to know what muscles he needed to use and how to accentuate them with greasepaint and color" ("Muscular").

Despite the "gigantic sets" that Universal used in its new Victor Hugo adaptation, which was touted as a "super-production" ("'The Man Who Laughs' Coming as Photodrama," in *The Man Who Laughs* pressbook), much of the film's impact occurs on a very small scale, at the level of the muscles of Veidt's face. For example, when Gwynplaine confesses his

love for Dea and she tells him that she will happily marry him without ever seeing his face, he is elated: Veidt pulls back the corners of his already unnaturally bowed mouth and raises his eyebrows as he embraces her, clasping her body to his. But, when Gwynplaine looks up over her head and sees a jeering crowd of gawkers watching them embrace, his momentary happiness quickly turns to surprise, sadness, and shame, as he raises his eyebrows and opens his eyes even wider, returning the gaze of the onlookers. His arms drop and he shifts Dea aside, opening his mouth wider and lowering one eyebrow. He bobs slightly with a quiver that can be read either as a laugh or as a sob (or both). In the next shot, Gwynplaine is even more distressed by the laughing crowd, pinching his eyes partly shut and widening his mouth as he shakes, as if about to cry. He then partly hides the signs of his emotions by drawing both his hands up over his mouth and closing his eyes, but his body betrays him as he drops despondently to the floor when the scene ends.

If at all times, and however misleadingly, his face bears the outward appearance of laughter, Gwynplaine's performance of laughter onstage as "The Man Who Laughs" creates a grotesque display of mirth that reverses the dynamic of many of the film's other scenes. Looking out from the stage, Gwynplaine laughs at the crowd as a public spectacle rather than bearing the brunt of their laughter during his own ostensibly private moments. And he does so in a way that further inverts the dynamic of being laughed at by pointing to a series of individual spectators and laughing at them (rather than laughing at the audience as a collective group). He wrinkles his brow, opens his mouth and eyes wide, and raises his eyebrows and the corners of his mouth. His laughter seems at once to be performed and spontaneous. But when Gwynplaine makes eye contact with the Duchess Josiana (Olga Baclanova), the vamp, he suddenly becomes self-conscious again and raises a sleeve to his face to conceal his mouth from view.

A lingering exchange of glances between Josiana and Gwynplaine is made portentous through the use of a slow lap dissolve to Josiana as—not laughing, but nevertheless utterly transfixed by the sight of him—she looks at Gwynplaine, and through a close-up shot that tilts up from Josiana's heaving bosom to her face as she slowly and hesitantly raises a sequined mask in front of her mouth. Although her gesture with the mask echoes his with the sleeve, the drawn-out upward movement of her arm and her failure to even feign any expression of

embarrassment or shame points to the asymmetry of this unmistakably erotic exchange. Josiana, who delights in strolling through the freak show at Southwark Fair, takes palpable pleasure in looking long and hard at Gwynplaine and simultaneously in being looked at by him, whereas he shyly recoils from her view and seems reluctant to return her gaze from the stage. Unable to reciprocate or fully participate in this seduction-at-a-distance, Gwynplaine reverts quickly to a disconcerting silent performance of laughter, cackling maniacally, blinking his eyes, and raising and lowering his eyebrows.

One contemporaneous reviewer noted director Leni's "happy bent for stylized acting" and called Veidt in *The Man Who Laughs* "easily one of the noteworthy performances of the season" (John S. Cohen, Jr., "'The Man Who Laughs': Additional Thoughts on the Success at the Central" [clipping], Robinson Locke scrapbooks). Another reviewer elaborated, "With the lower half of his face masked by a rigid, hideous grin . . . Veidt seems literally to live the tearing misery of the heartsick Gwynplaine with every movement of his body" (Katharine Zimmerman, "'The Man Who Laughs' Blazes Trail at Central" [clipping], Robinson Locke scrapbooks). Comparing *The Man Who Laughs* favorably both with Leni's previous German films and with an earlier Hugo adaptation staged in New York, reviews like these approvingly highlighted the stylization that has come to be described by latter-day commentators as "Expressionist." However, unlike Veidt's iconic performance as the somnambulist Cesare in *The Cabinet of Dr. Caligari* (Robert Wiene, 1920), with its broad strokes, his Gwynplaine is evidence of a rather different mode of Expressionist acting, one that was rendered with the precision and intimacy of a photographic portrait but that relied on unsettling distortions of the very architecture of the actor's physiognomy.

Like the rapid arabesques of Chaney's face and hands in close-up and medium shots, these performances suggest particular modes of acting, gesture, and expression that had their heyday during the late silent period, but would soon be made obsolete with the coming of sound. Indeed, soon enough the sound of recorded laughter would drown out many of the enchanting intricacies of silent-film performance— some of which we have only started to unravel.

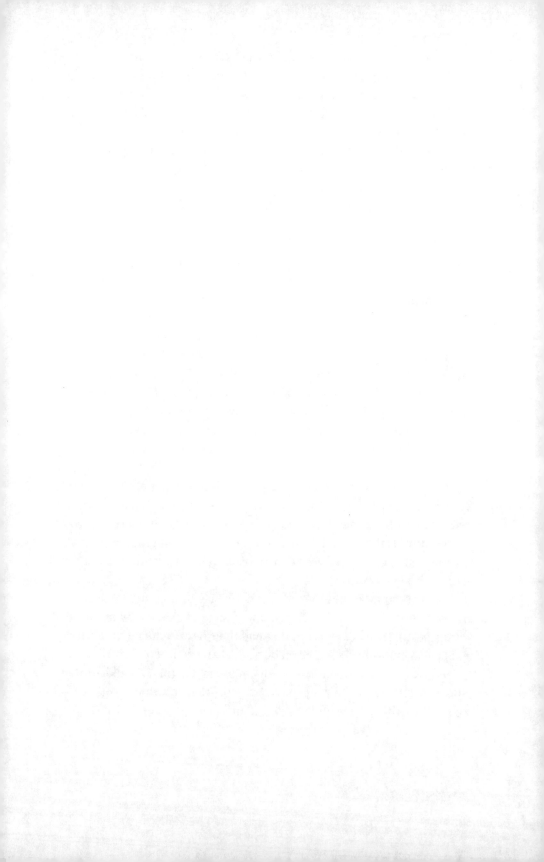

JAMES MORRISON

Wellesian Laughter

Orson Welles's laughter was one of his most distinctive features, by many reports. An interviewer for the *Saturday Evening Post*, visiting Welles in France in 1963 on the completion of his film version of *The Trial*, describes a "gust of wicked laughter shaking his Falstaffian frame" (qtd. in Macdonald 295). On the set of the "The Tonight Show" while compiling a profile of Johnny Carson, Kenneth Tynan hears "a gust of Wellesian laughter" (315) issuing from one of that program's most frequent visitors. On the first page of her book about her father, Welles's daughter Chris Welles Feder conjures an image of St. Nicholas when she recalls how Welles's "button nose twitched and [his] great belly shook when he let loose with a thunderous laugh" (1). At the end of his final film appearance, in Henry Jaglom's *Someone to Love* (1985), Welles is stranded onscreen, demanding that the camera be stopped; when it keeps running, Welles responds with gales of strange laughter. As Peter Conrad describes the scene, "[Welles] chortles, chuckles, laughs, guffaws, and applauds. . . . He is obliged to go on being himself. . . . Despite the pretence of mirth, his abiding self-mistrust is apparent in his sad, fearful eyes" (372).

Wellesian laughter is a force of nature, in such accounts. It comes in "gusts" and evokes "thunder." It denotes a recognition of the world's absurdity (in its "wickedness") and a form of revelry, a "Falstaffian" pleasure. At the same time, it connotes pathos, a loss of control ("let loose"), or decline of mastery. In its most characteristic forms, it is

not only an expression of unease but the cause that unease is in others. Dwight Macdonald, for instance, citing the *Saturday Evening Post* piece at the beginning of his contemptuous review of *The Trial*, reacts with the verbal equivalent of a cringe. In his film performances, Welles's laughter impends as an undercurrent threatening to overtake his booming, orotund voice. In *Citizen Kane* (1941), Welles's first full line—"Don't believe everything you hear on the radio"—is dispensed with a giggle, and the spontaneity of his performance is staked in large part on suddenly shifting registers of intonation, with traces of a joyless mirth shading much of his delivery. As Hank Quinlan in *Touch of Evil* (1958), Welles's speech is a slurry dribble that gives way on a dime to a rasping chortle or an aggressive silence, as if words were nothing but placeholders between those poles. Even as Falstaff in *Chimes at Midnight* (1966)—the performance that squares most readily with the recollections of Welles's daughter—Welles marshals laughter as a principal sign of Falstaffian exuberance, but his laughter in that film is seldom without its countercurrent of distaff melancholy. Whatever else it may be, Wellesian laughter almost never stands as an expression of straightforward happiness.

Subject to the rigors of theory, of course, laughter rarely does express simple happiness. The most influential accounts of laughter in the twentieth century do less to rescue it from its neo-classical associations with vulgarity than to redeem that vulgarity as a glorified reaction against the rigidity of modern officialdom. In his work on the carnivalesque energies of popular cultures, for instance, Mikhail Bakhtin notes that laughter troubles ordinary hierarchies of high and low even in its basic physical manifestations, issuing from the gut through the mouth. Traversing these bodily dimensions, laughter emerges, in turn, as a valuable weapon to dissolve social boundaries and degrade the power structures that derive from arbitrary divisions. In Bakhtin's work, the crowd joined in laughter produces an anarchic charge that works against the authority of imposed order. One might expect Elias Canetti to follow this line of thinking in his monumental study *Crowds and Power* (1960), because like Bakhtin—but by contrast to earlier theorists of crowds from Thomas Carlyle to Gustave LeBon and Sigmund Freud—Canetti views the crowd impulse as an alternative to pathologies of power. Yet he treats laughter not as a shared response that bonds the group but as a primal vestige by which one individual will

asserts its superiority to another. For Canetti, laughter is not an assault on power but a symptom of it, a reflex of the individual who derides others rather than entering into the potential equality of the crowd.

Bakhtin is hardly alone in perceiving laughter as an auspicious gauge of the cohesion of rebels against misrule—or indeed, rule of any kind—but he is among the most idealistic of commentators. Georges Bataille places laughter alongside sexuality at the base of all community but finds that lingering primal dimensions of both laughter and sexuality render community inherently fragile, though it can have no other real foundations. Henri Bergson also locates a vestigial element in laughter, finding that it arises in response to failed adaptations to modernity, when the organic clashes with the mechanized—when, for instance, the human body is subject to automatism and reveals its own rigidity and inelasticity (66). Although Bergson denies that laughter always implies the degradation of its object (141), he also observes that it exhibits "separatist tendencies" (73), whereby the one who laughs—*contra* Bakhtin—resists integration into the social order.

All these senses of laughter appear at some point across Welles's work. In the party scenes of *Citizen Kane, The Magnificent Ambersons* (1942), or *Mr. Arkadin* (1955), or the festival footage of the incomplete project *It's All True* (shot in 1941 and 1942), laughter signifies elements of the carnivalesque in something of the sense in which Bakhtin defines it: a release from identity and a diminishment of otherness, as the individual blends into the crowd. Except in *It's All True*, however, these celebrations are all shaded with portents of loss. Kane's revelries ring hollow from the start, as his colleagues call his apparent triumphs into question from the margins as Kane dances heedlessly, like a puppet whose strings are being jerked. By the end of the film, the beach party he decrees is comic in its lack of cheer, its lugubrious formality. In both *Ambersons* and *Arkadin*, the parties are the remnants of a vanishing order, their bacchanals indicative of an incipient grotesquerie, with little of the liberating potential Bakhtin attributes to the grotesque. The roistering in the tavern in the first half of *Chimes at Midnight*, too, is answered by the savage battles and stilted rituals of the second half. Although Canetti claims that a "negative crowd reverts easily to a positive one" (57), Welles's attitude is more ambivalent. His populist commitments give rise to hopes for the good of social collectives, but in practice, in any given film, these hopes are never ultimately sustained.

In Welles, it is the positive crowd that reverts readily to the negative, as all of his films detail paralleled processes of social and personal decay, again and again documenting the operations of systems running down.

Laughter sometimes reveals these processes of degradation, as in Aunt Fanny's exhausted, depleted heaves near the end of *The Magnificent Ambersons*, which run out of energy only to morph into hysterical shrieks. Here, as often in Welles's films, laughter appears as a bitter recognition of defeat. Derisive laughter is hardly absent, but it is usually peripheral. One example is the offscreen laugh Susan Alexander overhears in *Citizen Kane*, as she is about to debut on the opera stage, a fleeting, sidewise titter that she interprets as ridicule. Another is the mocking cackles of the witches at the start of *Macbeth* (1948), or Grisby's taunting jeers in *The Lady from Shanghai* (1948) as he draws Michael O'Hara into his schemes while they wend their way along jagged cliffs. Both the witches and Grisby are implicated in the plots that entangle the protagonists of those films, but they are really only agents of much larger, often intangible forces, and accordingly their laughter has a tinny edge. The laughter that resonates the most in Welles's films is not that which derides but that which erupts as the acknowledgment of one's fate as the object of a cosmic joke.

In either case, laughter remains bound up with power relations and therefore key to central themes of Welles's work. Bergson and Canetti both visualize laughter in strikingly similar images of dominance and subordination. Bergson's conception of a familiar provocation to laughter is quintessential: "A man, running along the street, stumbles and falls; the passers-by burst out laughing" (66). Canetti's also depends on a relation of the still-standing to the fallen: "Originally laughter contained a feeling of pleasure in prey or food which seemed certain. A human being who falls down reminds us of an animal we might have hunted and brought down ourselves. Every sudden fall which arouses laughter does so because it suggests helplessness and reminds us that the fallen can, if we want, be treated as prey. If we went further and actually ate it, we would not laugh. We laugh *instead* of eating it. . . . As Hobbes said, laughter expresses a sudden feeling of superiority, but he did not add that it only occurs when the normal consequences of this superiority do not ensue" (223). In both cases, however different the conclusions, the laughter issues from above, prompted by the sight of the fallen.

As many critics have noted, Welles's interest in power relations is often starkly literalized in cinematic terms through visual tropes that depend on spatial positioning above or below—for example, extreme low angles of figures looming powerfully (like the image of Thatcher looming over Kane as he presents his new sled); or high angles that dwarf the subject. In light of prevailing views of the sources of laughter, what is most striking in this aspect of Welles's work is how often, in such configurations, laughter issues from below. If Bergson and Canetti both discover an element of sadism in laughter—though Bergson finds a countervailing dimension of empathy—Welles recalls Bakhtin in a series of images that exhibit laughter from below, directed at grotesque spectacles of power. At the same time, far from achieving any victory, this laughter, if it expresses pleasure at all, expresses decidedly masochistic attitudes.

Abject Laughter

The first in this series is the well-known scene in *Citizen Kane* between Kane (Welles) and his second wife, Susan (Dorothy Comingore), in their tent on the beach, when Kane slaps her. He stands above as she kneels below, his shadow eclipsing her after he strikes. The closeness of the characters in space contrasts with their distance, emotional and spatial, in the preceding scenes at Xanadu in which Susan expresses mounting dissatisfaction with their increasing isolation and her own marginalization. There, Welles's use of deep-focus camerawork distends the cavernous rooms, emphasizing their emptiness; and both Kane's deep voice and Susan's shrill one resonate in the sterile vastness. In most of the scenes between Kane and his wives—but by contrast with the long takes that dominate the rest of the film—Welles employs relatively conventional editing in shot/reverse-shot patterns, as in the breakfast table scene between him and his first wife (Ruth Warrick), or in his meeting with Susan in the street outside her apartment. The cutting in the tent scene is sharper than in those examples, with edgier rhythms. For instance, after an initial shot/reverse-shot sequence with both characters seated, Kane grows more impatient with Susan's agitated rebukes. Finally he rises in anger from his chair, towering over the camera. At this point, we cut away briefly to the celebration going on outside the tent, and in the next shot, from behind

Shrieks of laughter sound over this close-up of Susan Alexander (Dorothy Comingore) in *Citizen Kane* (Orson Welles, Mercury Productions/RKO, 1941). Digital frame enlargement.

Susan, we see Kane standing over her, much closer than previously. His advance across space has been briskly elided by the cutaway shot, giving his bearing an aspect of stolidity that only amplifies the sense of menace. The following shot is the close-up of Susan in which he lashes out at her. In part due to the closeness itself, a discomfiting intimacy in a film of such overall detachment, the slap registers as a visceral shock.

What gives the moment an especially uncanny sensation is the shriek of female laughter that rings out just as Susan is struck and continues afterward. It clearly comes from the party outside yet still seems oddly sourceless, eerily dissociated, both orgiastic and terrified, closer to a scream than a laugh. And neither Susan nor Kane reacts to it in any way. In effect, it plays like a non-diegetic element of the film's sound track, a nightmare voiceover, an objective correlative of Susan's own inexpressible rage in response to Kane's violence. At the same time, as most know who have seen the film with large audiences, the slap itself is cathartic for uncharitable viewers who cheer because

James Morrison

they view Kane's violence as justified by Susan's relentless complaints and increasing shrillness. To an extent, the film seems to invite this response, yet the shrieks of laughter undermine any smug satisfaction in the conviction that Susan is getting what she deserves, if only in the discordant notes of enigma and irresolution they introduce. An externalized manifestation of Susan's inner turmoil, these shrieks suggest depths of anger and discontent even beyond anything she has articulated, laying bare the extent of her pain in the very moment when some might be inclined to take pleasure in her punishment.

The slap that stills a hysterical outburst was already a movie cliché by 1941—the scene of Heathcliff striking Cathy in *Wuthering Heights* (1939) is one of many examples of the era—but the point of this scene in *Citizen Kane* is that the slap does not stop the outburst; it displaces it, forces it into another register. Susan yields to Kane's physical domination, sitting back in submission as he towers above her. Welles's next film presents another example in which the one who laughs is also she who gets slapped. Aunt Fanny's breakdown near the end of *The Magnificent Ambersons* is a forceful eruption of uncontainable feeling. Once again, the positions in space of the characters are clearly defined. Fanny (Agnes Moorehead) is slumped against the cold boiler and viewed from a slight high angle, her nephew George (Tim Holt) standing over her and viewed from below. The power relations between them, however, are far less clear. At this point in the film, both have been defeated in different ways by the forces of modernity, Fanny by investing faith (and money) in failed technologies of progress, George by disdaining all progress. If from the film's start all the characters (including Eugene Morgan [Joseph Cotten], the main proponent of the values of progress) have been depicted as ineffectual and both the Ambersons and the Minafers, their fates entangled by marriage, have been sustained in delusions of stability and power by their long-standing wealth, in this scene all these delusions have been successively stripped away. The beginning of the sequence is notably stark in its lighting and mise-en-scène, by contrast with the rest of the film. Although this starkness gives way to a restoration of the Gothic styling that predominates, here it sets Fanny's frenzied laughter into sharp relief.

Earlier in the film, Fanny's laughter is restrained. In fact, it is a calculated part of her armory in the constant sessions of bickering among the members of the family. After the party, she directs a fey mock-titter

at her nephew—"Heh, heh, heh!"—to ward off his teasing. By the end of the film, it is clear that this seemingly marginal character is a principal locus of the film's emotional investments. Her appearances work out an intricate visual dialectic. She is typically glimpsed in the margins of the film's compositions but moves suddenly, and briefly, to the center at key moments, as when she stands over her dead brother's coffin and a sudden, shocking close-up reveals her bereft expression. Even when she is peripheral to the main action of a given scene, she is often its true subject, as in the tour of Eugene's automobile plant, where the play of her facial expressions forms the emotional core even though it may go unnoticed due to the surfeit of action elsewhere in the image and Welles's constant placement of her at the margins of the frame. One of the strangest shots in the film brings this dialectic to a head. After the death of George's mother (Dolores Costello), we begin on a close-up of Major Amberson (Richard Bennett) and pan away to follow a figure that passes before him. At first, this fleeting figure appears to be George, but it moves out of the frame quickly as, from a different, disoriented angle, George moves in, the camera placed behind him. Just as he enters, Fanny rushes in from another sideward direction and embraces him, repeating in a rasping whisper, "She loved you, George!" Before she can finish these lines, the oddly vertiginous shot has faded, just as Fanny moves into clearer view as if to deny her grief-stricken self-assertion. As exposition of Isabel's death, the scene is as jarring in its brevity as Virginia Woolf's eerily offhanded disclosure of Mrs. Ramsay's death in *To the Lighthouse* (1927). Both scenes adopt a brisk attitude toward the loss of a beloved figure in an ironic bid not to minimize but to amplify that loss. Something of the same logic attends the treatment of Fanny throughout. The pathos of her character grows in direct proportion to the extent of her being absented, until this process of marginalization itself becomes, in a sense, one of the central subjects of the film.

As the scene of this "absent" woman's out-of-control laughter begins, she bemoans her own failure to observe Isabel's wishes and "make a good home" for George, while George repeatedly enjoins her to get up from her slouch against the boiler, carrying out his own familial duties with dismayed frustration and embarrassment. As in the example from *Citizen Kane*, the scene depicts a stand-off of sorts—since Fanny in fact won't get up—a clash of wills that stalls narrative progression in a typically Wellesian moment of suspended time. Fanny's

speech alternates between a nasal whine and a wail, her humiliated tears giving way to bouts of helpless laughter that finally explodes. Just as in a scorching voice she professes indifference to her own pain—"I wouldn't care if [the boiler] burned me, George!"—the self-absorbed young man, not unlike Kane, asserts his superior force, dragging her to her feet and into the next room. The camera tracks backward, moving through a doorway to follow them. Not only is Fanny centered in this dizzying long-take, but she moves forward ahead of George as she issues her loud, lacerating laughter. The combination of the backward track with this framing of the shot makes Fanny seem to advance upon the viewer with raw aggression. The emphatic element is not by any means George's assertion of strength: with the camera in giddy retreat it is Fanny herself who drives the shot's startling momentum. In almost any other context, the moment would seem transplanted from a horror film, and certainly the scene shades Fanny's pathos with connotations of monstrosity. Culminating the dialectic outlined above, the scene's final effect is to suggest that this overwhelming acknowledgment of her own abjection is the only power left to her.

Deluded Laughter

This pattern of laughter from below recurs in Welles's late work with somewhat different implications, especially at the level of gender. In both *The Trial* and *Chimes at Midnight*, subordinated men direct laughter at representatives of male power positioned above them. In the scenes from *Kane* and *Ambersons*, the interactions between men and women have distinct Oedipal overtones, but they lack the psychosexual charge that another kind of filmmaker—Hitchcock, for instance—would find in them. In the scene from *Kane*, Kane's own behavior echoes both his father's and his mother's from earlier in the film. When he slaps Susan, in effect, he reenacts and completes his father's aborted assault upon him after his mother intervenes in the scene at the boarding house. At the same time, his dialogue here recalls that of his mother in the earlier scene. There, his mother replies to his father's objections to her surrendering custody of Kane by mechanically repeating, "I want you to stop all this nonsense, Jim"; in this scene, Kane answers Susan's complaints with a similar line, "I want you to stop this, Susan," spoken with a similar edge of weariness. In

Ambersons, too, unresolved Oedipal feelings simmer in every quarter, and the climactic scene between George and Fanny is no exception. At one level, it is about Fanny's inability to assume the role of the mother and George's failure to fill that of the father.

In neither of these cases, however, does the Oedipal narrative follow its prescribed course. Even after Kane outstrips the power of the symbolic father (Thatcher) and achieves full patriarchal authority, he remains in thrall to nostalgia for maternal union, his identity divided between mother and father. Meanwhile, if *Ambersons* is read as a film essentially about Fanny, then it concerns how a figure ostensibly outside Oedipal networks—the maiden aunt—is drawn into them all the same. Welles may be as beholden to Oedipal scenarios as Hitchcock, but his chief concern is how they infuse social forms, while Hitchcock's—in such films as *Shadow of a Doubt* (1943), *Psycho* (1960), and *The Birds* (1963)—is how they exceed social forms. In other words, Welles considers the "family romance" as a point of origin for the social, while Hitchcock considers it as one of the many social forms that attempt, and fail, to contain the primal psychosexual energies it also produces. This accounts in part for Hitchcock's interest in an attendant range of Freudian notions—the return of the repressed, and the like—and Welles's relative indifference to them.

It is with an invocation of Oedipus that the last scene of *The Trial* is introduced. A priest who has been aiding the main character offers a final caveat with a conventional priestly address of K. as "My son"; in an abrupt close-up, K. (Anthony Perkins) cuts him off with a blunt, portentous declaration: "I'm not your son." Thereupon, K.'s spectral, courteous executioners appear, lead him wordlessly through town, escort him into a pit, and then stand above it, looking down at him enigmatically. This conclusion departs from Kafka's novel at many crucial points. The novel depicts a largely acquiescent and obedient K., however he might be given to intermittent and unpredictable spasms of ineffectual resistance. In Kafka, K. is respectful to the priest to the end, in stark contrast to the defiant K. of Welles's film, with his flat rejection of the priest's fatherly authority. In the book, K. intuits that the executioners expect him to put an end to himself, with the implication that he accepts his "duty" to do so: "K. knew clearly now that it was his duty to seize the knife . . . and plunge it into himself" (230). In the film, K. forthrightly ridicules the men's halting inaction. "Do you expect me

to do the job myself?" he asks in outrage. From the start, Kafka's K. is mostly resigned, Welles's openly contemptuous.

Indeed, Welles systematically interprets Kafka's novel not as a tale of the futility of opposition to the forces of instrumental rationality, but as a parable about how delusions of individual mastery allow underlying structures of power to flourish. This understanding of the book is crucial to Welles's reconception of the material in explicitly postwar terms (the film was released in France late in 1962 and in the United States early in 1963). The action unfolds in environments with clear Stalinist associations, while massed groups waiting entry to the court evoke the imagery of prisoners in Nazi concentration camps. At the end of the film, the executioners toss dynamite into the pit; the final shot, after the dynamite explodes, is of a mushroom cloud, that quintessential image of the atomic age. Yet Welles is not merely re-framing Kafka's book as an Orwellian fable of Big Brother-ism (though he himself conjures that cliché in the *Saturday Evening Post* interview that stirred Macdonald's wrath). If Kafka's novel details the process by which the modern subject is rendered docile, Welles's film shows how that same subject is made active, invested with a sense of agency that only makes him complicit in his own destruction. This is a shift that, as the film makes clear, has everything to do with the postwar context in which the film appears.

To these ends, Welles's K. is a character always in motion, propelling himself constantly through the eerily dislocated spaces of the film. In Kafka, K. is repeatedly discovered in his characteristic attitude of impassive waiting. Only rarely is he shown going from place to place. Typically, indeed, he is already present within a given scene as it begins, with little sense of his having arrived there, and the scenes themselves are largely shorn of conventional spatial markers, giving the action its floating, dreamlike quality. Moreover, K.'s lack of motion is stressed: "Instead of working he swung around in his chair, moved a few items slowly around on his desk, and then, without being aware of it, left his arm outstretched on the desktop and remained sitting motionless with bowed head" (111). By contrast, Welles employs the most frenetic editing patterns to that point in his work to emphasize K.'s constant activity, cutting on K.'s movements, for instance, as he bolts through doors or advances down maze-like corridors and again and again sharply matching shots on actions to amplify their force.

Josef K's (Anthony Perkins) caustic laughter at his executioners in *The Trial* (Orson Welles, Paris-Europa/Hisa/FICIT, 1962). Digital frame enlargement.

Anthony Perkins's performance as K. furthers these effects. He is haughty, abrasive, and unyielding, quite the opposite of the meek and deferential K. that one could easily imagine and that critics of the film like Macdonald clearly expected.

K.'s caustic laughter at his executioners in the final scene shows that his sense of his own power is undiminished to the end. By Kafka's last chapter, K. is so beaten down that he has every intention of helping the executioners to kill him. It is only due to exhaustion that he "could not rise to the occasion, could not relieve the authorities of all their work" (230). Given the nature of Welles's adaptation, such a scene is inconceivable in the film. Although Welles's K. at first appears to comply with his killers, removing his shirt with an apparent intent to aid them, he quickly reverts to his more characteristic rebellion, shouting at them, "You'll have to do it—*you, you!*" While Kafka's K. submits to the knife and feels only shame at his inability to assist, Welles's K. hurls his rebellious laughter upward as his final refusal of his executioners' authority. At this, in conspiratorial silence they abandon the idea of stabbing him—removing the nightmarishly intimate, sacrificial element of the violence in Kafka's scene from Welles's version—and

produce the dynamite. This recourse to the impersonal violence of modern weaponry is exactly the point, even if K. never knows it. His laughter persists and grows louder through his final act of resistance, as a quick, elliptical shot shows him tossing an object forcefully from the pit—perhaps the dynamite. Only upon the explosion does the manic laughter abruptly cease, followed by the tragic flourish of Albinoni's "Adagio in G" that ends the film. Clearly, the rebellion of Welles's K. is ultimately no less futile than the resignation of Kafka's; it produces only new forms of destruction that circumvent with brisk efficiency the individual acts of resistance to which the possessors of power remain indifferent.

Both Kafka and Welles depict a world where authority is consolidated around the Law of the Father, and there is no hope for the son to assume that power. The edict to do so remains oppressively ubiquitous even though the absent fathers, their power predicated on their invisibility, have already ordained its impossibility. *Chimes at Midnight* is similarly concerned with definitions of power in explicitly Oedipal terms. The plays of the Shakespearean cycle Welles adapts— chiefly the two parts of *Henry IV*, with brief passages from *Henry V*, *Richard II*, and *The Merry Wives of Windsor*—turn on the passage of power from father to son. What clearly draws Welles to the material is his interest in how these transfers are blocked or rerouted, an interest that once again underlines the possibilities for Oedipal dynamics to follow unexpected trajectories. Even so, the plays end with the restoration of power, as the formerly renegade Prince Hal resumes the crown and ascends to the throne, rejecting the influence of Falstaff that had lured him astray. Whether in performance or in interpretation, this conclusion is often treated as the proper outcome, with Hal's return to the royal line securing social order and banishing the forces of anarchy that Falstaff represents. Nothing could be further from the spirit of Welles's approach. *Chimes at Midnight* treats Hal's rejection of Falstaff as pure tragedy; it is among the most chilling scenes in Welles's work.

That final encounter between Hal (Keith Baxter) and Falstaff (Welles) continues the pattern of disempowered laughter from below. Falstaff stumbles into the scene of Hal's coronation as king, breaking through ordered lines of sentinels and shouting vulgar endearments while guffawing with unselfconscious joy. He expects to be

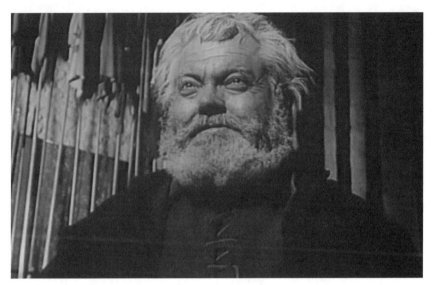

Falstaff's (Orson Welles) resigned, loving smile in the face of his rejection in *Chimes at Midnight* (Orson Welles, Alpine/Internacional, 1965). Digital frame enlargement.

embraced. When Hal turns on him, a reverse shot shows Falstaff's renewed laughter as he steps forward for his anticipated welcome, but Hal does not yield. The new king's speech banishing Falstaff is delivered with the cold-blooded calculation of pure rhetoric, without a trace of regret or the underlying tenderness another performance might have teased from it. Although Falstaff's laughter finally subsides, his expression settles into a resigned, loving smile. In the face of his rejection, he beams with pride in the spectacle of his former companion's ascendancy.

All that has come before makes it impossible to share this pride. From the start, Welles draws sharp visual contrasts between the palace, where the machinations of power run their course, and the tavern, where Hal, Falstaff, and others engage in their spontaneous revelries. The former is shown in fixed shots with angular lines and an overall sense of stasis; the latter is shot with a mobile camera that joins in the characters' romps. Laughter is crucial to this contrast. The first cut to the tavern finds Hal in mid-snicker as he frolics through the narrow halls. Laughter replaces language as a means of communication among the earthier characters throughout, while the scenes at the

court are filled with cold, sterile speechifying. Even so, what is most striking about the treatment of laughter as a theme in *Chimes at Midnight* is its unshared character. Despite the film's celebration of play, its delight in the carnivalesque, laughter here is no Bakhtinian catch-all, bringing the masses together in classless unity. In Welles's film, characters tend, however affectionately, to laugh *at* rather than *with* one another, as in Hal's loving ridicule of Falstaff as he goads him into ever more outrageous lies. For Welles, laughter divides rather than unites, and if it has the capacity to disrupt the operations of power at all, it can do so only for a fleeting moment.

The scene of Hal's rejection of Falstaff is edited in crisp shot/reverse-shot patterns. Never are the two characters shown in the same frame; the separation Hal decrees between them is absolute. The scene differs from previous examples chiefly in the framing of the principals. Though literally below Hal in space, Falstaff is shown from a low angle that does not suggest his subordination. In this sense, Hal and Falstaff are equals in visual terms. The shots of Hal, however, suggest his entrapment, as he is placed squarely among severe vertical lines—the swords of his protectors and the arches of the castle—that are visually echoed in the angular, ornate crown that seems to be pressing down on his head. The canted camera casts the image at an oblique angle with a dizzying sweep of upward-sloping space around Hal, overwhelming him visually for all his declamatory power. The shots of Falstaff, meanwhile, are closer, more direct, with Falstaff centered stably in the image. In spite of the earnest intensity of Hal's monologue, he is viewed as a comic figure. Treated as vacuous throughout the film, the pomp and circumstance of the court are now rendered patently absurd, and Hal's entry into that world makes him ridiculous, too. Falstaff, meanwhile, is granted a gentle dignity in the end. Yet all he can do is laugh.

As this thematic line running through Welles's work suggests, such laughter is a last resort. It mocks power, in its way, in the very moment of surrendering to power, when one has no other choice, after all alternatives have been closed off. Power in Welles is never merely symbolic. It has been laid down in advance by faceless authorities or cosmic forces, or by the megalomaniacal individuals who happen to obtain it, however arbitrarily, but it often manifests itself in language, rhetorical assertions like Hal's speech at the end of *Chimes at Midnight.*

K.'s executioners in *The Trial*, meanwhile, have no need of speech; they maintain the uncanny silence their authority affords them. Wellesian laughter arises in the space between this speech and this silence, after language has failed, but when one still cannot stay silent. Far from sudden, it emerges after a struggle. In a last gasp, it recognizes what all of Welles's work acknowledges: that power is never more absurd than when it is at its height.

JEAN-MICHEL FRODON

Jerry Made His Day

This text is about a film that for all intents and purposes does not exist.

So what? We who love cinema have always been able to dream films as well as to watch them. Sometimes we dream them instead of watching them; sometimes we dream them *while* watching them. I often proudly acknowledge that I slept during all my favorite films, from Murnau to Weerasethakul, from Vigo to Van Sant. So if I can dream films that do exist, how could I not dream those that do not? This film, though notoriously written, produced, and, to a certain extent, shot and edited, not only was never completed, and therefore never publicly screened, but is supposed to have no official existence. So we are talking about a ghost film. Which is actually quite appropriate, considering the filmmaker's subject.

Jerry Lewis's *The Day the Clown Cried* (1972) is actually a kind of dreamy movie—a nightmare, to be more specific. It tells the story of a German clown, Helmut Doork (Lewis), who finds himself accompanying Jewish children to the gas chamber in Auschwitz. Do I have to add that it is not a funny film? It's actually one of the saddest films I ever saw, or dreamt. But it is, to a huge extent, a film about laughs, about being funny, about being professionally funny—an issue Joseph Levitch, better known as Jerry Lewis, knew something about in 1971 when he stepped aboard this project, having been a standing comedian, comedy actor, and director for already more than thirty years.

If *The Day the Clown Cried* does not exist, its script does. It is even available on the Internet (www.dailyscript.com/scripts/the_day_the_clown_cried.html). The film I'm writing about is actually very close to this script, except for the very beginning. In this script, one can read what could have become the tagline for the film: "When you rule by fear, laughter is the most frightening sound in the world." This line is from Reverend Keltner, who is an inmate with Helmut. At this point in the film, we have seen how Helmut, the former number-one clown in Europe, has fallen in disgrace, becoming a stooge before being fired from the circus. Getting drunk to drown his despair, the clown insulted a portrait of Hitler (only then do we discover that the story is happening during this specific historical period), was arrested at once by the Gestapo, and sent to a concentration camp for political prisoners.

So far, Helmut cares only about his personal fate. Although he lives in Nazi Germany, he is interested in nothing other than the loss of his celebrity and the humiliation he undertakes from the circus director and the new leading clown. Separated from the rest of reality, including the tender love from his wife, he is unable to play by the rules. As an inmate, he claims to be a famous artist but refuses to talk to the others. Frustrated and bored, prisoners ask Helmut to entertain them, and since he refuses they become aggressive and even beat him to force him to make them laugh. (Thematically, this scene can be seen as a much darker version of Donald O'Connor's gentle [and funny] hysteria as he performs "Make 'Em Laugh" to the limit of his strength and beyond, in *Singin' in the Rain* [Stanley Donen and Gene Kelly, 1952].) Only Reverend Keltner stands on Helmut's side and tries to protect him.

Somewhat later, a new camp is opened, for Jewish children, on the other side of barbed wires. The political inmates are strictly forbidden to interact with the children but, as he performs (lousy) tricks under the menace of other inmates, it turns out that Helmut makes the children laugh. Stimulated by this response, the clown starts a complete act, achieving success with all his audiences: the Jewish children with their Stars of David, the political prisoners with their red triangles on their striped uniforms, and even the German guards in their miradors. But the *Kommandant* does not laugh. He brutally interrupts Helmut's act. In a later scene, the clown and Keltner will be severely beaten by the SS, and another prisoner will be shot dead because he

Jean-Michel Frodon

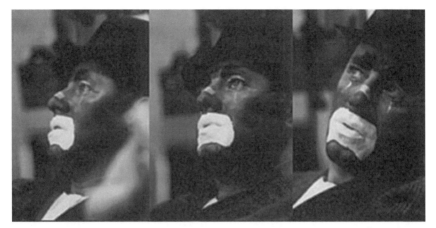

Three off-camera images of Jerry Lewis in make-up for *The Day the Clown Cried* (Jerry Lewis, unreleased, 1972). Digital frame enlargement.

helped Helmut to perform for the children, breaking the interdiction. Though openly non-realistic (a feature I discuss below), *The Day the Clown Cried* includes real brutality, shown in a stylized way that, for instance, excludes blood.

So far, Helmut has been acting as if he does not understand what is going on, manipulated by his own selfishness, by his genuine desire to make his audience laugh, and by obvious lies from the Nazi authorities whose plan it is to use him. And this will remain so almost until the end. Helmut Doork is not a sympathetic character, certainly not a hero in the regular meaning of the word. He is not a bad guy either.

This issue—how bad, or good, should the lead character be?—was one of the many reasons *The Day The Clown Cried* was not finished. The authors of the original script, Joan O'Brien and Charles Denton, had written the story of a much worse character. They became furious that Jerry Lewis, who made significant changes to their work, improved the qualities of Helmut. One can easily understand O'Brien and Denton's reaction: the fact that the clown was a complete bastard was a good way to tell this overly dramatic story unsentimentally, a bold attempt to create a terribly emotional narrative with no one for viewers to identify with.

Maybe Lewis was not as bold as the scriptwriters had been, though we know how bold he had been before about other issues.

But certainly Lewis wanted Helmut's character to be much closer to himself. If originally *The Day the Clown Cried* had been an audacious project—addressing the issue of the Holocaust with a clown as the main character—it became much more audacious, and also complex, when Jerry Lewis took it over. It was still meant to be a Holocaust movie with a clown as the main character, but it became a paradoxical meditation about comedy, showbiz, and Jerry Lewis himself. The scriptwriters did not recognize their Helmut because he had become too "Jerry Lewis-like" in the process.

In my view, it is not an impoverishment but rather a deepening and enlargement to have the presence of Lewis affecting the meaning of *The Day the Clown Cried*. First, the original critical attempt—to deal with the Holocaust from this particular angle, invoking the clown as lead character—is still at work. But now the film goes way beyond this, since it does not question only "those who rule by fear" but a much larger array of characters, institutions, and types of social relations. It questions the very process of making people laugh, in any political situation. And it does this in a remarkably open way, which operates several reverses around the ambiguous Helmut figure as well as around the audience attitude and the possible instrumentalization of laughter by any power, including "those who rule by fear," of course, but also "democratic" powers—if there is such a thing, which is obviously not what the Jerry Lewis of this film believes.

The film openly deals with the use of comedians, or more generally of the artist, by people in positions of power. First forbidden to entertain the Jewish children, Helmut is later ordered to do so, in order that they may be kept quiet until they meet their doom. The clown obeys with a triple motivation: he believes he will be released if he does his job correctly; he is glad to have such a responsive audience; and he is happy to bring a little light and fun into this terribly dark situation the children are enduring. As a result, Helmut clearly becomes their guard, or even their shepherd, a shepherd who will accompany his flock toward death. And, even though he's been doing it mostly because he believes he'll gain his freedom in exchange—at least he has pretended this to himself—at the last moment he decides to stay with the kids and enters the gas chamber with them, leading them like the Pied Piper of Hamelin (to whom the script openly refers) but with the major difference that he accepts to die with them: "Helmut takes his

place at the head of the line, like the Pied Piper, leads the youngsters out the door, playing a crude sort of circus parade music."

Here stands a major issue, which actually percolates through the whole film but of course reveals its complete meaning only at the end, a fact that might account for part of the misunderstanding the film suffered. Jerry Lewis does not fool around with what he is talking about, or the frame in which he is setting his story. It's nothing less than mass murder, mass murder of the Jews by the Nazis, including mass murders of children because they are Jews, as a line explicitly emphasizes: "The children? You mean the Jews!" Here stands one absolute difference with Roberto Benigni's regrettable *Life Is Beautiful* (*La vita è bella*, 1997): *The Day the Clown Cried* does not *use* the extermination camp as an overdramatized setting to give more strength to a fable that could actually be set in any tough penitential institution. It bluntly addresses the very issue of the Holocaust, with its only decent though traumatizing end of the road: death. Exactly what Steven Spielberg carefully avoided with *Schindler's List* (1993).

The reasons why *The Day the Clown Cried* was never completed and released are complex. The producer of the project, Nathan Wachberger, who originally brought the script to Lewis and convinced him to direct and act, failed to provide financing during shooting. As a result, the actors and technical crew went unpaid while on location at a Swedish military camp used as a stand-in for the concentration camp. Another reason involves Lewis's bitter experience during the shoot: he had to pay out of his own pocket to keep the production going, and then, when he was unable to continue self-financing, the Swedish film labs retained some of the stock for lack of payment. In addition, the scriptwriters, especially O'Brien, unhappy with the way the director had taken possession of their story, claimed that Lewis had never paid for it. Much later, another producer, Michael Barclay, bought the script rights with the intention of producing a new adaptation. This part of the story continued for several years at the beginning of the 1990s, with first Robin Williams and then William Hurt set tentatively as the lead actor; the project went nowhere but also made it impossible for the original film to be viewed; most of that film stock may still be in a Swedish laboratory.

Beyond all these reasons were the comments—negative comments—made against a film that does not even exist. Most of this bad reputation comes from the American comedian Harry Shearer, who

was able to watch rough cuts of the half-edited and incomplete film and found it awful. He told as many people as he could about it and in 1992 took part in a panel discussion organized by *Spy* magazine as part of a survey titled "Jerry Goes to Death Camp" by Bruce Handy (www.subcin .com/clownspy.html). The *Spy* panel unanimously concluded that this non-existent film was terribly bad.

An opinion I do not share.

Quite the opposite: it seems to me that Jerry Lewis attempted with this film something on the order of cinematic milestones such as Chaplin's *The Great Dictator* (1940) and Lubitsch's *To Be or Not to Be* (1942). These three films all address the darkest aspects of modern barbarity using the tools of comedy, and therefore they question show business itself and its relation to oppression and totalitarianism. One should remember that neither of the two earlier films was successful upon first release, and I would guess that a panel similar to *Spy*'s would have generated similar comments against Chaplin or Lubitsch after sneak previews of their films.

Why did *The Day the Clown Cried* generate such negativity? I believe it is because it does not fit with the expectation of either a Holocaust movie or a Jerry Lewis movie. It is neither seriously sentimental nor funny. From my point of view, this is exactly what's great about it. The film makes any viewer experience a terribly uncomfortable situation. Mortal sin! But since when are you supposed to feel at ease watching a movie about the Holocaust? This discomfort is not based on the fact that this is a Holocaust film: most Holocaust films are actually comforting, especially the tear-jerkers, which constitute the majority. But the discomfort produced by *The Day the Clown Cried* is due to its complexity and to the interaction of multiple factors. It relates to the unstable characterization of Helmut and to the persistence of Lewis's image through this has-been clown, even in a concentration camp. I am convinced this is not a weakness of the film but exactly what the actor-director was aiming to achieve.

Another aspect of what I see as a clever directing choice, but what is likely to be rejected by people with a formatted definition of a "good movie," relates to the very strange form of non-realism at work in *The Day the Clown Cried*. Jerry Lewis had been a master of this specific kind of non-realism in his comedies for many years. This made him a major artist working directly in the tradition of surrealism, as acknowledged

Lewis in a publicity still with two of his young extras. Digital frame enlargement.

by European film buffs, though to the American media he remained deeply incomprehensible (see Gordon for an intensive discussion of Jerry Lewis and the *comique idiot* in cabaret and early cinema; and Pomerance for a number of interesting discussions of his method and characterizations). But here he uses the same kind of exaggeration and distortion in a serious, even tragic context. Actually, those accustomed only to Hollywood pseudo-realism are likely to find the story's relation to historical facts nearly unbearable; it is pseudo-realism, with its plausible (though dramatized and simplified) translation of tragic history into film, that audiences consider a minimally acceptable form of entertainment. This is true regardless of the setting or genre, such as those set on a remote asteroid or featuring stuntmen pretending to be cowboys and Indians (though no cattle worker or native American ever dressed this way, even for carnival). The format of pseudo-realism dictates how boy meets girl, how good and bad guys confront each other, how a cop, a child, or a naïve girl would speak in any given situation, and it decides as well how to depict children in a death camp. This format is exactly what Lewis was trying to escape, destroy, or elude throughout his career as a filmmaker. But if it was only, as people

said, "a bit embarrassing and exaggerated, though funny" when it was in movies labeled as comedies, Lewis's stylization became outrageous in a Holocaust tragedy. His trademark funny faces in front of children trapped behind barbed wire were considered disturbing to audiences, and his stage routines—especially when he entertains the children in the boxcar prior to taking them to the gas chamber—in this context cast an even darker shadow on the jokes. Or perhaps they reveal that his showbiz capers were always that dark, that cruel, that crazy, even if— especially if—they were encased in a comedic frame.

The Day the Clown Cried is not realistic, either according to reality itself or to Hollywood pseudo-reality. It is a very dark fairytale, closer to the Brothers Grimm than to Raul Hilberg.[1] And it never intends to "look" realistic. Lewis was sensible enough to understand not only that a realistic depiction of the Nazi mass murder is impossible, but that any pretention to realism is morally unacceptable. On this level, he demonstrates an ethical sensibility toward representation of the Holocaust that few directors, especially American directors, have shown (see Frodon). Where does Lewis find the tools to tell his tale? Mostly in his comedy trunk, that of his own kind of comedy, which helps us relate Helmut to Jerry. Facial contortions, body disarticulations, exaggeration of simple gestures to the point where they become at once acutely accurate and completely absurd, all may seem so ridiculous as to appear embarrassing, breaking the boundary between the human and the animal. But Lewis also finds some resources in old legends. To a certain extent I am reminded of Michel Tournier's novel The Erl-King, which uses ancient European myth to evoke Nazi barbarity. The most unrealistic but significant choice in The Day the Clown Cried is probably having the children imprisoned not in a barracks but in a solitary boxcar, standing alone on a track in the middle of the forest. Such a device has more to do with the witch cabin in the Hansel and Gretel story than with the actual procedures of extermination within the Nazi machine.

If Lewis had tried to make his film realistic, this choice would have been both unbearable and despicable. And the way he involves his own character (not Helmut but Jerry Lewis's own character), his own job (clown), his milieu (showbiz), and those who support his career (the audience) inscribes the central topic of the film, the Nazi mass murder, in a deep and contemporary network of meaning and questioning. Far

Jean-Michel Frodon

from weakening the atrocity of the historical facts, this embedding of murder in the context of performance and the stylized way this film is built augment the possibility of playing on different levels without letting any one level obliterate the others.

It is not often that a clown interrogates how his work, intended to please an audience, can be used by powers of all kinds (not only dictatorships) to maintain the social order and to compel people to act as that power demands. It is not so often that a first-rank Hollywood entertainer acknowledges that his craft is (among other things) a way to make people obedient, even to drive them to their worst, as Helmut does when he walks the children toward the gas chamber, repeating, "It's all right. It's all right. Everything is going to be all right."

Lewis even addresses the issue of the entertainment industry when Helmut argues to his fellow prisoners that he needs props, costumes, makeup, lights, an orchestra, supporting players, and a massive professional circus apparatus in order to perform. Of course, the clown argues in bad faith, not wanting to perform at all for his fellow inmates because he feels he should not be among them. Nevertheless, the pretext he uses refers to a certain form of entertainment itself, far from the "natural" artist-to-audience relationship that he will re-create almost by chance, through barbed wire, with the children. Even while he was directing *The Day the Clown Cried*, Lewis as a comedian relied on industry backing, in Hollywood as well as Las Vegas, his two main venues. Helmut's evasion is a clear statement about Lewis's own situation, the ambiguity of being part of an industry while attempting not to play by its rules. Yet on another level, the depiction of the violent working relationship in the circus world at the beginning of the film, based on a struggle for life between colleagues whose job is to make people laugh, is certainly not limited to the situation in Germany during the Nazi period. At that early junction in the film, the viewer doesn't even know the setting in which the story takes place. The geographical situation may even be misunderstood given that most of the other actors in the first act are French, Italian, or Scandinavian, not German: the new clown star is played by Pierre Étaix; the circus director by Armand Mestral; the other clowns by the Bouglione Circus troupe; and Helmut's wife by the internationally celebrated Swedish actress Harriet Andersson.

These opening circus scenes differ from the original script for budgetary reasons, Lewis having been obliged to reduce costs. The French

actors worked for free in tribute to Lewis's genius, and the large crowd scenes in the script were replaced with a three-character scene set during a rehearsal rather than a public performance. The multinational cast and the almost abstract setting, without the large circus audience, brings an original environment to the film, emphasized further by a very long shot during which Jerry-Helmut contemplates with shame and sorrow his own face in the mirror while putting on the clown makeup. These opening scenes are thus not only about Helmut the German clown in the Nazi era but about entertainers in the showbiz world, whenever, wherever.

There is a clever glissando with a scene in a bar, where Helmut gets drunk after being fired and humiliated. It starts as a follow-up from the previous scene, during a dialogue with the bartender, and then is suddenly distorted when the inebriated clown addresses the man on the wall—the portrait of Adolf Hitler—with the most unpredictable speech about the true meaning of words and how the betrayal of language will lead anyone, including the Master of the Third Reich, to catastrophe:

HELMUT: The trouble with man today is that he takes everything for granted. . . . He thinks things he's told to think . . . and accepts it! Just because we know meanings of words we use them and we fool ourselves. . . . People should use the dictionary more . . . look up words like "good" . . . "bad" . . . "honest" . . . "loyal" . . . especially loyal. I know what "loyal" means, and I have always been that . . . but does anyone care? No! Of course not. . . . Only when it is expedient. . . . When it isn't . . . (he slashes his throat with his finger) . . . ZIPPPP! You're out!

[Helmut stops with his BACK TO CAMERA looking straight at "Hitler" and screams:]

HELMUT: And that goes for you too, Mein Fuhrer.

[He shoves his right arm up and out at the photograph of "Hitler."]

HELMUT: You, too, are a fool. You allow yourself to think you have "loyal" followers. Ha! Wait until they've had it with you . . . You'll get yours . . . all the smiling, bowing, heel clicking idiots will shaft you too. And you will deserve it because if you allow people like Herr Schmidt to go about his business of lying, and cheating, and being

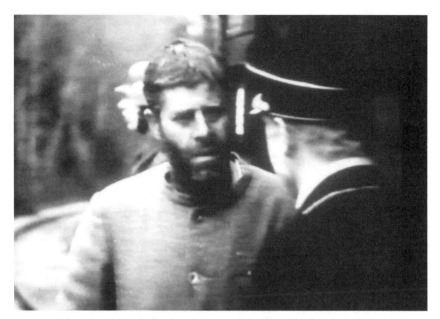

Lewis as Helmut Doork in a distinctly unfunny moment. Digital frame enlargement.

disloyal, one day all the Schmidts in Germany will turn on you and you will finish as the dumb little corporal you started as, and never know what hit you.

At this moment, the bar, which had seemed to be empty, reveals the presence of SS and Gestapo officers, who immediately seize the blaspheming drunkard. Later, interrogated by a Gestapo officer, Helmut shows his pusillanimity, exaggerated pride, and selfishness in a situation that is not at all intended to be funny but that openly shows a despicable main character in front of a brutal and mean officer. It's only much later, when Helmut actually succeeds in performing tricks for the children, that Lewis's comic skills appear, but in an inappropriate setting.

It is this very unusual mix of violence, gags, darkness, sentimentality, and harshness that makes *The Day the Clown Cried* so uncannily powerful—and that puzzled its viewers and turned them into hostile critics. The film's weird and disturbing combination of tones sets it far apart from almost any fictional film related to the Holocaust, especially those that drown in self-importance. Such a comparison is enlightening

in reference to *The Last Butterfly* (1991), directed by Karel Kachyna, a quasi-remake of *The Day the Clown Cried* (though based on real events). Set in Theresienstadt during the making of *The Führer Gives the Jews a City* (Kurt Gerron, 1944), the Nazis' fake documentary, Kachyna's film suffers from its constant solemnity and simplistic point of view.

The bizarreness of Lewis's film is not its weakness but its strength. It was very clear that Lewis made it this way by design, though the film obviously was affected by its production problems. And, as happens so often, the production problems could have become part of the specificity of the film, what the film exactly looks like, its "personality," so to speak, if too many legal, financial, and ego problems had not interfered and blocked it from being completed and released. It seems that in early 1973 the director still expected that a solution could be found, and even announced that it would premiere at the Cannes Festival the same year and have a subsequent U.S. release (www.youtube.com/watch?v=83AL_Cxcx5M).

I am convinced that no matter what might have been said about *The Day the Clown Cried*, including by Lewis himself, the film signalled not a rupture from Lewis's career but the radicalization of what he had been aiming at his entire professional life, especially from when he gained control of his own films. Either he would be the director, completely and wholeheartedly, or not. From *The Errand Boy* (1961) to *The Day the Clown Cried*, continuity is at least as important as difference or rupture in Lewis's oeuvre. It has to do with a sense of tragedy in life and of impurity in filmmaking, which exemplifies Lewis's unique personality, inside and outside the American showbiz industry. One might argue that this attitude, which made possible such a strange and daring project as *The Day the Clown Cried*, also created the impossibility of its public existence. Since 1972, the film has been haunting the history of cinema, especially the cinema related to the Holocaust. This is a painful but actually quite appropriate state of being, given that so many "normal" movies have traversed a less tortured path in telling stories about this definitively abnormal issue.

NOTE

1. Hilberg is the author of the enormous and hugely important work *The Destruction of the European Jews* (1961).

Jean-Michel Frodon

Thomas Leitch

Noir at Play

Even though films noirs have always been among my favorite movies, I never taught a course in noir until a few years ago because I couldn't imagine what twenty-year-olds might find appealing about black-and-white films over half a century old that presented a world so unremittingly bleak. I'm happy to acknowledge how much my students have taught me about noir and my own fondness for the genre. Perhaps their single most important lesson has been their laughter, over and over again, at films that aren't supposed to be funny.

Some of this laughter, of course, indicates nothing more interesting than the films' age. Raymond Borde and Etienne Chaumeton report the "general outburst of laughter" that greeted "Marlowe's third blackout" in the Toulouse Ciné Club's 1953 screening of *Murder, My Sweet* (Edward Dmytryk, 1944), which spectacularly failed to capture "the state of tension and malaise that the critics had been unanimous in describing seven years before" (143). As even the most hardboiled films slip into the past, their tabloid urgency inevitably becomes hedged with a sense of nostalgic ritual for audiences that can't help see their tensions as quaintly, even anthropologically, dated. My students often greet with a cascade of rising giggles the thirty times in *Double Indemnity* (Billy Wilder, 1944) that Walter Neff (Fred MacMurray) calls Phyllis Dietrichson (Barbara Stanwyck) "baby." Men's taste for addressing women by epithets hasn't dimmed since 1944—think of the variety of piquant epithets contemporary rappers use for their women—but

the choice of "baby" has dated so dramatically that my students find it ridiculous. On the whole, however, their laughter isn't directed at aspects of the films that were intended to be serious but are now impossible to take seriously. Instead, their reactions have made me realize that even though thematic descriptions of noir make the films sound tragic and despairing, something always keeps them from being depressing to watch.

From its beginnings, commentary on noir has minimized this something because it has been so concerned to emphasize the thematic seriousness of the films. Robert Warshow establishes this strain when he describes the gangster film, thinking surely of film noir as well, as a stinging rebuke to the "cheerful view of life" to which American public culture is committed: "the final meaning of the city [in these films] is anonymity and death" (127, 132). Borde and Chaumeton continue along these lines when they trace noir's roots to hardboiled fiction, Freudian psychoanalysis, French surrealism, German Expressionism, and the Hollywood triumvirate of gangster films, horror films, and detective films (15–26). Paul Schrader, contending that "*film noir* is more interested in style than theme," describes its world as disillusioned, cynical, corrupt, fatalistic, hopeless—altogether "an acute downer" (63, 54).

As a result, our received wisdom about noir, which emphasizes the gloomy side of its cynicism, is incomplete. Thematically speaking, Jack Shadoian is right on the money when he describes the final scene of *The Killers* (Robert Siodmak, 1946): "Masquerading as a 'light' scene, a pablum envoi of sorts, this final sequence sustains the film's cynicism down to the last twist. [The insurance investigator] Reardon's boss, bright and cheerful, his faith in the *principle* of life insurance justified and reinforced, commends a weary, yawning Reardon for a job well done. . . . [But] Nothing has any significance. After all the smoke has cleared, it's back to work on Monday" (102).

Yet my students are much more receptive to the humor Shadoian dismisses so easily, from the mock solemnity that R. S. Kenyon (Donald MacBride) takes in estimating the minuscule likely effect the dogged detective work of Jim Reardon (Edmond O'Brien) has had on the Atlantic Casualty Company's rate for 1947 to Reardon's transparently unconvincing attempt at modesty ("It's the job") to his double take when he's offered "a good rest" that amounts to the weekend off and the

Jim Reardon (Edmond O'Brien) exits the doom-laden world of *The Killers* (Robert Siodmak, Mark Hellinger Productions/Universal, 1946) with a broad grin at his boss's joke. Digital frame enlargement.

broad grin he flashes as he turns from leaving the office to indicate that he's in on the joke and it's fine with him.

They are more sensitive to another aspect of the film Shadoian identifies: "Life is that kind of game, with both sides sticking to a set of rules there is no way of changing. The game is often vicious and costly. Between moves, a resigned, defensive, disenchanted humor lets the players take it all in stride" (103). Foster Hirsch agrees that in noir, "a mordant humor seeps through even the darkest moments of the action" (5). And James Naremore, noting that John Huston's film adaptation of *The Maltese Falcon* (1941) is "strikingly witty, especially at the level of performance," characterizes its wit in liminal terms: "The film is just stylized enough to represent the private-eye story as a male myth rather than a slice of life" (61).

Unlike Shadoian and Hirsch, who emphasize the existential despair that underlies these violent, treacherous games, my students are more

likely to see a conventional humor overlaid on an equally conventional cynicism. They don't find the scene, or *The Killers* generally, funny, but they do find it playful. This may seem an odd reaction because even though the heroes and heroines of noir spend a great deal of time playing games, these games are subverted in several ways. The poker game in *The Killers* provides the pretext for the fatal quarrel between Swede Anderson (Burt Lancaster) and Big Jim Colfax (Albert Dekker). The shooting match in *Gun Crazy* (Joseph H. Lewis, 1950) unites Bart Tare (John Dall) and Annie Laurie Starr (Peggy Cummins) in a fatal *folie à deux.* The horse race that provides the central metaphor for the overdetermined lives of the small-time crooks in *The Killing* (Stanley Kubrick, 1956) is disrupted when the favorite is shot to provide a distraction from the racetrack heist. The daily numbers everyone plays in *Force of Evil* (Abraham Polonsky, 1948) are run by gangsters, some of whom fix the game in order to bankrupt a rival faction. The boxing matches in *Body and Soul* (Robert Rossen, 1947), *The Set-Up* (Robert Wise, 1949), and *The Harder They Fall* (Mark Robson, 1956) are rigged by crime lords whom boxers defy at their peril. Even more dangerous are the cat-and-mouse games of flirtation and masquerade in *Double Indemnity, The Big Sleep* (Howard Hawks, 1946), and *Criss Cross* (Robert Siodmak, 1949). Games like boxing or card playing or horse-racing or flirting that ought to provide healthy exercise, competition, or diversion are constantly corrupted by greed for the money at stake, determination to rig the game, or both. As Borde and Chaumeton put it: "The fair fight gives way to the settling of scores, to the working over, to the cold-blooded execution" (9). The result is that although many games are played in films noirs, the players never seem to have a good time.

Even so, noir is radically playful—if not for its characters, then certainly for its audience. Quite apart from farcical noirs like *The Big Steal* (Don Siegel, 1948); noirs interrupted by the maniacal laughter of psycho killers like *Kiss of Death* (Henry Hathaway, 1947); noirs that ensnare comical people like the clueless husband and his boss whom Casey Adams and Don Wilson play in *Niagara* (Henry Hathaway, 1953) or the hapless pair of goons in *The Big Sleep*; and parodies like *Dead Men Don't Wear Plaid* (Carl Reiner, 1982), noir is playful all the way down to the depths of its dark heart. Its playfulness is not a counterpoint to its seriousness. It is not even a technique chosen to intensify

its seriousness. It is even more intrinsic, more essential, than its seriousness. And it leaves its mark everywhere.

Its most obvious mark is on noir dialogue. Beneath a veneer of realism, the language of noir's tough guys and girls is alternately poetic in *Force of Evil*, clownishly philosophical in *Kiss Me Deadly* (Robert Aldrich, 1955), and crammed with wisecracks in *Out of the Past* (Jacques Tourneur, 1947), whose hero and heroine and the criminals who surround them all seem equally incapable of giving a straight answer to a straight question, or even of asking a straight question. Diner owner Marny (Mary Field) sets the tone early on when customer Joe Stephanos (Paul Valentine) asks her to tell him something and she replies, "You don't look as if I could." When Valentine gets worked up over newspaper reports that Kathie Moffat (Jane Greer) has shot his boss, Whit Sterling (Kirk Douglas) calmly advises him, "Smoke a cigarette." As Jeff Bailey (Robert Mitchum) falls in love with Kathie over a roulette table, she asks him, "Is there a way to win?" and he responds, "There's a way to lose more slowly." The badinage continues to their final scene, when she tells him, "I think we deserve a break," and he coolly replies, "We deserve each other." Convoluted as the plot of *Out of the Past* is, it often seems mainly a backdrop for the torrent of epigrams the characters use to prove that they're tough and jaundiced and playful. Even *Double Indemnity,* one of the grimmest of all noirs, makes room for Walter and Phyllis's bravura exchange about flirting and speeding, the litany of poisons and ways to commit suicide that Barton Keyes (Edward G. Robinson) delivers, and the mordant reference Walter picks up from Keyes to the streetcar the conspirators can't get off before the cemetery. Nor do these moments provide breaks from the film's fatalism; they just make it clear that even the characters' most apparently innocent remarks, like Phyllis's "Hope I've got my face on straight," are invariably double-edged.

Scarcely less playful than noir dialogue is noir structure. The preference for extended flashbacks that noir inherits from *Citizen Kane* (Orson Welles, 1941) leads to the convoluted multiple flashbacks of *Laura* (Otto Preminger, 1944), *Mildred Pierce* (Michael Curtiz, 1945), *Backfire* (Vincent Sherman, 1950), and *The Killers* and the even more baroque structure of *The Killing,* whose inveterate shifts of time and perspective, framed by the horse race the film begins over and over again, annihilate any sense of a meaningful present or individual

Loren Visser (M. Emmet Walsh) laughs sardonically at the news that the woman who just shot him thought she was killing the husband Visser murdered himself, in *Blood Simple* (Ethan Coen and Joel Coen, River Road Productions/Foxton Entertainment, 1984). Digital frame enlargement.

agency. Even *The Woman in the Window* (Fritz Lang, 1944), which might seem no more playful than *Double Indemnity*, rescues its hero from certain doom by reframing his entire story as a dream. All the major structural innovations of noir stem from the obsession with dramatic irony, feeding the audience information that is withheld from the characters. The flashbacks of *Double Indemnity, Murder, My Sweet, Detour* (Edgar G. Ulmer, 1945), *Out of the Past,* and *Sunset Blvd.* (Billy Wilder, 1950), helpfully framed by first-person narrators, allow the heroes to point out exactly where they went wrong ("How could I have known that murder can sometimes smell like honeysuckle?") or how dumb they were ("The poor dope—he always wanted a pool"). The result is to invite filmgoers to a double consciousness of the he-roes' actions as they appear both *sub specie aetis* and *sub specie aeter-nitatis*. The final scene of *Blood Simple* (Joel Coen, 1984) reveals the connection between playfulness and the seriousness of such dramatic irony when Abby (Frances McDormand), having just shot crooked de-tective Loren Visser (M. Emmet Walsh) to death, mistakenly thinking that he's her dead husband Marty (Dan Hedaya) because she has no idea her husband ever hired Visser to follow her, screams in terrified exultation, "I'm not afraid of you, Marty!" and the laughing detective

Thomas Leitch

replies with his dying breath, "Well, ma'am, if I see him, I'll sure give him the message."

Many noirs are based on overtly playful literary sources. The opening paragraph of *The Big Sleep* (1939) instantly reveals Philip Marlowe's playful sense of the most appropriate way to introduce himself: "It was about eleven o'clock in the morning, mid-October, with the sun not shining and a look of hard wet rain in the clearness of the foothills. I was wearing my powder-blue suit, with dark blue shirt, tie and display handkerchief, black brogues, black wool socks with dark blue clocks on them. I was neat, clean, shaved and sober, and I didn't care who knew it. I was everything the well-dressed private detective ought to be. I was calling on four million dollars" (589). By the end of the story Marlowe has become more darkly reflective—"What did it matter where you lay once you were dead? . . . You were dead, you were sleeping the big sleep, you were not bothered by things like that" (763–64)—without ever letting up on the wisecracks, even though his plot, as mind-bogglingly complex as that of *Out of the Past,* has become even more of a playful throwaway in the film adaptation than in Raymond Chandler's novel, which at least took the trouble to explain exactly who killed the Sternwood chauffeur.

Cornell Woolrich, whose fiction spawned more noirs than that of any other novelist, can be playful even at his most nightmarish. *The Bride Wore Black* (1940) is constructed as a series of cat-and-mouse games between the avenging Julie Killeen and the men she holds responsible for her bridegroom's death. *Rendezvous in Black* (1948) uses a similar structure to show Johnny Marr's growing ingenuity in killing the loved ones of the men who accidentally killed his fiancée on the anniversary of her death, despite the men's increasingly determined and well-informed attempts to protect them. *Phantom Lady* (1942), originally published under the byline William Irish, introduces its playful opening sentences—"The night was young, and so was he. But the night was sweet, and he was sour"—with the balefully playful chapter heading: "The Hundred and Fiftieth Day Before the Execution" (1).

Many films noirs, however, intensify the playfulness of their source material or replace their self-seriousness with a more playful tone, partly because movies, unlike novels, are designed to be watched by large groups of people whose amusement can be contagious, partly

because Hollywood adaptations, recognizing this difference, typically broaden rather than refine their sources. None of the dialogue I quoted earlier from *Out of the Past* has any basis in the film's source novel, Geoffrey Homes's *Build My Gallows High* (1946). As Jeff Schwager has demonstrated, uncredited screenwriter Frank Fenton "was responsible for the bulk of the film's best dialogue," from Whit's throwaway characterization of his chief henchman—"Joe couldn't find a prayer in the bible"—to Jeff's response to Kathie's choked "I don't want to die"— practically the only time in the film she shows any fear—"Neither do I, baby, but if I have to, I'm going to die last" (16). Because noir's playfulness is eminently compatible with earnestness, lack of humor is no obstacle to noir at play. The humorlessness in Ben Ames Williams's novel *Leave Her to Heaven* (1944) did not prevent Twentieth Century–Fox from playing with the screen images of its virginal leading lady Gene Tierney, whose dazzling close-ups and Technicolor wardrobe make her femme fatale Ellen Berent appear larger and more intense than life. The film's tendency toward self-conscious mythologizing and monumentality, which makes every character and gesture and musical cue from the film's portentous opening scene to its soft-focus finale feel more vivid and expressive, more *itself* than it could possibly be in real life, is only one aspect of noir's most widely remarked stylistic signature, the expressionistic visuals that tell the audience much more about the characters' world and their feelings than such variously obtuse, inarticulate, and deceptive characters could ever reveal about themselves.

So firmly do noir's dialogue, narrative structure, and visual stylization establish its playfulness that even the limitations it places on its characters' freedom come across as playful. Most of the first half of *Dark Passage* (Delmer Daves, 1947) and virtually all of *Lady in the Lake* (Robert Montgomery, 1946) are restricted to shots from the hero's optical point of view. The effect may be oppressive, but like the long takes in Alfred Hitchcock's contemporaneous *Rope* (1948), it is clearly a playfully self-imposed exercise in technique. The game of cat and mouse that Det. Sgt. Walter Brown (Charles McGraw) plays in protecting his snarling witness, Mrs. Frankie Neal (Marie Windsor) in *The Narrow Margin* (Richard Fleischer, 1952) only intensifies when they board the train to Los Angeles, committing themselves to a series of tightly enclosed spaces besieged by murderous gangsters. The

claustrophobia of *D.O.A.* (Rudolph Maté, 1950), in which Frank Bigelow (Edmond O'Brien) has only forty-eight hours to find the man who slipped him a fatal dose of radium poisoning, is temporal rather than spatial, but it is equally playful for viewers who perceive that Frank's success is as certain as his death. *The Set-Up*, in staging its seventy-minute story in a seventy-minute movie set largely in a boxing arena its hero cannot escape, combines spatial and temporal claustrophobia in a way that is both grim and playful.

More widely noted is noir's play with the gender dualities of masculinity and femininity, which it confounds by conflating hyperfemininity with transgressive masculinity, so that its femmes fatales become dangerous usurpers of masculine power to precisely the degree that their femininity is emphasized and fetishized. The obvious example is Annie Laurie Starr, whose sharpshooter in *Gun Crazy*, originally titled *Deadly Is the Female,* is introduced by the carnival barker who is keeping her as "so appealing, so dangerous, so lovely to look at!" But Ellen Berent, who refuses to keep servants in *Leave Her to Heaven* because she wants to do all the cooking and cleaning for her bridegroom herself, turns out to be just as dangerously transgressive. The more demurely feminine Ellen acts, the more fatal the consequences, even though her attacks are strikingly passive-aggressive (encouraging her husband's inconvenient young brother to swim too far and then declining to save him from drowning), suicidal (feeding herself arsenic so that she can implicate the sister she is jealous of in her death), or both (throwing herself down a flight of stairs to kill her unborn child). Noirs fear women who covet men's power, but their greatest fears are reserved for women who seek male power by exploiting their own femininity.

The reverse is equally true, for sometimes, as Detective Burgess says of Carol Richman in *Phantom Lady,* a woman is "the best man of us all" (217). Pausing before entering the Sternwood mansion for the first time, Philip Marlowe sees "a broad stained-glass panel showing a knight in dark armor rescuing a lady who was tied to a tree and didn't have any clothes on but some very long and convenient hair. The knight had pushed the vizor of his helmet back to be sociable, and he was fiddling with the knots on the ropes that tied the lady to the tree and not getting anywhere. I stood there and thought that if I lived in the house, I would sooner or later have to climb up there and help

him" (589). Marlowe naturally identifies himself with the armored knight rescuing the lady. When he finally tracks down Eddie Mars's wife to a house in the foothills outside Realito, however, he assumes the role of the lady instead, "trussed like a turkey ready for the oven" (733), and has to be rescued by someone who will cut the ropes— in Chandler's novel by Mrs. Mars, whose silver wig covers "hair that was clipped short all over, like a boy's" (736); in Howard Hawks's film by Vivian Rutledge (Lauren Bacall), who's been alternating insolent wisecracks and kisses with him through the whole film, in distinct contrast to her kid sister Carmen Sternwood (Martha Vickers), who throws herself at men and then shoots them when they don't respond. All three of these women thoroughly confound the gender roles conventionally assigned men and women, Carmen by fetishizing her own infantile girlishness in a way that both provokes and conceals her tendency to sociopathic violence, Vivian and Mona Mars by shouldering more manly burdens than the detective-in-distress they rescue. In revealing that apparently dualistic gender roles are mutable and fluid because they are performed rather than given, they show the serious possibilities of playing with gender by playing at being a man or woman.

As the range of these examples indicates, neither play nor playfulness is limited to playing games. One may play a role or play with a convention or an expectation. Festival, as Mikhail Bakhtin and C. L. Barber remind us, is playful. So is comedy, of course, along with wisecracks and bantering dialogue and cynical self-awareness and the use of obviously stylized narrative structures or performances or mise-en-scène. Whether or not it is linked to particular games, play is optional, pleasurable, transgressive, consequential within its limits yet liable to overflow those limits, potentially endless, and always deliberately chosen. Even the desperate heroes of *The Killers* and *Gun Crazy* choose from their very limited options to play the games that will lead to their death. Play is not restricted to human beings, as any cat fancier can attest, but play requires enough agency to enter into an alternate world in which things modeled on real-world counterparts can be recognized as either different, as in the coldly amoral universe of *Double Indemnity,* or more themselves than in the real world, as in the outsized tableaux of *Leave Her to Heaven* or the witty performances Naremore finds in *The Maltese Falcon.*

Thomas Leitch

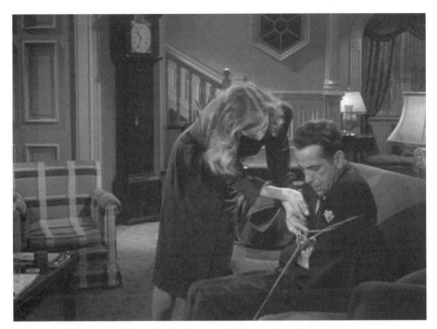

Hardboiled detective Philip Marlowe (Humphrey Bogart), who must be rescued by Vivian Rutledge (Lauren Bacall), takes the place of Raymond Chandler's damsel in distress in *The Big Sleep* (Howard Hawks, Warner Bros., 1946). Digital frame enlargement.

Players stand both inside and outside the world in which they play. They recognize its arbitrariness and limitations but accept it conditionally anyway. This conditional acceptance, in fact, is crucial, for play is hypothetical. It dissolves the *what* of the world we think we know into the *what if* of another world. As a result, playfulness is threatening to anyone whose comfort requires certitude, stability, and a single predictable tone. Hence Borde and Chaumeton's unmistakably fraught articulation of noir's keynote: *"the state of tension created in the spectators by the disappearance of their psychological bearings"* (13). At the same time, it creates a world players willingly enter despite, indeed because of, its obvious artifice, instability, and dependence on hypotheses rather than certainties. Although we may well feel at home in this world, we never simply inhabit it because we are always aware that it has been constructed for our pleasure. Fiction is essentially playful. So are performance and theatricality. That's why we call *King Lear* a tragic play.

The playfulness of noir suggests that another vital locus for play is genre. Film genres allow moviegoers to stand both inside and outside the movies they watch in several playful ways. We can recognize that each new genre release is the same as all the others but different. As Linda Hutcheon has said of adaptations, genre films feed our desire for "repetition without replication" (7) by playing with the conventions that enable them. Noir's preference for long flashbacks and voiceover narration often extends this double awareness to fictional heroes who feel as if they're both inside and outside the story of their lives. Jeff Bailey expresses this feeling memorably when he tells his friend the cab driver in *Out of the Past*, "I think I'm in a frame"—a feeling informed fans of noir are invited to share, albeit at somewhat lower stakes.

The close identifications we often form with the doomed heroes of noir are never so close that we forget that they are doomed. We see them as both variously empathetic individuals and genre types, characters who are as easy to identify as they are to identify with. The resulting dialectic of intimacy and detachment, which I have elsewhere identified with remakes and Hutcheon with adaptations, is in fact so indispensable to all genres that Rick Altman has described it as a "split subjectivity characteristic of genre spectatorship" (146). Many films are disconcertingly playful not merely because they combine incongruous features of different genres, but because they reveal and redouble a radical ambivalence toward their foundational subjects. As William Paul writes of the return of the monster in gross-out horror films, "We see in the monstrous an anarchic force that is worth celebrating as much as it is worth fearing, something we want to embrace and pull away from at the same time." These films' "resistance to closure," Paul observes, produces "an art of ambivalence and, with it, the promise of ceaseless festivity" (418–19). The dialectic of immersion and detachment, of belief and skepticism, of empathy and analysis, of identifying with and identifying, is at the very core of noir, and indeed of every genre.

Or it would be if genres had a core. What they have instead is a generational lack of self-identity born of the foundational tendency of genres to establish themselves by playing with their own rules from their very beginnings. This tendency is nowhere better illustrated than in the seminal noir novel, Dashiell Hammett's *The Maltese Falcon*

(1930). Although there had been earlier novels about hardboiled detectives, including two by Hammett himself, the opening paragraph of *The Maltese Falcon*, like the opening paragraph of *The Big Sleep*, addresses itself directly to a still earlier genre: "Samuel Spade's jaw was long and bony, his chin a jutting v under the more flexible v of his mouth. His nostrils curved back to make another, smaller v. His yellow-grey eyes were horizontal. The v *motif* was picked up again by thickish brows rising outward from twin creases above a hooked nose, and his pale brown hair grew down—from high flat temples—in a point on his forehead. He looked rather pleasantly like a blond satan" (391). Apart from establishing that Spade looks nothing like Humphrey Bogart or any of the other actors who have played him, this passage seems considerably more earnest than Chandler's corresponding introduction of Marlowe. Yet it is just as playful in its own way. The emphasis on physical detail, apparently minutely observed, conveys practically nothing about Spade, not even a powerful image. The description, in fact, is less memorable for its physical particulars—always a red herring Hammett uses to indicate that he's not showing us what Spade is thinking—than for its rhythm, its use of epithets, and the thematic unity its programmatic iconography imposes on the hero, who looks rather pleasantly like a blond satan.

This last phrase, of course, is a poke in the eye to the so-called Golden Age detective fiction of Agatha Christie, Dorothy L. Sayers, and S. S. Van Dine. Not only does Hammett serve notice that his interest in physical detail will be very different from theirs, theme-driven rather than clue-driven; he announces from the beginning his inversion of the Golden Age detective story's moral order, which enshrined the detective as sage, teacher, and guide. Yet Spade isn't merely satanic; he looks rather pleasantly like Satan, and a blond Satan at that. Within a single paragraph Hammett has gone far to indicate the complex legacy his hero inherits from detective heroes like Hercule Poirot, Lord Peter Wimsey, and Philo Vance, a fictional sleuth Hammett particularly despised. In addition, he establishes Spade as different even from himself, as pleasantly likely to depart from generic norms as to conform to them.

The Maltese Falcon's assault on the received generic norms of the detective novel will continue from this opening paragraph to the final scene between Spade and Brigid O'Shaughnessy, when Spade will

fulfill some of these norms admirably while violating others in the most egregious way. If the attack has the predictable effect of establishing new norms Hammett and his followers can play with and against, that's perfectly normal. It's exactly how genres mutate, for, as Altman has persuasively argued, genre is "not the permanent *product* of a singular origin, but the temporary *by-product* of an ongoing *process*" (54). Genres begin life by playing with the rules of earlier games and develop by playing with their own.

In short, noir is playful for the same reason that all genres are playful: because that's the nature of every genre, whose members, like Norman Bates's mother, are never quite themselves. Play with its own identity—the insistence that each new entry is different despite being the same—is what makes a genre a genre. The only reason commentators haven't more frequently noted this generic playfulness in musicals, romances, and slapstick comedies is that play seems so much a part of these genres' thematic material that it passes invisible as a strategy for constituting the genre.

This sense of playfulness lies scarcely below the surface of a surprising number of Hollywood genres. Anyone who thinks about westerns, which might not seem especially playful at first, will realize that they operate precisely by treating a historical narrative of settlement and violent, often genocidal conflict playfully, typically by converting the constant threat of violence into a series of manageably violent games, mostly limited to two players at a time. A perfect example is the climactic shootout, which transforms the general threat of violence into a ritual whose precise and unalterable rules, which can readily be traced to the aristocratic European code of *duello*, have no historical precedent in the settling of the American West. The playful nature of this ritual becomes explicit in *The Quick and the Dead* (Sam Raimi, 1995), which is nothing more than an extended series of such showdowns, each staged as a life-or-death game.

Many other genres—war films, biopics, documentaries, avant-garde films—seem even less playful. Yet each of them regularly finds room for some sort of play with its enabling norms, from the knowingly playful way the biopic treats its hero's resistance to the fate the audience is certain awaits him to the avant-garde film's frontal assault on the norms of generic cinema that somehow manages to create new generic norms recognizable enough to allow us to identify films as

avant-garde. The playfulness essential to the operation of genre be-comes most noticeable as a return of the repressed in those genres that logically ought to be most determined to banish it: the gangster film, the thriller, the horror film, the film noir.

Despite the large claims I have made here for play, I would stop short of equating playfulness with entertainment as such. Other impulses are equally important in the manufacture of mass entertainment—for in-stance, the myths of energy, abundance, intensity, transparency, and community that Richard Dyer identifies in "Entertainment and Utopia" (21–22), or the Aristotelian myth that life is meaningful and that dra-matic action is a privileged way to unlock its meaning. Although it is not the only ingredient, playfulness is an indispensable ingredient in any recipe for the replication of commercially successful formulas; it's what allows filmmakers to turn an experiment or a happy accident into a formula.

It is certainly true, of course, that the playfulness of noir is very different from the playfulness of the musical, the romance, and the slapstick comedy. But commentators who focus on those species-specific differences are in danger of losing sight of the more funda-mental similarities that underlie them—the similarities that enable the production and enjoyment of genres. Genre theorists need to take playfulness more seriously. As scholars of gender studies, whose field has been immeasurably enriched by the hypothesis that gender is per-formed rather than given, could tell them, the play's the thing—and that goes whether the play is *Hamlet* or *D.O.A.*

CHRISTINE CORNEA

"So Bad It's Good"

Critical Humor in Science Fiction Cinema

Perhaps more than any other Hollywood film genre, science fiction tends to provoke deeply divided and often impassioned popular response. Whether a science fiction film is considered "good" or "bad" in press reviews frequently hinges upon a reviewer's understanding of its narrative coherence, as well as the apparent credibility of its special effects and character performances. In part, this demonstrates the ongoing attachment of many reviewers to a narratively and visually realist style that, in one form or another, has dominated Hollywood film since the 1920s. According to David Bordwell, Janet Staiger, and Kristin Thompson: "Hollywood cinema sees itself as bound by rules that set stringent limits on individual innovation; that telling a story is the basic formal concern . . . ; that unity is a basic attribute of film form; that the Hollywood film purports to be 'realistic' in both an Aristotelian sense (truth to the probable) and a naturalistic one (truth to historical fact); that the Hollywood film strives to conceal its artifice through techniques of continuity and 'invisible' storytelling; that the film should be comprehensible and unambiguous" (2). Following these industry "criteria," Bordwell, Staiger, and Thompson detail the construction and development of a set of formal and stylistic "norms" that worked to uphold the principles of a Hollywood cinema,

I wish to thank Thomas Rhys for his assistance in gathering certain review materials from the British Film Institute Library, as part of my early research preparation for this chapter.

as based upon narrative intelligibility and sociocultural verisimilitude. The crux of their argument is that these norms coalesced into what amounts to a "classical paradigm" that was "activated by and tested against any given film" (8). For Bordwell, Staiger, and Thompson, "classicism" held sway until about 1960, after which, they argue, the dominance of Hollywood was challenged by international art cinema and the "force of the classical norm was reduced somewhat" (10). While they stress that classical norms allowed for certain levels of stylistic flexibility and the production of a variety of recognizable film genres, exceeding the limits of the paradigm generated a degree of perceptible artifice in opposition to the coherence of classicism.

Of course, particular Hollywood directors played with the boundaries of the "classical paradigm" to indicate authorial intervention, and it was not unusual for norms to be violated in order to signal the "unrealness" of certain events (i.e., dream sequences) in an otherwise classically constructed film. Where the picture becomes more complicated is at the level of genre. Although various Hollywood film genres might seek to present the illusion of sociocultural verisimilitude, the narrative pretext and the formal and stylistic construction of a genre are also demarcated by specific codes and conventions. Assuming that these codes and conventions are familiar to an audience, the plausibility of a genre film is as much guided by audience expectation as it is by the relationship of the genre to sociocultural verisimilitude. However, the desirable proximity to, or distance from, verisimilitude differs between genres. While the narrative and stylistic elements of a war film or western might claim a close allegiance to real-world events, the musical film or fantasy adventure film is quite openly more closely aligned with an internal and obviously fictionalized logic. Nonetheless, even if a genre maintains a noticeable distance from verisimilitude, an individual film may retain a level of plausibility within its particular generic framework. In other words, an audience familiar with the codes and conventions of a non-verisimilar genre may still "suspend disbelief" because the stylized events presented in the film fulfill expectations. That said, as Steve Neale has pointed out: "The predominance of ideologies of realism in our culture tends to mean that, unless marked as high art, many avowedly non-realist genres are viewed as frivolously escapist, as 'mere fantasy,' and thus as suitable only for children, or for 'mindless,' 'irresponsible' adults" (35).

Christine Cornea

As I have argued elsewhere, contrary to the rather polarized realist/ non-realist model set out above, the science fiction film is unusually located in a generic liminal zone: science fiction is sandwiched between overtly stylized Hollywood genres, like the fantasy or musical film, and those genres that rely more heavily upon the adoption of contemporary modes of sociocultural verisimilitude (Cornea 2–11). Therefore, the formal and aesthetic composition of the science fiction film frequently oscillates between familiar realist and non-realist constructions, which can operate to foreground the genre's constituent features. In part, this may explain the often disparaging criticism leveled at sci-fi film. Confused by its liminal status, popular response is often based upon the same evaluative criteria applied in assessing "realist" genres, with little regard for the codes and conventions of the science fiction genre or its particular mode of address. Alternatively, judged on its merits as a fantasy film, for many critics the science fiction film may be seen to fail in the provision of the complex and exhaustive conventions of narrative "world building" necessary to assure "suspension of disbelief." Add to this the traditionally lowly status of non-realist genres and it is hardly surprising that science fiction film has received bad or contradictory press.

The following chapter therefore offers an account of non-academic reviewer rhetoric in association with the science fiction film. In particular, I focus upon the use of humor in disparaging reviews of science fiction films. Beginning with an analysis of reviews of U.S. science fiction films from the 1950s, I discuss the presence or absence of intentional humor as a textual feature of the "bad" science fiction film (using *Plan 9 from Outer Space* [1959] as a case study), before moving on to take a comparative look at the use of humor in contemporary reviews associated with the science fiction film. Finally, I discuss the centrality of the genre in the commercialized development of a veritable "bad film" business. While Barbara Klinger and others have paid close academic attention to film reviews as an aid to understanding "the cultural hierarchies of aesthetic value reigning at particular times" (70), or have looked at parody as a component of paracinematic or camp viewing practices (see Staiger 124–32), my approach here is both broader and more particular. In the space of one chapter, what I hope to indicate is the continued use of what I call the "critical humor" associated with this genre, and, especially, the usefulness of applying

theories/philosophies of humor in detailed analysis and understanding of popular critical reception of this genre.

REVIEWING SCIENCE FICTION IN THE 1950S

When this film genre came to prominence in Hollywood in the 1950s, the critical stances outlined above were evident in the reviews for a variety of both high- and low-budget science fiction films from this period. A comparison of reviews of *The Day the Earth Stood Still* (1951) is illuminating in this regard. A caustic review from Bosley Crowther in the *New York Times* asserted that this film failed to deliver the sense of wonderment expected in "a fable of such absurd assumptions": the mixed "lukewarm philosophy" and naturalistic performance styles were understood as no more than "tepid entertainment in what is anamolously [*sic*] labeled the science-fiction field" ("Emissary from Planet Visits Mayfair Theatre in 'The Day the Earth Stood Still,'" *New York Times*, 19 September 1951, 37). Understood in alignment with the fantasy film, the elements of realism and adult philosophizing seemed incongruous to this reviewer. On the other hand, two separate reviews in *Variety* lauded the film on the grounds of visual and narrative realism. The first pointed out that the "yarn" was "imbued with sufficient scientifiction [*sic*] lures" and that the mise-en-scène conferred an "almost documentary flavor" (Stal [staff writer], "The Day the Earth Stood Still," *Variety*, 5 September 1951, 6). A following review praised the "dazzling" flying saucer featured in the film, with reference to actual scientists "who claim to have researched three such spaceships in New Mexico," and commented on the superior mathematical abilities of the alien visitor Klaatu (Michael Rennie) as being believable in the context of "magnetic calculating devices which are claimed to dash off a million calculations a minute" (Frank Scully, "Scully's Scrapbook," *Variety*, 3 October 1951, 72). These positive reviews went to some lengths to validate the film in accordance with a kind of verisimilitude. Conversely, the distinctly otherworld setting of *Forbidden Planet* (1956) seemed to cause less confusion, and many reviewers assessed it as a family-friendly fantasy film. Crowther's review praised the colorful spectacle and array of "gaudy gadgets," and, downplaying more disturbing aspects, commented that the film "offers some of the most amusing creatures conceived since the Keystone cops [*sic*]" ("Wonderful Trip

in Space—Forbidden Planet Is Out of This World," *New York Times*, 4 May 1956, 21). For this reviewer, the film's detailed fantastical setting and focus upon futuristic mechanical devices assured its non-realist status and suitability for children. At the same time, Crowther seems to be taking a sideways swipe at the film by indicating that it is not to be taken seriously.

Both of these films were made on relatively respectable budgets ($1.2 and 1.9 million, respectively), and while contemporary critics may have struggled with the strange mix of realist and non-realist elements, they generally found it easier to either ignore or completely condemn the lower-budget science fiction films of the period. Choosing to review science fiction films from independent producers like Walter Wanger and Bert I. Gordon or films from studios specializing in lower-budget fare (e.g., Allied Artists, American International Pictures) more often than not presented the film critic with an opportunity for humorous wordplay and sarcastic commentary. Take, for example, Don Siegel's science fiction/horror film *Invasion of the Body Snatchers* (1956), which led one reviewer to gleefully proclaim, "Watch out there! You too may become a potted plant. Or at least a hollyhock," and to summarize the film as set in a California town in which "practically the entire population turned into a vegetable salad" (Sara Hamilton, "Invasion of the Body Snatchers," *Los Angeles Examiner*, 1 March 1956, 6). With an equally derisive tone, the *Boxoffice* review disparaged this film for leaving "as many loose ends as are found in a bowl of spaghetti" ("Invasion of the Body Snatchers," *Boxoffice*, 25 February 1956; reprinted in LaValley 167), while *Variety* remarked on Siegel's lack of direction in allowing "his leading character, Kevin McCarthy, to overact in several sequences" (Whit [staff writer], "Invasion of the Body Snatchers," *Variety*, 29 February 1956, 6). Although contemporary reviewers pointed to what they saw as laughable elements in this film, it is interesting to note that later interviews with the director revealed that the studio went to some lengths to eradicate intentional humor in the scripting and editing. As Siegel testifies: "I felt that pods growing into a likeness of a person would strike the characters as preposterous. I wanted to play it that way, with the characters not taking the threat seriously." What Siegel apparently intended was that the initially jocular response from protagonists would be juxtaposed with their "full shock and horror" in discovering the truth of the "pod people" (see LaValley 154).

Other critics of the low-budget or B movie reveled in reassigning the supposedly serious science fiction or science fiction/horror a comedy classification and in reporting the audience laughter apparently induced by weak plotting or unimpressive special effects. Securing reviews in *Variety*, *Mesa of Lost Women* (1953) was deemed "for laughs only" (Whit [staff writer], "Mesa of Lost Women," *Variety*, 17 October 1956, 6), while the alien creature in *It Conquered the World* (1956) purportedly "inspired more titters than terror" (Kove [staff writer], "It Conquered the World," *Variety*, 12 September 1956, 6). This kind of reviewer tactic can be understood with reference to philosophies concerning the social uses of humor. One particular strand in these philosophies is generally labeled the "superiority theory." The theory has been traced back to Plato and Aristotle, but is also commonly associated with the English philosopher Thomas Hobbes, specifically certain passages from his book *Leviathan* (1651). As Michael Billig succinctly describes it: "The superiority theory is basically a theory of mockery, for it suggests that laughter results from disparaging or degrading others" (39). In alignment with ancient theories of laughter, the superiority theory of humor is thought of as a kind of rhetorical device, as serving a disciplinary function within society, as a way of policing normative borderlines. However, Hobbes's critique of humor introduced a psychological perspective by considering the basis of laughter in attempts to elevate the self by degrading others. As such, the critical deployment of humorous wordplay or reporting of audience laughter in reviews can be read as a kind of sanctioned exercise in disciplinary authority on the part of the reviewer, or as a way of indicating personal superiority at the expense of the films in question.

Aside from recognizable formal and thematic elements, genres are regularly identified with reference to their "affectivity." For instance, it is evident that expectations of wonderment as well as scientific validity come through in the reviews of *The Day the Earth Stood Still*. Also, in dealing with the science fiction/horror films of the period, many reviewers appeared to base their judgments upon a proper mix of believability, wonderment, and fear as designating "successful" illustrations of this hybrid genre. In his analysis of how "fear" is provoked, Noël Carroll declares: "Harmfulness, of course, is the criterion for fear. Thus, the depictions and descriptions in horror film are critically pre-focused to make the prospects for harm salient in the world

of the fiction. The relevant harms here take the form of threats—generally lethal threats—to the protagonists in the horror film, and the locus of these threats is standardly a monster, an entity of supernatural or sci-fi provenance. . . . Moreover, they have certain capacities or advantages—such as great strength, cunning, indomitable technologies, supernatural abilities, or even invisibility—that are not easily deterred. This makes them particularly dangerous and fearsome" (38). Denigration of certain science fiction/horror films by reviewers was partially built upon a lack of perceptible harmfulness and credible threat. The "prospects for harm" are understood as either absent or implausible and the ability of the alien or monster to inflict damage or injury is not assured. Thus, the somewhat clumsy, cucumber-shaped Venusian in *It Conquered the World* was seen as no real threat to the army personnel featured in the film ("It Conquered the World," 6), and the monster in *Teenagers from Outer Space* (aka *The Gargon Terror* [1959]) looks, to one reviewer, more "like the silohuette [*sic*] of a fly unhappily caught in the aperture of the projector" (Jack Moffitt, "'Outer Space' Pic Strictly for Juves," *Hollywood Reporter* 155: 16, 2 June 1959, 3) than a threatening, alien entity. The apparent absence of believability, wonderment, or fear leaves an affective gap for these reviewers that can be filled by humor and laughter. As if in response to reviewers, in a feature interview for the *New York Times,* the head of AIP, James Nicholson, claimed, "In our concept of each of our monsters we strive for unbelievability. Teenagers, who comprise our largest audience, recognize this and laugh at the caricatures we represent, rather than shrink in terror. Adults, more serious-minded perhaps, often miss the point of the joke" (Irving Rubine, "Boy Meet Ghouls, Makes Money," *New York Times,* 16 March 1958, 2: 7). Thus, Nicholson's declared intention to provoke laughter in films like *It Conquered the World* works against reviewer superiority, by suggesting that their mockery actually indicates lack of insight rather than expert judgment.

THE INCONGRUITY OF *PLAN 9 FROM OUTER SPACE*

Of course, the lower-budget *Invasion of the Body Snatchers* was subsequently reappraised and has since become part of a canon of respected science fiction/horror films. While popular response to many other low- or shoestring-budget films produced in the 1950s has not really

changed over time, some have accrued cult status and have been cele-
brated for their formal transgressions in the context of the classical
norms of the period. Indeed, revisionist academic criticism has even
viewed a number of low-budget examples of the genre from this era
as auteurist artifacts, elevating the status of some films by reading
them in alignment with the practices of "art cinema." Ed Wood's *Plan
9 from Outer Space* (1959) is perhaps the most notorious example in
this regard. On one hand, academic reconsideration of this film has
led Barry Keith Grant to explain the cult status and notoriety of *Plan 9*
as due simply to the filmmaker's lack of "basic technical competency"
(124). On the other, Jeffrey Sconce offers the following comments on
Wood's cult filmmaker status: "No longer regarded as a hack, Wood
is now seen, like Godard, as a unique talent improvising outside the
constrictive environment of traditional Hollywood production and
representation" (114).

"Plan 9" literally denotes an alien battle strategy (from "Outer
Space") that involves turning dead humans into compliant zombies,
which can then be directed by alien technology to attack the living
human population. While the might of the American army does not
deter this alien force, "Plan 9" is finally thwarted by a plucky group of
civilians, with the result that the aliens flee planet Earth. *Plan 9 from
Outer Space* was made on a shoestring budget and was largely the re-
sult of Wood's tenacious energy, some funding from a local Baptist
church, and the good will of friends and associates who worked on his
films with little hope of financial reward.

Leaving aside, for a moment, the question of *Plan 9* as an auteur or
art film, Grant's assertion serves as a point of departure in tracing the
textual and intertextual mechanisms at play in this film. Certainly the
inclusion of both aliens and zombies in *Plan 9* would seem to signal
the generic codes the film was working with and its positioning as a
science fiction/horror film. Operating within these strictures, it is rea-
sonable to assume that if this film triggers (derisive) laughter it does
not live up to the generic expectations of the critic and can be judged a
failed example of the genre. While *Plan 9* did not attract that much at-
tention from American reviewers at the time of its release, in the opin-
ion of British reviewers the film was "unintentionally laughable" ("Plan
9 from Outer Space," *Kine Weekly* 2734, 25 February 1960, 22), and was
seen as "just about the weakest SF-cum-horror thriller to come out of

Hollywood in years" ("Plan 9 from Outer Space," *Monthly Film Bulletin* 27: 315, April 1960, 54). Looking to philosophies of humor once again, an application of what is known as the "incongruity theory" is also useful in attempting to account for the "laughable" in conjunction with a film like *Plan 9*. In much the same way as the superiority theory, the roots of this particular approach have also been traced back to Aristotle, and the further development of incongruity as providing a kind of foundation for humorous affect can be followed through in the philosophical works of Immanuel Kant and Arthur Schopenhauer. For Michael Clark, the Kantian notion of amusement as "frustrated expectation" comes close to what, in philosophical circles, is now known as the incongruity theory. Clark pursues the development of this theory through to Schopenhauer, drawing attention to his idea that laughter is caused by "the sudden perception of the incongruity between a concept and the real objects which have been thought through it in some relation" (Schopenhauer, qtd. in Clark 145). While Clark accepts that what is perceived as incongruous does not necessarily signify humorous intent or always result in an amused response, he suggests that incongruity remains the basis for amusement and laughter. Building upon Schopenhauer, Clark therefore refines his definition of amusement as "the enjoyment of (perceiving or thinking of or indulging in) what is seen as incongruous, partly at least because it is seen as incongruous" (150).

In understanding Schopenhauer's and Clark's use of the term "concept" as analogous to "expectation," it is clear that humor arises in a film like *Plan 9* due to the perception of incongruity. This film draws upon and repeatedly breaks with the stylistic conventions of the "classical paradigm" as well as generic codes and conventions. Clark also argues that there are various ways "in which incongruous instances differ from paradigm instances of the concept. . . . The objects of humor are so various partly because the modes of incongruity are various" (149). Likewise, as much as the sheer perception of incongruity is at the heart of how humor emerges in a film like *Plan 9*, as demonstrated by the following summary analysis, various modes and levels of incongruity are to be found in this film. For instance, one may find different kinds of examples of what I would call "internal incongruity" within the film—parts that do not fit or harmonize together as might be expected—as well as moments of what might be thought of

as "external incongruity," brought about in the clashing together of preexisting generic expectation and various aspects of the film. At a basic level, there are numerous instances when believability is shattered, whether this happens in unexplained and contradictory declarations; character performance; lack of continuity in narrative structure, chronology, and even casting; or elements in setting that seem out of place in the science fiction/horror film. Consider how the oft-quoted opening lines, earnestly delivered to the camera by the film's narrator (a celebrity psychic called "The Amazing Criswell"), immediately expose bewildering inconsistencies in the scripting. While declaring that what we are about to see offers a true account of past events, Criswell also elicits the attention of the audience in the forthcoming narrative through the following: "And remember, my friends, future events such as these will affect you in the future." Aside from the way the clumsy phrasing undermines the authority of the speaker, this declaration also confuses the temporal setting of the film: is the film's narrative set in the past or in the future? Further discrepancies can be noted when airline pilot Jeff Trent (Gregory Walcott) reports his encounter with an alien spaceship: Trent's description of the spaceship as "shaped like a huge cigar" is obviously incompatible with the repeated display of the classically round flying saucer in the film.

The inept use of techno-babble later in the film also ruptures generic plausibility, especially as in the space of one scene characters seem unable to articulate the name of the powerful technology that the aliens threaten will be unleashed upon the world. Stumbling over pronunciation, they identify variously as "solarbonite," "solarnite," and "solaronite." Further, odd and seemingly inappropriate moments in performance fracture any sense of unity in characterization. For instance, at one point a police detective clumsily brandishes a gun and, while maintaining a conversation with his colleague, continues to gesticulate with the gun in his hand in a somewhat bizarre and hazardous manner. Perhaps more astonishing is the substitution of actor Tom Mason for Bela Lugosi. Previously shot footage featuring Lugosi was used at the beginning of the film to set up the character credited as the "Ghoul Man." Shooting of what became known as *Plan 9 from Outer Space* began later, following Lugosi's death in 1956. Wood simply replaced Lugosi with Mason in the same character role. Although attempts were made to hide this substitution (assuming the familiar "Count Dracula" posture,

Trent: I saw a flying saucer . . . It was shaped like a huge cigar! *Plan 9 from Outer Space* (Ed Wood, Reynolds Pictures, 1959). Digital frame enlargement.

Mason played the character with the lower part of his face covered by his long cape), passing Mason off as Lugosi is visibly undermined by the fact that Mason is a younger and much taller man. If these occurrences fail to indicate an internalized incongruity, then the sight of supposedly heavy (cardboard) gravestones toppling over as characters pass by, or the presence of what appear to be large velvet curtains as part of the décor inside the alien spacecraft, disrupts both classical realist verisimilitude and generic plausibility.

Certainly it is possible to argue that *Plan 9* can be understood in alliance with the kind of deconstructive urge exhibited in the late 1950s and 1960s French New Wave. Jean-Luc Godard's insistence on the display of artifice and cinematic construction, as well as his blatant and extensive use of reference to past Hollywood films, could be read alongside the demonstrable inconsistencies in *Plan 9*. Even so, the geographic and cultural contexts within which their films were produced do separate Wood and Godard, as much as academic analysis might seek to question the boundaries between "esteemed" art film

Velvet curtains as backdrop décor inside the alien mother-ship in *Plan 9 from Outer Space*. Digital frame enlargement.

and "disreputable" B movie/exploitation film. Still, it seems that issues of authorship and intentionality are crucial in the critical reading of the humor of *Plan 9* and other examples I have covered in this chapter.

PARODY AND THE "BAD FILM"

As outlined above, the ridicule of the science fiction or science fiction/ horror film in reviews was generally brought about by foregrounding what was understood as unintentional incongruity between a particular work, the classical paradigm, and the acceptable execution of generic codes and conventions. In other words, reviewers designated a film's failure within what they assumed to be the culturally defined boundaries of the day. However, as partially demonstrated by Nicholson's comments above, the perception of incongruity can also be taken as a failure on the part of the critic to identify the correct or most current set of audience expectations. Also, if it was the filmmaker's intention

Christine Cornea

to provoke laughter, then critical ridicule could mean the reviewer has brought the wrong set of expectations to the film. Alternatively, this could mean that the filmmaker has failed to signal a comprehensive comic intent or comical moments as intentional. Perhaps, therefore, it is possible to understand *Plan 9* as deliberate parody aimed at the classical conventions of Hollywood, and/or as an example of self-reflexive, generic parody. Generic film parody—parody that targets the codes and conventions of a particular Hollywood film genre—was not unknown at this time. Both horror and science fiction had been previously utilized as generic backdrops by the comedy duo Bud Abbott and Lou Costello in *Abbott and Costello Meet Frankenstein* (1948) and *Abbott and Costello Go to Mars* (1953), among other films they made at Universal. However, this form of film comedy really flourished in the 1970s and 1980s with famous examples of horror and science fiction parody films, including *Young Frankenstein* (Mel Brooks, 1974), *Sleeper* (Woody Allen, 1975), and *Spaceballs* (Brooks, 1987). It seems the post-classical period in Hollywood brought with it a kind of comic nostalgia for the Hollywood genres of the classical period; genres that were familiar to filmmakers from their youth, and genres that provided ripe targets in what Dan Harries describes as this new "age of irony" (21). Indeed, as Harries goes on to argue, since the 1970s "the parodic itself has become so marketable and so predictable that its status has mutated into the very thing it has long assailed: a canon" (21). This canonization of generic parody therefore implies an understanding of specific parodic structures that are now widely recognized and can be drawn upon in terms of the expectations audiences and reviewers bring to films. Given that generic parody works through the appropriation and recontextualization of established codes and conventions, it also implies a working knowledge of the history of Hollywood filmmaking practices and generic traditions. As Linda Hutcheon makes clear in *A Theory of Parody*, "Parody historicizes by placing art within the history of art" (109). Even as there may be a growing familiarity with parody, until relatively recently the mainstreaming of generic parody in Hollywood has generally required the presence of a known comedian, comic actor, or star director with a track record in comedy. In this way comic intentionality is heavily signposted, to avoid possible confusion or misreading on the part of the audience or reviewer.

In the case of *Plan 9*, there is little in the way of an overtly parodic framework, in the sense accepted by reviewers in the 1950s. For instance, any reliance at this point in time upon the star persona of Lugosi seems to render the film's generic status as ambiguous. Lugosi's appearance, later in his career, in *Bud Abbott and Lou Costello Meet Frankenstein*, as well as in *My Son the Vampire* (aka *Mother Riley Meets the Vampire* [1952]) and *Bela Lugosi Meets a Brooklyn Gorilla* (1952), might have suggested comedic intent in the case of *Plan 9*. However, these earlier comedy films explicitly relied upon the fact that after *Dracula* (1931) Lugosi could not escape being typecast in horror. Unlike earlier Lugosi comedies, *Plan 9* was not a vehicle for a well-known comedy actor or comedy duo. Although this film also referred to Lugosi's associations with the Count Dracula character, without the mediating influence of a recognizable comic actor or the comedy framework familiar from past films it may have been difficult to pin down any intended effect in the use of this star/character. So, could Maila Nurmi as "Vampire Girl" in *Plan 9* perhaps be taken as an indicator of parodic intent? Nurmi had adopted the celebrity character of "Vampira" as host of "The Vampira Show" (1954–55), a format that operated as a framework for late-night broadcasts of low-grade horror movies. As "Vampira" she would regularly comment upon and mock the film feature to follow. But she did not have a speaking part in *Plan 9*, so her role as ironic mediator between audience and film is undermined. Indeed, this casting could equally be read as an attempt to recuperate horror rather than as a signal of parodic intent.

Even if parodic intent is less than clear in *Plan 9*, as active decoders audiences may choose or be encouraged to read the film in this way. Following "The Vampira Show," the "film host" framework was avidly taken up in American television: with tongue firmly in cheek, many a "host character" provided an ironic framing for horror and science fiction films, and some would even interrupt films with inserted segments or commentary. Extending this now familiar television format, a later series, "Mystery Science Theater 3000" (1988–99), featured comedian Joel Hodgson (as "Joel Robinson"): imprisoned on an alien spaceship, Joel is force-fed B movies as a form of torture. (Michael J. Nelson, as "Mike Nelson," replaced "Joel" as captive host in 1993.) As captive hosts, silhouettes of Joel and his robot sidekicks were visible throughout the film and their continual comic commentary was audible over

the film sound track. With mockery and ridicule underpinning the commentary script, this was a tremendously popular show, tapping into the sort of parodic viewing practices that Nicholson claimed for his AIP film audience. Interestingly, although in 2009 Nelson was part of the RiffTrax team in a theater presentation of *Plan 9 from Outer Space*, accompanied by live comedy performance in the style of the program, "Mystery Science Theater 3000" chose not to feature *Plan 9*. The reasons for this were reported in a later Internet fan site interview, in which it was claimed that "the voice-over from Criswell would interfere with the commenting that Joel/Mike and the 'bots would make. Second, making fun of this movie is just too easy. . . . Third, it's kind of redundant: The movie really makes fun of itself" ("Mystery Science Theater: Frequently Asked Questions," online at *www.mst3kinfo.com/mstfaq/subtle.html*). Whether or not parodic intent was clearly identifiable when *Plan 9* was first released, this interview demonstrates how parody has since been understood as a facet of the film.

Now widely touted (indeed, respected) as the worst film ever made, over the years *Plan 9* has been regularly referred to in reviews, usually operating as critical shorthand for reviewers in their derision of the most current "bad film" released upon an unsuspecting public. Take, for instance, Elvis Mitchell's description of *Battlefield Earth* (2000) as "'Plan Nine From Outer Space' for a new generation" ("Earth Capitulates in 9 Minutes to Mean Entrepreneurs From Space," *New York Times*, 12 May 2000, E10). Further, the reviews for *Battlefield Earth* provide a clear and prominent illustration of the current trends in journalistic ridicule. What is perhaps most notable is that the critical language employed has not really changed that much since the 1950s and early 1960s: *Battlefield* is variously derided as "laughable" (Desson Howe, "Escape from *Battlefield Earth*," *Washington Post*, 12 May 2000, N51), "ludicrous" (Henry Sheehan, "From Sci-Fi Pulp to Celluloid Pap," *Orange County Register*, 12 May 2000, F10), "hilarious" (Sharon Waxman, "Silly 'Earth' Looses the Battle at the Box Office," *Chicago Sun Times*, 2 June 2000, Weekend: 31), and lacking "credibility" (Julie E. Washington, "You'll OOh, You'll AAh, But Believe It? Nah," *Cleveland Plain Dealer*, 16 June 2000, 4). Reliance upon verisimilitude and unintentional humor are still very much part of the critical armory for the press reviewer. What has changed is the frequency of references to past films in describing the depths to which a "bad film" is understood

John Travolta's Terl fails to convince as the aggressive alien overlord in *Battlefield Earth: A Saga of the Year 3000* (Roger Christian, JTP Films/Battlefield Productions, 2000). Digital frame enlargement.

to sink. Also, where *Plan 9* was once the automatic default for comparison in reviews of newly released science fiction films, lately *Battlefield* seems to have picked up the baton: now reviewers often refer back to it in their judgments of the latest "bad film." For example, in her description of dubious moments in an otherwise purposely humorous *Shrek* (2001), Eleanor Ringel Gillespie comments, "Sure, it's intentional, but then, so was 'Battlefield Earth'" ("Fairy Tale 'Shrek' Has Its Moments," *Atlanta Journal-Constitution*, 18 May 2001, 1). In a "mini-review" of *The Caveman's Valentine* (2001), Gary Arnold declares, "Samuel L. Jackson gets a 'Battlefield Earth' to call his own, courtesy of the addled young director Kasi Lemmons" ("The Caveman's Valentine," *Washington Times*, 15 March 2001, M22). While disparaging comparison to *Battlefield Earth* might be explainable a year or two after its release, its reputation continues in the most recent reviews of science fiction films. In his account of *The Book of Eli* (2010), Colin Covert kicks off, "Travolta had his 'Battlefield Earth,' Costner had his 'Waterworld' and now Denzel Washington has his truly awful sci-fi epic" ("The Bad 'Book,'" *Star Tribune*, 15 January 2010), while Dennis Willis says of *The Last Airbender* (2010), "It's not 'Battlefield Earth' bad, but it's close" ("The Last Airbender? Let's Hope So," *San Jose Mercury News*, 8 July 2010).

The $44 million poured into *Battlefield*, as well as the film's associations (via Travolta) with the quasi-religious views of L. Ron Hubbard and the Church of Scientology, suggest that it was meant as

a serious film with a serious "message." This made it the perfect target for the popular critic and reviewer. After all, things have changed since the studios banned humorous banter in the scripting of *Invasion of the Body Snatchers*: a post-classical Hollywood often embraces the lighthearted joke and the knowing, ironic statement from its science fiction characters. Also, the affectionate parodying of science fiction was big business in mainstream Hollywood by the mid-1990s, as witnessed in *Mars Attacks!* (1996), *Men in Black* (1997), and *Galaxy Quest* (1999). In addition, a veritable industry has now been built upon the public acknowledgment of the "unintentionally funny" or simply "bad" film, especially upon those films that can be classified under the science fiction or science fiction/horror category. For example, science fiction and science fiction/horror features are regularly nominated in mock "Oscar" ceremonies, like the Golden Raspberry Awards (the "Razzies"), as well as being central to the televised Spike TV Scream Awards. Tapping into preexisting fan and cult cultures circulating around the "bad film," there is an attempt to uphold an oppositional distance from conventional cinema culture in the rhetoric surrounding these alternative events. If the news and industry press generally gave the "unintentionally funny" science fiction film short shrift back in the 1950s, the science fiction "bad film" today has become a focal point for widespread media activity and therefore a business that, in its own right, laughs all the way to the bank.

DAVID STERRITT

Wrenching Departures

Mortality and Absurdity in Avant-Garde Film

The greatest filmmakers explode not only the forms but also the moods of conventional cinema, injecting our neural circuits with affective tumult and intellectual uproar. In this essay I focus on the cinema of the absurd, an aesthetic modality built on oscillation between breakthrough and breakdown, geared to what Gilles Deleuze calls "the violence of sensation . . . inseparable from its direct action on the nervous system" (34–35). My primary specimens are Bruce Conner's *A Movie* (1958), a work of mournful hilarity; Michael Snow's *Wavelength* (1967), a drop-dead tragicomedy; and Ken Jacobs's *Two Wrenching Departures* (1990), a derisive laugh in the face of death. Each takes mortality as its subject, offering a subversive vision of life entering its final fadeout.

CONNER: OBSCURITY, ILLUMINATION

Bruce Conner began *A Movie* soon after he set up shop as a young artist in San Francisco in 1957. His work at this time included conceptual art, performance pieces, painting, printmaking, drawing, collage, sculpture, and assemblage. When he decided to make a movie, he envisioned a loop of recurring footage back-projected in a room-sized installation piece. But money posed an insuperable problem. "I was a movie usher, my wife had a job as a secretary," he told me years later. "As soon as I got into the film project, I realized this was a rich man's art form."

Making a virtue of necessity, Conner realized that while a camera was beyond his means, he could afford silent 16mm condensations of feature films sold by a local store. So he took inspiration from a nonsensical montage in one of his favorite pictures, the Marx Brothers comedy *Duck Soup* (1933), and began editing store-bought footage into a surrealistic chase sequence that became a key scene in *A Movie* (David Sterritt, "Bruce Conner: Crafting Visions from Film Pieces," *Christian Science Monitor*, 24 October 1984, online at www.csmonitor.com/1984/1024/102408.html). Conner made many subsequent films, most of them composed of found-footage sequences carrying the same visual energy and sociopolitical drive that make his initial production a work of such galvanic power. Like his work in other media, his films center on "the struggle between dazzling illumination and tenebrous obscurity . . . locked into a state of eternal suspension," in curator Peter Boswell's words (27).

The practice of montage, whereby strips of film are cut and spliced to form rhythmic sequences, is closely related to the practice of collage, whereby pieces of material are juxtaposed upon a surface; what the latter does in space, the former does in time. Conner's taste in collage-montage aesthetics was partly formed by the zigzag collisions of comic, melodramatic, and action-adventure footage in the coming-attractions trailers he saw while growing up in the 1940s. "I started fabricating a movie in my mind," he said later, "[that] would have scenes from *King Kong* and Marlene Dietrich movies, all sorts of things, combined with soundtracks. It was just a fantasy" (MacDonald 254). Until it wasn't.

Conner and *Duck Soup* both entered the world in 1933. Directed by Leo McCarey at Paramount Pictures, the film places Groucho, Harpo, Chico, and Zeppo Marx in the fictional realm of Freedonia, which is beset by problems emanating from Sylvania, a hostile country nearby. Groucho's character, Rufus T. Firefly, becomes the leader of Freedonia thanks to Margaret Dumont's character, Mrs. Teasdale, a wealthy matron who keeps the nation out of bankruptcy with the fortune she inherited from the late Mr. Teasdale, whose replacement (in the bank as well as the marriage bed) acquisitive Rufus would like to become. Conner saw the film at age sixteen and long remembered the scene that most captured his imagination: "There's a war going on, and the Marx brothers are surrounded in a farm house. Groucho

says, 'We need help,' and all of a sudden you see soldiers and airplanes and dolphins and giraffes and everything else running to help them" (MacDonald 253).

Extending, expanding, and complicating this concept, Conner crafted *A Movie* from pieces of a Hopalong Cassidy western, a 1953 newsreel compilation, a German propaganda film, a *samizdat* girlie-movie clip, and a novelty item called *Thrills and Spills.* He also used a good deal of film marked with countdown numbers and codes from processing labs—utility footage that is throwaway stuff by almost any definition, but captivates Conner for two reasons. First, it taps into his reflexive fascination with the materiality of film. Second and more important, he finds sinister implications in the way this visual material, indispensable to the mechanics of filmmaking, is withheld from view when films are commercially shown. He sees this suppression as a form of censorship connected with the militarism, male chauvinism, and media manipulation that are raging cancers on contemporary culture. Censorship, he said, is "death against life. This has something to do with the images in the film—the numbered leaders—the information which you were not supposed to see. The projectionist who controls the projector is not supposed to allow you to see that. . . . We are presented with things that look like we are seeing everything when in fact we are not, which is much more pernicious than when we are simply told we are not permitted to look at certain things" (Brakhage 140–41).

Hence the special place Conner reserves for the overlooked, the undervalued, the misunderstood, and the disdained. "In immediately breaking the boundaries between the acceptable and the taboo," critic Bruce Jenkins rightly observes, "Conner concisely announces his intention to expose the persistent (but unseen) ideological filters and viewing procedures that shape the mainstream media" (190). And, we may add, the cramped sociopolitical norms that these filters and procedures legitimize and affirm.

After launching *A Movie* with a comic pizzazz worthy of the brothers who inspired its opening sequence, Conner soon brings its darker ramifications to the fore. After an introductory blitz—utility footage, blacked-out frames, soft-core porno shots, many repetitions of the filmmaker's name, and an intertitle proclaiming "The End" about a minute into the film—the movie "quite literally cuts to the chase" (Jenkins 190) with its Marx Brothers mélange, commencing with shots

A Movie (1958) cuts to the chase, and the chase becomes ever stranger and more unsettling as Bruce Conner draws hilarity and horror from obscure film footage in his archive. Digital frame enlargement.

of attacking Indians and fleeing pioneers that grow ever shorter, more quickly edited, and less logically linked. The sequence derives a degree of narrative meaning from the Wild West content of the shots, but the film's hold on reality takes a tumble when horses pulling an old-fashioned fire engine abruptly enter the image flow, soon joined by a galloping cavalry, a charging elephant, a chugging locomotive, and military tanks leaping toward the camera, all hurtling full speed ahead. (It's funny.) The sequence then shifts to vintage racecars crashing and spinning through the air, then to an antique auto diving disastrously off a cliff. (That's not so funny.)

After a brief interlude, *A Movie* now takes to the air—a zeppelin floats in the sky, daredevils do stunts high above city streets—and then to the sea, where a submarine's periscope reveals a woman in a bikini, at whom a seaman (!) fires a phallic torpedo that explodes with the spectacular force of a nuclear bomb. The resulting waves are titanic, but there's a beach boy surfing them! Or so it seems in Conner's montage,

David Sterritt

which expands to include boaters and water skiers being swamped and submerged, and then (suddenly back on land) people riding ridiculous bicycles, mud-bogged motorcycles, and a crashing plane. (This is sort of funny.) Then a massive bridge collapses; bombers dispense death from the sky; Theodore Roosevelt declaims; a bishop conducts a ritual; cars collide; the Hindenburg bursts into flames. (This isn't very funny.) Another, larger bridge wobbles and collapses. The Hindenburg flames rise higher. A ship sinks. A firing squad executes a captive. Corpses hang in public display. More dead lie scattered on a hillside. (This is emphatically not funny.) African hunters converge on a slain elephant with machetes . . . a dark-skinned child weeps and shivers with fear . . . the Hindenburg disintegrates into smoke and ash . . . (All of this is the dead opposite of funny.)

As disturbing as this dreadful procession is, Conner transforms it into a resounding cosmic joke by means of the music—*The Pines of Rome* by Ottorino Respighi, a longtime staple of the light-classical

The ending of *A Movie* is artfully ambiguous, alluding to humankind's habit of evading existential challenges by seeking out the murky depths of experience. Digital frame enlargement.

hit parade—that has underscored the entire film and now produces its most richly paradoxical effect: the more ghastly and tragic the images become, the more the music swells with gladness, glory, and pride. This culminates in the concluding sequence, in which a scuba diver explores the wreckage of a sunken ship, eventually disappearing through a dark opening in the hull, whereupon the film ends with a shot of the sun as seen from beneath the water's surface. The final moments of *A Movie* are artfully ambiguous, yet their fundamental import is plain. The camera peers *up* at the shining sun whereas the diver goes *down* into the dark: once again humanity swims away from the light, seeking a cowardly haven in the benighted depths. As so often in Conner's work, Boswell observes, "the line between comedy and horror in *A Movie* is a thin one" (32). While its humor is impossible to miss, its tone is harrowing and mournful—rollicking tragicomedy for an era drowning in vicarious thrills, mediated spills, and lethal, unforgivable triumphalism.

Snow: Time, Space

Canadian filmmaker, musician, and artist Michael Snow describes *Wavelength* in straightforward terms: "The film is a continuous zoom which takes 45 minutes to go from its widest field to its smallest and final field. It was shot with a fixed camera from one end of an 80 foot loft, shooting the other end, a row of windows and the street." This is accompanied by an electronically generated hum that starts a little way into the film and continues until the end, rising steadily in pitch. What these descriptions don't convey is the action-packed nature of this seemingly obsessive work, in which the zoom proceeds by barely discernable fits and starts, color filters constantly alter the room tones, and a ghostly quasi-flashback occurs shortly before the end. "The room (and the zoom) are interrupted by four human events including a death," Snow continues in his program note for the Film-makers' Cooperative catalog (online at www.film-makerscoop.com/search/search.php). The verb "interrupt" is precise, since the events are intrusions on the normal state of the room and zoom, which are marked by emptiness, absence, and steadily diminishing visibility.

The last-named properties of *Wavelength* have evidently shaped the way some spectators respond to it. Rudy Burckhardt, a considerable

poetic filmmaker in his own right, said it sent avant-garde cinema into a tailspin. After its arrival, he wrote, "16 mm art films then became conceptual, structural, strictly styled, often heavy-handed and humorless. They were written about in *Artforum*" (98). Another negative critic is John Pruitt, who claims that Snow's films "willfully shut out the real" (59).

Asserting that Snow shuts out the real, willfully or otherwise, is a mistake. Like the films by Conner and Jacobs discussed in this essay, *Wavelength* excludes not the real but rather the *reality effect*—the suspension of disbelief induced in movie viewers by entrenched narrative-film conventions—in order to foreground the truth, beauty, and reality that are intrinsic to cinematic synthesis itself. Unlike the human events in *Wavelength*, its inherently filmic properties—the color shifts, the superimposed images, the small glitches in the zoom—are not interruptions. They are the existential substance of the work, constituting its form, content, and meaning. Elaborating on this, Snow calls *Wavelength* a "summation of my nervous system, religious inklings, and aesthetic ideas" as well as "a definitive statement of pure Film space and time, a balancing of 'illusion' and 'fact,' all about seeing."[1]

Where is the strange laughter in this? Nowhere, if we look for laughter in the literal sense of a physiological act sparked by an impulse to revel in superiority or release pent-up energies. It is everywhere, however, if we take laughter to be "an expression of pleasure at a psychological shift," in the words of philosopher John Morreall (58). The psychological shift that *Wavelength* demands from its viewer is best described in terms taken from Henri Bergson's philosophical scheme: the film encourages an adjustment *away* from everyday perception of space and time—the extensive, quantitative markers of the material world navigated by the sensory-motor system—and *toward* heightened connections with the intensive, qualitative energies operating in the psychic system. This is a paradoxical demand for a film to make, since a movie necessarily reaches the mind through the sensory apparatus that *Wavelength* seeks to transcend by means of stripped-down imagery and a glacial pace. Viewers expecting a "real movie" typically respond to its meditative ethos with impatience, frustration, and antagonism, whereas those who catch on to its methodology and goals may feel the kind of pleasure they would receive from an inspired joke or an ingenious play on words. This is appropriate, since on important

levels *Wavelength* is in fact an inspired joke inflected by an ingenious play on words.

But let's begin at the beginning, or rather in the interstices of the film, which are occupied by its four human events. (1) A woman in a fur coat enters, leading two men who carry what appears to be a large wooden bookcase; they place it according to her directions and all depart. (2) The woman returns with a friend; they sit and have refreshments, listening to the Beatles song "Strawberry Fields Forever" on a radio, then leave again. (3) An offscreen sound of shattering glass is heard; shortly afterward a bearded man staggers into the room and collapses on the floor. (4) The fur-wearing woman reenters, looks nervously at the man on the floor, and phones someone named Richard, describing what she sees and saying he should call the police. Borrowing from Russian Formalist theory, one might say these incidents are the *syuzhet* (plot) of *Wavelength* and the zoom shot is its *fabula* (story). But saying this would be an act of irrelevant labeling, and its very inadequacy would point to the plethora of ungraspable, uncategorizable tensions between order and chaos, stability and flux, sense and nonsense bodied forth by the film. Its attenuated "plot" notwithstanding, *Wavelength* is not a tale to observe but a continuum to inhabit; and to attune one's mental operations to the tenor of that place is to experience precisely the kind of psychological shift that invites an inner laughter both pleasurable and profound.

Wavelength is equally congenial when taken as a game, or rather as a puzzle that ultimately solves itself. At the beginning we see everything: the entire room, the urban architecture visible through windows on the far wall, and the events that transpire in this space, from the playing of a pop song to the expiration of a life. But the zoom implacably reduces the visual field, changing the view from plenitude to paucity. Has the film painted itself into a corner, doomed to terminate with a dull, constricted close-up of some nondescript spot on the opposite wall? If so, this is a movie offering blatantly diminishing returns! Snow's solution to the problem becomes evident late in the zoom, when art casually pinned onto the wall (some of it gleaned from Snow's seminal "Walking Woman" project) becomes large enough to be legible.[2] The item in the center is a photograph of waves on a body of water, and as the zoom gets ever closer we can finally foresee how the movie will end; indeed, the alert viewer can now perform a mental flash-forward, envisioning

how the watery photo will eventually fill the screen. As if to endorse the viewer's flash-forward, Snow provides a confirming counterpoint: when the fur-wearing woman walks to the phone beneath the photo, the film effects a ghostly flashback, showing her last movements in repeated overlapping shots that ride the final crest of the room-zoom much as an imaginary surfer might ride the waves in the photograph.

When the photo finally fills the entire screen, the sound track's electronic tone slowly fades in volume while mingling with the sound of sirens (perhaps Richard has called the cops) that intrude on the scene from outside. Are the sirens actually sounding in the street beyond the apartment windows? Or have they been post-dubbed by Snow in a bit of Hollywood-style fakery? We have no way of knowing, and this epistemological haziness is integral to the movie's comic import, which we are now in a position to spell out. While the steadily shrinking visual field suggests that the film will come to a cinematic dead end, Snow has flummoxed expectations by aiming his camera at a photograph of something vast and boundless: a body of water that ultimately fills the frame with the most expansive image in the film. How much time it takes to realize this vision—the length of time it takes to reach the waves—is as central to the film (and its title) as the varicolored wavelengths of light and the variegated waves of sound (diegetic dialogue, extradiegetic whine, perhaps-diegetic sirens) of which the film is made.

A second level of humor relates to the large apartment windows near the photograph. They are the most immediately conspicuous element of the mise-en-scène, and they are visible for a longer time than anything in *Wavelength* except the patch of wall bearing the valedictory photograph. Any reader of film theory can recognize them as a nonverbal analogue for the phrase "window on the world," referring to what some theorists regard as cinema's essential function, to wit, opening a vista of sights (and sounds) to moviegoers wrapped in the comfort and convenience of a darkened auditorium or equivalent. The naïveté of this view is wittily exposed by the film's steady stream of artificial elements—the uneven progress of the zoom, the abrupt cuts between daytime and nighttime, the shifts in color effected by filters in front of the lens, the phantasmal flashback near the end, and the electronic wail that has little or no connection with the profilmic environment. What we see through the window of *Wavelength* is no world at all, just a small slice of "reality" rendered highly *un*real by this overlay

of photographic artifice. All of which is quite a joke, aimed at film-theory notions that have long outlived their usefulness.

The deepest, richest joke in *Wavelength* centers on its main male character, who enters the space only to make an immediate departure in the most abrupt and thoroughgoing way imaginable. The film's other elements work to make his death as incongruous as can be: the earlier human incidents have established a casual, everyday atmosphere, and the zoom and the electronic tone have suggested regularity and predictability. Incongruity has been posited by numerous philosophers, including Immanuel Kant and Søren Kierkegaard, as a leading impetus for laughter; in Arthur Schopenhauer's version of the theory, laughter is prompted by the "paradox" that arises from "the sudden perception of the incongruity between a concept and the real objects which have been thought through it." He adds that the greater the contrast is between the concept and the reality, "the stronger is the ludicrous effect which is produced" (76–77). In this sense the "concept" of *Wavelength* is its all-embracing structure, and the "real object" most incongruously subsumed by that concept is the film's male character, whose appearance and immediate demise are rendered incongruous by their difference from everything else in the film, and are made *more* incongruous by the absence of information as to who he is, where he came from, or why he's in this movie at all. Laughter, whether externalized or felt within, is an unsurprising response to this surprising event.

Laughter is all the more fitting in the metaphysical context of *Wavelength*, which deals with "religious inklings," as noted earlier. Certain forms of laughter present "an element of victory over supernatural awe, over the sacred, over death," according to cultural theorist Mikhail Bakhtin (92), and such victory is precisely what Snow is after here: victory over death, which is recognized and depicted but not dwelt upon or answered by sorrow or grief; victory over the sacred, which is excluded by the film's emphatic materiality; and victory over supernatural awe, which is a structuring absence in *Wavelength*, a work profoundly informed by the rejection of supernaturalism associated with Theravada Buddhist meditation, whose goal of exacting mental discipline is evoked by the intractably patient, infinitely undistractible zoom.

In an interview with Snow a few years after *Wavelength* was completed, I asked him why he hadn't used a mechanized device to smooth

out the jerks, hesitations, and imperfections in the zoom. He replied that the "imperfections" are essential to the film, since they reveal the presence of the artist who operates the camera, transforming what might have seemed a detached mechanical exercise into a work with manifestly human meanings and sensibilities. To my mind, the play between the overall rigor of the design and these interwoven hitches and hiccups is an inspired way of integrating Snow's religious inklings with his profound interest in conundrums of the spatial and the chronological, the actual and the virtual, the real and the unreal, the living and the dead. "Subjectivity is never ours," Deleuze wrote, "it is time, that is, the soul or the spirit, the virtual" (*Cinema 2* 82–83). Showing subjectivity at work in actual time, virtual space, and the liberating flow of the creative spirit is the task Snow has assigned to what I find his greatest film. The man who dies in *Wavelength* contributes his soul to a movie that lives on imperturbably after he is gone. His demise is a human comedy at the center of a divine one.

JACOBS: ANTICS, OPTICS

Ken Jacobs is the great mad scientist of contemporary avant-garde cinema. Or rather the great mad alchemist, since his movies and methodologies are so distinctive that standard cinematic apparatuses can't contain them. His rare imagination, far-reaching aspirations, and deep understanding of film history require innovative gizmos to render his notions viewable on the screen, and a significant portion of his artistic energy has gone into developing new devices and techniques, most notably in the area of 3-D imagery. Attending many Jacobs screenings over the years, I have experienced 3-D in a variety of ways that do not involve wearing funny little glasses. These include (1) watching a film while holding a dark filter in front of one eye, which puts that eye into night-vision mode and desynchronizes it with the other eye, transmuting 2-D on the screen into 3-D in the brain; (2) viewing footage shot with a stereoscopic 16mm camera (a manufacturer's experiment that never caught on) with *eyes crossed* to just the right degree; and (3) seeing Jacobs present a film via the Nervous System (to be discussed below), his crowning accomplishment as an artist, inventor, and performer.

These and similar ventures notwithstanding, Jacobs is not interested in new-fangled methods per se: "This is not formalist cinema;

order interests me only to the extent that it can provide experience," he said of his 1995 film *Disorient Express* (Film-makers' Cooperative). His aim is to excavate the cinema of the past with novel technologies, stripping away social, cultural, and political encrustations so that antique images take on spontaneous new meanings of which their makers never dreamed. His radical revisions of the moving image demolish the axioms, platitudes, and truisms on which conventional art practices too often rely.

When a painter looks at a blank canvas, Deleuze writes in *Francis Bacon: The Logic of Sensation*, the canvas isn't blank at all. On the contrary, it is filled with the uncountable clichés that assault the artist (like everyone) at almost every waking hour in our media-saturated world, invading the brain and smothering authentic thought in all but the most fiercely original creative personalities, who alone can create the *sensation* that is art's raison d'être. Jacobs's cinema doesn't so much scrape away clichés as blast them to smithereens, doing so in a thoroughly Deleuzian spirit. "The violence of sensation," Deleuze declares, "is opposed to the violence of the represented (the sensational, the cliché). The former is inseparable from its direct action on the nervous system, the levels through which it passes, the domains it traverses" (2004, 34–35). This is the sublime violence—a violence against violence—that Jacobs produces with his Nervous System.

Jacobs's Nervous System has roots in his 1960s experiments with *paracinema*: shadow plays, multimedia shows, multiple-projector works. The heart of the system is a pair of hand-controlled 16mm projectors equipped to run forward and backward as slowly as one frame at a time. They are threaded with identical strips of found footage, projected at the same place on the screen. A sort of propeller spins between them, blocking the light from one while unblocking the light from the other, and vice versa, at dizzying speed, while the projectionist continually adjusts the frame-by-frame passage of the film. This transforms the movie into an eye-boggling slide show, pervaded throughout by the throbbing, pulsing flicker caused by the twirling propeller that alternately masks and unmasks the light from each machine. The goal is to penetrate cinema's collective memory and use its traces to create *eternalisms*, which Jacobs describes as "unfrozen slices of time, sustained movements going nowhere, unlike anything in life" (San Francisco Cinematheque Program Notes, online at www.archive.

org/stream/sanfranciscocine92sanfrich/sanfranciscocine92sanfrich_
djvu.txt).

When he speaks of memory and unfrozen time, Jacobs recalls the
ideas of Henri Bergson, a philosopher he read with interest as a young
man. In our daily lives, Bergson writes, we organize our perceptions
around the needs, demands, and habits of the body, mentally carving,
curving, and immobilizing time and space to facilitate our actions in
the world. While this carries practical benefits, it cuts away our con-
sciousness of the universal, all-embracing *élan vital* with which all
things are always already connected in an infinity of ways. Carrying
this insight to the realm of cinema, Deleuze contends that filmmakers
since World War II have employed spatial and temporal innovations
to heighten contact with the unimpeded flows, intensities, virtualities,
and becomings from which we normally disassociate ourselves. Re-
awakening awareness of this all-inclusive current is the intuitive philo-
sophical goal of Jacobs's cinema in general and the Nervous System
in particular—not to comprehend or explain the infinite field of pos-
sibilities, but to "show that it is there," as Deleuze and Félix Guattari
write, "unthought in every plane, and to think it . . . as the outside and
inside of thought, as . . . that which cannot be thought and yet must
be thought" (59–60). The thought that *can't* be thought but *must* be
thought has got to be a *comic* thought, and here we come to the strange
laughter prompted by much of Jacobs's cinema, including but not
limited to the films you look at cross-eyed.

The most powerful examples of Jacobs's sharp-edged wit appear in
two of his finest Nervous System works. *Ontic Antics Starring Laurel
and Hardy*, first performed in 1997 and revised for DVD in 2005, takes
its found-footage raw material from a flamboyantly comic movie: *Berth
Marks* (1929), a Laurel and Hardy short that I have long considered a
crowning achievement in the cinema of the absurd. Its core is a har-
rowing train-ride scene in which Stan and Ollie, retiring for the night
in a sleeping car, climb into an upper berth, doff their daytime clothes,
and don their nightshirts. Not surprisingly, their trusty ineptitude
turns this simple situation into an existential nightmare of entangled
limbs, intractable garments, unmanageable movements, and episte-
mological breakdown. The sequence is a prodigious display of slapstick
tragicomedy, phantasmagorically exploiting the "incongruity between
a concept and the real objects which have been thought through it" in

which Schopenhauer found the essence of the ludicrous. When reanimated and transmuted by the Nervous System, *Berth Marks* becomes even more uproariously oneiric, as when Ollie is endlessly groped by Stan's ostensibly helpful hand, which then becomes a giant lobster claw, which then joins a nightmarishly muddled assemblage of bed furnishings and body parts that impossibly but incontrovertibly *give birth* to Stan, who materializes from within the chaos as if emerging from a comic-cosmic womb. It is a stunning moment of pure cinematic sensation, partaking of an (il)logic that surely *can't* but obviously *must* be thought, since there it is, right in front of our eyes.

The raw material of *Two Wrenching Departures*, first performed in 1989 and revised for DVD in 2006, is filmed material shot by Jacobs around 1960, featuring Jack Smith and Bob Fleischner, erstwhile collaborators with whom Jacobs had fallen out years earlier; he was moved to resurrect the footage—and thereby resurrect his former friends, after a fashion—when they died less than a week apart in September 1989. The most striking material appears at the end of the film, depicting Smith in a characteristically anarchic street performance, dancing along the sidewalk with his face turned toward the camera, filmed from the waist up. As always, the Nervous System's paradoxical synthesis of movement and stasis attenuates a few seconds of action into several minutes of throbbing slow motion. The scene is accompanied by clashes, clangs, and engine sounds from a noisy railroad yard.

Although he is wearing ordinary clothing, Smith has wrapped himself in a large sheet of transparent plastic that might be a voluminous poncho or a piece of salvaged packing material. The focal point of his costume is the headgear: covering the middle of his face is a bizarre mask, apparently of rubber, with a huge protruding nose atop deeply wrinkled eyes and cheeks, all framed by the plastic sheet, which flows like a long bridal veil from the top of his head to his shoulders and back. He holds the mask over his face with his right hand, which hides his mouth and chin from view. His left hand extends toward the camera, enveloped in the plastic veil, and the pulsing Nervous System repetitions give it an up-down motion resembling a goodbye wave. When he turns away from the camera, the veil covers almost all of his visible body, giving him the likeness of a harpy or a Japanese *onryo* ghost;

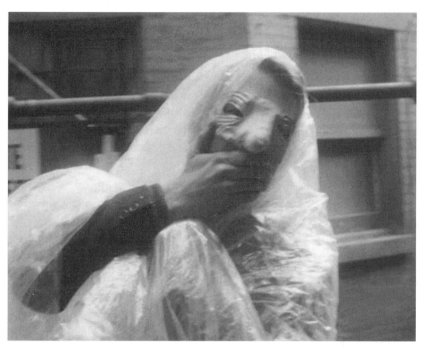

Two Wrenching Departures (Ken Jacobs, 1990) closes with Jack Smith dancing toward extinction in a gown of rubbish, mocking decency, propriety, and the solemnity of death itself. Digital frame enlargement.

when he again turns toward the camera, with only his eyes showing above the veil, he looks like a demented Baba Yaga or a figure from a painting by Bacon, who often limns semimorphous shapes that seem both organic and inorganic, perilously alive and aggressively lifeless at once.

In the film's last moments, Jacobs's camera films Smith through the bars of an iron fence. The figure now seems to be gazing out from some *huis clos* of the living dead, spreading his arms like a horrible-hilarious Halloween spook. Moving toward the end of the sidewalk, Smith sweeps his plastic-veiled right arm back across his chest so his face is entirely hidden, then allows the robe to trail eerily behind him in mid-air. In a final gesture he stands erect with his arms up-stretched and the plastic flowing downward from his hands, looking for all the world like an angel of death—his death—or perhaps an angel of the undead,

a *nosferatu*, a vampire. And finally he vanishes through an opening on the left of the screen at the end of the visual field, leaving behind the flaccid robe as a wilted *memento mori*.

This is as mind-wrenching a departure as the cinema has portrayed, impossibly poignant and piercingly nonsensical. In a role he was born to play but couldn't play until he died, Smith the underground legend becomes Smith the underworld sprite, prancing toward extinction in a gown of rubbish designed to mock, deride, and ridicule every right-thinking notion of decency, decorum, and propriety. This is the body without organs that Deleuze and Guattari discovered in the work of Antonin Artaud, a dis-organized body across which energies, intensities, and sensation slide in infinite, eternal freedom. It is the grotesque body that Bakhtin found in Rabelais's great novel *Gargantua and Pantagruel*, the uncontainable corpus that "ignores the impenetrable surface [that] closes and limits the body as a separate and completed phenomenon," fusing "the outward and inward features . . . into one" (318). It is the body of sensation whose nervous system, galvanized and amplified by the Nervous System, acts directly upon ours with a sardonic potency that would have made Bacon roar with glee. It is the hysterical body that hoots and dances in the shadow of death, silently snickering at mortality as it glides to the chaosmos that awaits us all. May we be no less merry when we join Smith there, sharing what Hermann Hesse called the "frightful laughter of the hereafter, hardly to be endured by man" (161). Ringing out from the unknown, it's a laughter fearsomely comical, wildly hysterical, spellbindingly strange. It's a scream.

NOTES

1. Scholars generally place *Wavelength* under the rubric of structural film, defined by P. Adams Sitney as "a cinema . . . in which the shape of the whole film is predetermined and simplified, and it is that shape which is the primal impression of the film" (2002, 348).

2. Snow's work between 1961 and 1967 made use of a flat cardboard silhouette called the Walking Woman, which he deployed in many configurations in a wide variety of media and locations.

Georgeの...

George Toles

Time's Timing and the Threat of Laughter in Nicolas Roeg's *Don't Look Now*

"Some jokes have such a deliciously serious side."

Walter de la Mare, *Memoirs of a Midget*

"Oh, God, he thought, what a bloody silly way to die . . ." (57). So ends, with disconcerting, throwaway abruptness, Daphne du Maurier's short story "Don't Look Now." John Baxter, the central character, spends his last moments of conscious life considering the absurdity of the chain of events that led him to confuse a female dwarf serial killer for his drowned daughter, Christine. How did it happen that he should be slain by this perfect (perfectly nonsensical) stranger in the watery city of Venice through a "silly" mistaken-identity blunder? His valiant effort to comfort and rescue a haunting semblance of Christine came to less than nothing—a ghastly joke on him.

Nicolas Roeg's 1973 film adaptation of the story makes extremely sparing use of overt humor; it would be wrong to characterize the film's intentions or tone as "darkly comic." Yet I would argue that a certain comedy shadows the entire narrative, like the "ghost" of the dead daughter in her eye-catching red mac. The stifled presence of comedy is worth investigating precisely because its pressure is so easily ignored. Comedy offers no clear alternative perspective on any of the narrative's significant events, and seldom rises to the surface as an available detour or relief during times of crisis. Characters occasionally laugh, and

more often smile, in the film, but we have little incentive to join in. If amusement is occasionally sanctioned, something in the Venetian air blocks it. The best picture of comedy's place in the narrative design is supplied in a shot of an unidentified female prison guard, whose mouth mechanically forms a smile, then instantly retracts it, though no one but us is watching. *Don't Look Now* finds a form flexible enough to accommodate episodes of harrowing terror, one of the most remarkable love scenes in the history of film, and a comedy that repeatedly threatens to break loose but is mysteriously held in check. Roeg maintains a delicate, complex sympathy with his characters' plight at all times. Nevertheless, the bad timing that is our inescapable mode of seeing in *Don't Look Now* performs a quiet sabotage on our investments of feeling. We are always headed toward that extravagant, unthinkable dwarf, and death at her hands must remain, at some level, ridiculous (see Sanderson; Lanza; and Emma Wilson).

A typical instance of "bad timing" occurs very early in the film. Laura Baxter (Julie Christie), enjoying a cigarette in her kitchen, hasn't the slightest inkling that her daughter has just drowned in the backyard pond and that her husband John (Donald Sutherland) is at this moment struggling to rise from the mud from which he is trying to carry the child's body to the house. We view Laura, ensphered in untroubled thoughts, as she passes behind the kitchen windows. Immediately behind her is a vase of red flowers that we catch a glimpse of and register as a slight visual shock. The redness is galvanized by its association with Christine, still clad in death in her bright red coat. Thus, we have a sense that red death is coming at oblivious Laura simultaneously from in front and behind. She is hemmed in by red, but still unseeing. Emerging from the house she turns to face the backyard, instantly catching sight of John and Christine and absorbing the import of what she is looking at. She screams, fingers flying to her mouth to block the recognition her violent sound lets loose. Enigmatically, her fingers remind us of an earlier visual match: Christine's fingers playing about her mouth as she wanders outside and an idiosyncratic gesture of Laura's indoors. "Like mother, like daughter . . ."—a resemblance that is underscored only to be negated: the daughter will grow no further in such resemblances.

Before Laura can complete her scream and the full mental act of "taking in," an alien sound of a power drill cuts it off. A jump cut

throws us ahead in time and space to Venice, where John, his face hidden behind a visor, inspects the damaged foundation of an ancient church as an assistant pierces the stone with a drill. The sound and visual shift are both severe dislocations. We are whisked away from the scene of tragedy before we can feel the ordeal is done, before we have sufficient time to be done with it. And the scream is emotionally connected to the drill: the iron mask that shields John from the shards of drilling debris works by association to shield him from the unappeasable cry of his wife, aimed at him in their ravaged English backyard. Here John adopted the mask of control and detachment he would stubbornly wear through most of the ensuing events of the film. As he works to lift Christine inside, his young son watches, not daring to believe what he sees and apparently having sent his mind on a blank errand to avoid processing the death. As the boy tries not to fathom events, his father strives, and in several different ways fails, to set things right.

Laura's carefree walk into the sightlines of horror assumes the form of a dreadful double-take. We see her advancing toward an emotional collision, which bears some relation to a comic's blind stroll toward a menacing object. Granted a wider perspective on the situation, the viewer is cued for the collision. He knows exactly where Laura is headed, and the trouble that awaits her there. In the execution of comic double-takes and falls, the precise timing of the impact is what we are usually unable to foresee. Our mental picture of the event is both confirmed and slightly thrown off by the comic actor's way of physically completing the convergence. Some crucial detail or event is typically sprung on the viewer that did not match up with calculations. In slapstick scenes where the response is a double-take rather than a fall, the performer gives us either more or less in his perceptual ricochet than we anticipated, completing his mental turn more briskly or slowly than the occasion seems to demand. The comedian's idiosyncratic means of catching up with the surprise lying in wait pleasurably quashes our expectation of what the resolving moment will be and of exactly how his blithely set attitude will be derailed. In this case—a horrifying "take" on slapstick—Laura's scream arrives before we have had adequate time to prepare for it. She responds with shocking speed, and she scales to the peak of realization in what seems the blink of an eye. She scarcely has time to connect the details (which we have

absorbed at a painfully slow rhythm) before the scream is torn out of her with unrestrained savagery. While we are knocked off balance by the abruptness and volume at the scream's commencement, we are equally unsettled by the swiftness with which this noise fuses with (and is supplanted by) the power drill. Laura is visually obliterated in the act of shrieking, as though the moment of terrified discovery swallows up, perhaps for good, the image of the woman she has previously been. Time itself seems to be driven into "fast forward" by the emotionally unfathomable noise that pours out of Laura. I'm reminded of a tone arm audibly skittering and scratching across the dark surface of a phonograph record, before it finds a different groove to settle in and the music (without hearing its own rupture) continues.

The altogether-too-muchness of Laura flying apart at the news of her immense loss is, of course, wholly justified and intelligible in human terms, but its form and rhythm move it close to the extravagant excess of comic collisions. The pertinent phrase "It took everything out of her" pushes us both positively and negatively: one could apply it with equal precision to giddy fatigue or unendurable emptiness. The imaging of excess in our moments of creaturely reduction can create mirroring effects of a ghostly kind between the tragic and comic realms. The perceptual labor belonging *strictly* to each realm can grow confused.

What does du Maurier's baffling title, "Don't Look Now," with its prohibition against seeing "just yet," have to do with Laura, at this devastating point of contact? Would it make the least difference to Laura had she been spared the out-of-control, unbuffered response to an awful sight that comes with ill-timed looking? In effect, Laura stumbles into knowing (as many of us do) without any advance warning, without any chance of cover. Caught entirely off-guard, she might be said to take in too much at once, in a single jolt, and she comes undone because what is shown is not only terrible as disclosure but immoderate in presentation. There is a ghastly unseemliness here as moaning, mud-covered John bears the child toward her, as if to offer her up. Tragedy often unveils itself this way, as a quivering obscenity, an offense to eye and mind together, something that seems *brutally* angled (by some malevolent force) in its delivery and reception. Shouldn't some humane covering be available? Couldn't one at least be sitting down and gently told, so the hideous news could be absorbed,

by slow degrees, with a measure of privacy—rather than in this merciless, disheveled, out-in-the-open assault? Are dignity and social forms of any use at such times? If there is a cold joke disguised in du Maurier's title, it has to do with seeing—even of such soul-shriveling finality as Laura's—remaining partial. What you are seeing, if you look *now*, is disguised and confused, no matter how much suffering it brings with it. You never get to see the pain whole or clear, however much is in view. There is something further that must be seen if the disaster presently set before us is to be made clear—in its true, full relation to us. Whatever we see "now" is seen askew. We are not properly placed in time to make sense of it.

As has often been argued, film has only a single tense: the electric present. Whether we are in a flash forward, flashback, or the designated narrative present tense, we always have a "now" relationship to what we are gazing at in film. The sense of the present can be conceptually adjusted, made teasingly deceptive or otherwise tampered with, but it never really gives way. Film irrepressibly favors the immediate experience. The injunction not to look "now"—as though some better time (a safer, more privileged vantage point) might become available and we should delay our attentiveness until then—hints at Roeg's intention of making the filmic present a slippery place to be. He cannot do away with the present, but he finds a way to turn it into a provocative, *insistent* perceptual puzzle. From the very outset, *Don't Look Now* sets us eerily adrift in time, the link that fastens space and time together onscreen seeming to have come undone: two children are playing outside and a seemingly married couple performs activities separate from one another indoors; are these happening at the same time? The children may be in the couple's past, or in a distant location. A first-time viewer may entertain the possibility that the two pairs occupy a discontinuous timeframe. Does the childhood episode happen before, after, or concurrently with the indoor conversation? Does it have a fantasy component? Perhaps the children are directly connected to the couple's own childhood.

John and Laura begin their first conversation in the film by pondering a question posed by Christine. She has been perplexed by the fact that a frozen pond could be flat if the world is indeed round. Contained in this innocent query is perhaps a premonition about the child's own drowning, and a linkage of the pond with the roundness of recurrent

circling. When Laura finds a satisfactory encyclopedia solution (one that closes the gap between scientific fact and perceptual error), John distractedly declares, "Nothing is what it seems." In between her book search and his response to the "little mystery," we observe Christine outside quickly stepping into a puddle; her brother riding his bike over a large, sun-streaked piece of glass, smashing it, and falling off his bike; and John looking up from the lightbox on which he has been concentrating, either in memory-thought or intuitive *response* to the accident. The first-time viewer feels that she understands what is happening in each of the discrete shot "shards" but lacks the key to draw them together. Vivid, isolated acts like the child splashing the puddle or the glass smashing seem to have a *surplus* significance beyond what is manifestly going on. A threat, linked with not knowing, gathers urgent force as we are propelled from one sighting to another. The hypervisibility of the details conjoins oddly with a sense of being blind to what they are expressing to us. We can't settle for an awareness of recognizable event fragments or restricted (because so obviously incomplete) cause-and-effect revelations. For example, not long after the boy tumbles off his bike we find him checking the front tire for damage. While he is engaged in this work, we hear in the background the voice of a soldier doll young Christine has been carrying around with her ("Action man patrol, fall in!"). Hearing the sound, the boy looks off to where the girl is standing near the pond in the distance, reestablishing spatial continuity. We can connect the two children in space, but we don't know what to do with the element of distance and separation. The boy is momentarily attentive to her whereabouts, but he doesn't keep her in view. The bike matters more.

Does his brief alertness make us more anxious than if he had not glanced in her direction at all? "Nothing is what it seems": appearances and casual linkages aren't enough to convey the sense of what we are witnessing. Because time does not run smoothly (and hence intelligibly) in this sequence, we feel that being out of sync with time is the major obstacle to setting actions and relationships in their "proper," clarifying order. If the time problem is sorted out, or if we learn to adjust to the unusual temporal rhythm, we will in all likelihood gain the knowledge and the emotional orientation required to enter the film and be part of it. For now, though, "timing" (the "where-are-we-in-time" question) has the power to retract meaning that spatial

navigation has apparently given us. At the opening of the sequence, we heard a non-diegetic musical theme played uncertainly on a piano. A child seemed to be in the early stages of practicing this piece. The rhythm was hesitant, broken. Images seeking their full relation in time are akin to the piano piece being slowly mastered. When it is adequately rehearsed it will be played straight through—without lingering "blindness" about the placement, blending, and succession of notes. Although time is running interference with space, form itself strikes us (whatever our perplexity) as resilient and somehow autonomous. For all of the slip-and-slide of our grappling with temporal and spatial "out of jointness," the form that we falteringly try to comprehend possesses a secure solidity in advance of our arriving at it. The pattern confronting us feels dense and strongly articulated. Our task is to catch up with it somehow, so that we can be inside its flow rather than spectators held at a distance.

When the boy is shown running around the pond toward the house, the man inside (ah, it is *the same* house!) coordinates his own movements with the boy's (who has not yet arrived with his news). We instantly know what he has to report as we catch a glimpse of the body of the girl in the red coat sinking into the water of the pond. When the man leaves his home and breaks into a full run (matching the boy's), we have the sharp sense of time snapping back into present tense. The elaborate pattern converges with our previously blocked effort to bring the disparate visual realms and the jagged editing rhythms together. We suddenly behold a *familiar* (however disconcerting) family crisis dynamic. A father reacts quickly to a sensed emergency involving his child. What is most peculiar about the knowledge transmission at this juncture is the competition of rising dread (a young girl is drowning) with the relief that attends getting a clear grasp of the total situation. The extreme disorder or rupture brought on by a terrible accident is peculiarly balanced by the uncanny sensation of moving with assurance *inside* the movie world at last. We exchange the pent up agitation that comes from registering points of possible menace and confusion over too wide a field with the release of "being sure." *Now* we know where we are, and the drowning of Christine, while a large price to pay for a more stable orientation, seems like a fair trade-off. To phrase our discovery as a punchline: death is our reward for learning how to see.

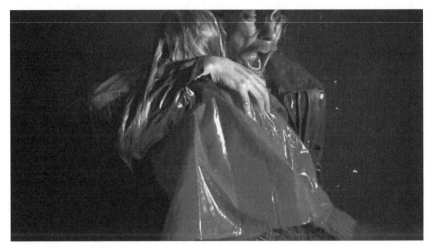

Too late to save his daughter Christine (Sharon Williams) from drowning, John (Donald Sutherland) raises her body—in a repeating moment—from the pond in *Don't Look Now* (Nicolas Roeg, Casey/Eldorado/DLN Ventures, 1973). Digital frame enlargement.

When John finally catches hold of his daughter's body underwater, we watch three times as he lifts her out—a triple view, as time gets briefly jammed at a single point of trauma and repeats itself. For all the replenishing surge of air and light, there is no bringing Christine forth; the day refuses to let her back in. The overdetermined emphasis on rising up, with the gasping for breath and the secure clasping of the found child, briefly casts the apparent sense of the image in doubt. Repetition tells us, contrarily, that the action cannot be completed "in time." The water will not free John or Christine from the tenacious grip of its insuperable logic. And is there not a joke attempting (with scant hope of success) to convert the terrible redness of Christine's shiny coat into a reminder that it is waterproof? The coat is like a talisman in a fairytale: wear this and you'll stay visible and safe. When John later plays hide and seek with flashes of this red coat in the labyrinth of Venice, he and we are enjoined to *trust* the teasing sign. We see it as a guarantee of Christine's lingering presence in the outer world, and feel that John would do well to overcome his rationalist misgivings and pursue it.

In Buster Keaton's very first independent short, *One Week* (1920), there is a memorable double-turn about misdirection. The wretchedly ill-constructed house that Buster and his wife have assembled must

be transported elsewhere immediately, since it occupies the wrong lot. As they tow it by car to its rightful location, the misbegotten, endlessly unlucky product of their labor gets stalled on a railroad track. Having expended as much energy as they can to get it free before a fast approaching train arrives to demolish it, husband and wife resign themselves to the inevitable. They stand back, hug one another, and avert their gaze from the impending catastrophe. They are spared this outcome, however, by an unforeseen circumstance. The visible train was, in fact, approaching on a separate, parallel track. The house hasn't been touched. As they (and the spectator) register equal surprise at this unexpected reprieve, a second train, hitherto invisible to us, enters the frame from the opposite direction and crashes through the house, producing even more spectacular damage than we had originally foreseen. The comic payoff is doubled by giving us the result we had predicted (and, with mixed feelings, wished for) but not at the time that had been designated, and not in the manner that the converging forces rendered inevitable. The failure of Keaton is somehow more splendidly gratifying by including in its unfolding an interval of protection and accidental triumph that we are given just enough time to resent (as a broken promise of assured disaster) and to realize we couldn't really tolerate.

There is a stoic recognition at the heart of much slapstick comedy that whatever losses the hapless hero suffers, whatever is destroyed in his life, can be of no enduring consequence. He must shrug off disappointment quickly, let go the most recent defeat without a trace of lingering regret. What is the idea of fate in *Don't Look Now* and what kind of dissembling does it rest upon? Roeg's film world seems divided up between an exceptionally strong ordering principle, at the level of form, and a tilt toward senselessness and gruesome mistiming at the level of lived experience. Yet as we have seen in the opening sequence, our way of absorbing slipped, missed, or drifting time can be repaired. Our initial sensation of being *left behind*, disconnected, as we labor to piece together bewildering character actions in weirdly split settings pleasingly gives way to full synchronization as we join the father in his decisive rescue attempt. We gain ground and become clear-sighted just at the point that emotional focus of the most difficult sort is required of us. The moment-to-moment struggle of the father to locate his daughter in the pond, resuscitate her, and then carry her lifeless

body home is emotionally saturated for us as we are suddenly let in to the action, and able to experience it without any residual barrier.

Our searing but tenderly intimate involvement in John's hopeless task can convince us that the film's *order* is allied with a humane perspective. We combine two modes of seeing: the events finally match up and fit together for us (rational comprehension) and we see empathetically all that a couple's dawning sense of irreparable loss entails. We could hardly be brought any closer to a family's tragedy and its inner vibration. So we stay with the *idea* of order in the film as it continues to be articulated powerfully (in the subsequent emphasis on shot linkages, visual anticipations, and echoes). Our narrative placement becomes more secure than it was in the film's opening, but we feel that the pattern we are working with is being elaborated somewhat ahead of the spot where we happen to be situated. We are given steady projective glimpses of actions and details that we can't quite figure out, but the enrichment of the design does not seem opposed to the couple's efforts. Order and form, that is to say, appear to be *on the side* of the couple, as they slowly draw closer together and try to recover their equilibrium. Naturally, as the film moves on, their recent calamity is still present in the minds of both of them, "quivering" in the past-haunted Venice air. If we apprehend "order" making gains in the arrangement of images, in large and small ways, we associate that order with the couple's advance in rehabilitation, their exertions to rejoin life as a pair.

We are by no means certain that either John or Laura will be saved from the peril that seems gathered against them in the Venetian labyrinth. In a manner befitting a labyrinth, the couple seems stalked by threats from many directions at once. But whether they are ultimately doomed or whether they will decipher the tapestry of warnings and omens they are confronted with "in time," we are encouraged to feel that "form" works in concert with John and Laura's emotional recovery. The mystery encircling them wants to be solved, for their sake; it depends on their coordinating separate kinds of detective work. John wishes to proceed rationally, Laura intuitively, and we can't readily dismiss either of their claims, or the needs (born of different ways of mourning) that give rise to them. Love, as the form of the film expresses it, includes, as one of its aptitudes, higher, more far-reaching sight. If the couple is destined to lose their battle, form will not stand

separate from their defeat (indifferent to it) but instead will enter into their suffering and honor its significance.

As it turns out, form is secretly, cunningly elaborating a negative pattern, an inhuman triumph that operates equally against the promptings of John's besieged logic and Laura's countervailing intuition. The form *knows*, as it were, from the outset that John can't be saved. He is finished—within the trap of form—before initiating his first move, or making a single free gesture. What he is able to understand "in time" is irrelevant. The form of the film *demands* that John misconstrue nearly everything that has bearing on his survival; only in dying will he be properly fitted to the temporal design constructed around his necessary blindness. Seeing is hauntingly and ironically belated; none of the countless, ephemeral *nows* that John tries to absorb and that make up his narrative existence can take him off his preordained path or alert him to the true crisis that shapes his end (an end, in fact, already shaped). It is as though the events we have regarded as belonging to John have all been taking place behind his back, and behind our own. He interprets what is happening, but the actual meaning of his efforts is accumulating elsewhere, screened from his always too limited, misdirected probes. He has a near brush with death, for example, in the church that he is working to restore, and he naturally imagines that he has time to reconnoiter and make fresh assessments of Laura's warnings to him. But his being saved here does not really supply an opening to an undetermined future. The action is telling him, if he could but hear, that his real, imminent death will draw upon similar materials: a church; a height; isolation; a sudden, outrageous surprise.

The film's form is comic to the extent that every gesture of reprieve it vouchsafes is dissembling, and that its governing perspective is serenely detached from the shuddering loss it depicts. Form registers the loss of John ornately, as material for an impressively complicated picture (as though a religious painting were painstakingly executed to reach and uplift the faithful but the artist had no faith of his own to draw upon). The death foretold is as intricately engineered as the arrival of the second train in Keaton's *One Week*, and in both cases the destruction, when it arrives, seems of no human consequence. The life that passes before John's eyes, after he is stabbed, seems recognizable in its pieces, but not in its ordering. Form proceeds with its patterns, but they are not for us. The patterns supply neither help, acknowledgment

of our striving, nor consolation. "Nothing more to build on here," the form declares while bringing to a close its impersonal dictates. We apparently make headway against impediments, foreign and intimate elements confronting us with barriers and invitations as we press forward from one mysterious destination to another, but as we wrestle with formlessness—lawlessness in relation to our present, often inopportune, direction—form of some kind may be taking shape out of our perceptual reach. We plunge forward, and may not return, may not have any more chances left. I am reminded of the late Nietzsche fragment: "To see the shipwreck of tragic figures and to be able to laugh, in spite of the profound understanding, emotion and sympathy one feels, that is divine" (Wood, *Road* 169).

The Venetian church has its broken mosaic pattern that John scrutinizes and attempts to repair as a means of gaining distance from his own pain. He needs to be able to control *something*—with the patient exercise of knowledge, love, intuition, and discipline. Within another church, at the end of the film, an old female face expresses refusal: its owner shakes her head and mirthlessly smiles at John before directing a knife stroke unerringly at his neck. John has done his best, by turns, as a rationalist, a determined seeker of his "lost" wife and child and one finally open to messages from beyond; but none of his roles and endeavors can cure the blindness that in this film seems to be equated with life itself. "The divine laughter" that Nietzsche alludes to seems to pass through understanding and sympathy like a forlorn mist en route to transcendent high spirits. The laughter issues from a place from which feeling and struggle (in their stiff and straining aspects) have vanished. The door is closed on these pictures of striving amidst the living. As light and free of meanness as a child's laughter when lost in play (Christine leaping toward a puddle with curiosity before it has become a pond), laughter aligns itself with a form that firmly discounts John's intentions, whatever they may have been, and leaves him behind. Laughter purges the new linkages that suddenly seem available of their *need* for any continuing connection with us, with John.

Lionel Trilling once memorably reflected on the famous parable of the appointment in Samarra. After encountering Death in the marketplace of Ispahan and seeing that dark familiar make a "threatening gesture" to him, a servant flees his fate, riding off in fear to Samarra (the very city where Death had an appointment to meet him). In the

market, the servant misconstrued Death's expression of surprise for a threat, as Death later confides to the servant's master. He hadn't anticipated coming into contact with the servant in Ispahan, but he was fully prepared to claim him that evening, in Samarra. Trilling contends that the parable's outcome "offers nothing for the mind to engage" (43). One can only respond with an "ironic shrug" to the recognition that "the joke was on him," this hapless man "without dignity" who also proved himself a "servant" in his double error of sight and futile calculation (43). I'm not certain that Trilling is right in his casual dismissal of the tale. The central moment when the servant misconstrues an expression of surprise as a "threatening gesture" carries with it the faint alternative possibility of the servant giving death the slip by not reacting in fear but staying put. Death *might not* take him if he did not turn up where he was expected (or "fated") to be. What engages the mind in the Samarra parable is the tingling possibility of reading death's expression differently, in such a way that a favorable result might be attained. Is it conceivable that one could "know in time" how to look with self-possession at death in a chance encounter, and survive?

John Baxter also becomes "fate's fool" when he mistakes a dwarf for his dead child—a muddled slayer who had nothing (yet now everything) to do with him. How, in the ironic scheme of *Don't Look Now*, does the imposing order that closes in around John's ignominious death in Venice teeter between a preservation of his "dignity" and a forfeit of it? And to return once more to Trilling's question, how does the mind of the viewer "engage" with John's death, which will not quite allow the term tragedy, no matter how much we are moved by it, but whose powerful *effect* of significance will not entirely disallow it either? John walks toward his doom with his eyes sealed but also with all the best parts of himself open. It is John's vulnerable, fully receptive, courageously roused-to-action state that is shockingly negated and laid low.

To solve the riddle of how we are to engage mentally with John's fate, we might turn our attention to the great love scene that occurs at the film's center (its emotional midpoint). Vincent Canby, in his review for the *New York Times*, erroneously described the cross-cutting strategy that Roeg employs in the love scene as "essentially comic" (Sanderson 21). Canby's misreading is instructive. We are obliged to sort out and choose between two discontinuous timeframes in the

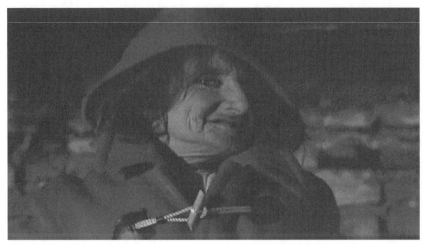

The female dwarf (Adelina Poerio) lets John in on the horrible joke of his mistaking her for Christine. She smiles, and shakes her head, before killing him. Digital frame enlargement.

lovemaking segment, one of which appears to be the truer—that is to say, the time in which we should strive to place ourselves to gain the fullest perspective on what is transpiring in an actual present. In one, John and Laura, in an ecstatic trance, are moving forward in the throes of sexual intimacy. We have reason to suspect that this is the first occasion when they have successfully joined together in love since Christine's removal from their lives. In the other frame, John and Laura are dressing and preparing to go out for dinner after they have concluded making love. It becomes clear, fairly early in the depiction of their preliminary embraces, that the sexual act precedes the retrieval of clothes and the getting ready to go out, and thus constitutes a *past* in relation to the future (which is also a wobbly present) of the couple's postcoital activities. The problem with this sensible division is that the "past"—to which we keep returning—is still going forward, and the unsettling power of this achieved togetherness is visually and emotionally stronger than the bits of less coordinated action that continue to "interrupt" it. The present of the sexual act is not *done*, even though the chain of ordinary gestures and tasks to which John and Laura turn their attention intimates that they are well on their way to leaving their beautiful, fragile, effortless closeness behind. Mentally, emotionally, they are still very near it, dwelling within its aura, as it were, but with

　　　　　　　　　　　　　　　　　　　　　　George Toles

each further step toward the domain of separateness (which includes separate consciousness and isolated behavior, the pronounced reassertion of private concerns, unobserved movements, and expressions) it slips away from them. Their memory can't for long secure their place *within* this vanishing act of loving.

What Canby found comic, no doubt, was the "where are we?" dimension of the viewer's (and couple's) predicament. We aren't allowed to settle in to the event that we naturally wish to be part of. Our view of the lovers is teasingly obstructed, suggesting that the lovers can't hold on, for any meaningful duration, to the shared well-being that they have found. "It's over and gone before you know it," is the skeptic's deflating verdict, and joke. "We've finished fucking, now when are we going to eat?" Roeg's cutting might seem to set itself in opposition to the lovers' fervent, poignant clasping of each other *now*, in a Venice hotel room at the end of the season. The room is suffused with a melancholy blue tint that conveys the sadness they are bent on overcoming. (Even the hotel proper wants to shut down; its furniture is mostly covered with ghostly sheets.) Certainly, it seems likely that the cross-cutting tactic would eventually establish a tension that works to separate us from the oblivious lovers. If we are too detached from them, the force of their coupling as a momentous thing in itself is reduced. A highly fragmented treatment of an event deprives it, minimally, of stand-alone value, and the integrity of its little space in time. We might decide that there is a slow drift in the pair toward lonely isolation and preoccupation as we take note of their various reflex adjustments: John checks the clock, drinks whiskey from a glass, and registers the sharpness of its taste while sitting, elegantly attired in shirt and tie, on the edge of the bed. We observe Laura in the bathroom doing her lashes and, later, reflectively holding a lipstick dispenser to her mouth. If we are so inclined, we can apprehend the automatism of habitual gestures, with their accompanying mild fatigue and scatteredness. Logically, cross-cutting seems to pull things apart, to insist on discontinuity, rupture, and difference, which distinct timeframes would only accentuate further.

Yet I would argue that, against the implied *fact* of splitting, a subtle sympathetic cohesiveness is achieved and sustained throughout the sequence. John and Laura have spent a long time searching for one another, from their respective islands of grief. On this bed, in the fading

light of late afternoon, it suddenly appears a perfectly simple matter to reach out, touch, and find the stranded partner again. The relief of mutually recovered presence spills over the boundaries of their lightly desperate, grateful holding and stroking. The after time (of dressing, primping, waiting), the time of returning to themselves as disengaged, slightly lost beings, is irradiated with the glow of their still happening, accelerated finding. Further and further, toward and inside each other they go, and in the necessary turning away, the departure from this bed and enfolding unity, they somehow carry the astonishing certitude of their reconnection. Thus the intensity does not seep away as they are shown resuming their private burdens. Their lovemaking is paradoxically both behind them, something to marvel at in a pleasing daze, and ahead of them, demanding their full involvement. When John and Laura finally leave the room arm in arm, they manage to take everything they have exchanged there with them, as though continuing the charmed act, the lovely spell of moving toward it.

The grotesque, stifled comic and ironic elements of the killing scene reinforce our sense that John's own sense of his life while living it hardly figures into the unyielding mosaic pattern that is so swiftly being assembled. He took nearly everything that passed before him the wrong way, it would seem, as did we. Every sighting was a falling short; so many telling details were overlooked, left out of consideration. We saw, but strangely did not see, or never saw sufficiently.

Playing against these many wrong turns of sight are recurring images of Laura, including a feral image of John and Laura *still* making love in their hotel room. The ongoingness of that singular episode flows with unabated fullness through this one revived image. The human connection established in that piece of lost—and repeatedly regained—time reaches out to other timeframes in the montage. John's dying builds positive Venetian bridges through his many ways of seeking out, taking hold of, even literally calling out to Laura in the final labyrinth of images. She looms larger in the mosaic than he does himself, and it is as though the mental energy left to him while his blood drains out is used to ratify her loving presence in relation to him and to give her the means (a better second sight than his own) to perceive and absorb the message: but a single audible word inside his paroxysm of fading vision. He cries Laura's name as a funeral barge sails past beneath him and he watches, transfixed, from a bridge.

Laura (Julie Christie, c.) and Wendy (Clelia Matania, l.), the blind seer, on the *vaporetto*, as John's body is transported to his funeral. John's second sight enabled him to see this incident in advance, but (comically and tragically) he misread it. Digital frame enlargement.

Christine, for her part, has merged (as one dead but not gone) with the murderous female dwarf, who can only cut down what approaches her. The dwarf Christine is unappeasable, as well as unreachable, in the manner of all dead things. Saving Christine from a second death, in Venice, was a false (but inescapable) fantasy for John and Laura. How could they not need to keep the child alive in whatever way lay open to them? Will they not find her somewhere in the maze of their grief? John's grief is painfully clenched, Laura's is painfully open, buffeted by every chance reminder. The grotesque and horrific turning round of the dwarf—and the beholding of her ancient, indecipherable, malevolent features, mimicking those of a church gargoyle that John had hoisted into place earlier—transforms, rapidly, into a turbulent, rushing sadness. The harshest moment in the montage occurs when John encounters Christine's face in his delirium and it appears as closed against him as the dwarf's, in spite of the futile risks he has been driven to run on her behalf. Part of the message that John would convey to Laura, were it possible (in his cascade of farewell images), is that it was just too much. The load of Christine that he lifted out of the pond was too great for him to carry. Without his quite seeing it, he had done nothing else since, had never been able to let her go.

Time's Timing and the Threat of Laughter in Don't Look Now

Laura smiles enigmatically in close-up as we catch up with her on the funeral barge. This is the *vaporetto* we saw before at John's side, gliding down the canal with Laura and the English tourists Wendy and her blind seer sister Heather aboard. We wondered where it was going and why. Obstructions to hearing and perhaps seeing in time have, for a stretched instant, been removed. John's voice has now penetrated ("Laura!") and he has made contact before it became too late and she passed out of view. It is smooth sailing for the barge now; we understand its business this time through. As this barge passed earlier, John was seeing the future. When the barge reaches the steps of the church, everyone on board begins the long ascent to the building, except for Heather, who is accidentally left behind by her preoccupied sister. Wendy soon goes back to the *vaporetto* to collect her neglected, waiting loved one (a necessity to her life, its primary definition, and an aggravating chain of obligation). We witness the comic miming of our general human quandary as Heather takes a few halting steps toward this funeral-in-readiness. We may recall now, as we reach the very end of *Don't Look Now*, the good news from "beyond the grave" that Heather brought to Laura during their first meeting, when both women were so trustfully eager to be of help to one another: that she has *seen* Christine, and the child was "laughing, laughing." As Heather takes her hesitant steps toward John's laying to rest, Christine—we are at liberty to imagine—lightly trips off. In the midst of all the film's fated, mournful heaviness, there is also a vagrant, groundless freedom, where love and time get their messages through, and both, in the spirit of comedy, are as light as air.

MURRAY POMERANCE

The Gangster Giggles

The cheaper the crook, the gaudier the patter.

Spade, in *The Maltese Falcon*

My argument here rests upon the proposition that like other oral enunciations made socially, laughter is linguistic. It is one of those productions of the body that interactants feel freely compelled to interpret for the meaning of its descriptive nuances, the detail of its contextual placement, and the emphatic value it adds to articulated language. Thus, quite beyond its function in psychodynamic release (what Freud would call its permitting of repressed aggressiveness through disguise [153 ff.]), the laugh moment can be read and interpreted as a brief song of situated meaning. Glottal, enunciatory, rhythmical, and syntactical, laughter is accorded the character of an utterance and attributed with purport, indeed identified—typically, one might add, as commentary on eventful conditions or on other linguistic sounds that come before or after. Bruno Antony (Robert Walker) guffawing at length beside his confused mother (Marion Lorne) in Hitchcock's *Strangers on a Train* is offering critical judgment of her painting (of St. Francis, as she would have it, although he sees his own father). Given the flexibility of speech to shape itself to unfolding happenings, and to camouflage or exhibit

With thanks to Lester D. Friedman, Adrienne McLean, and Martha Nochimson.

itself in contextual surrounds, it is problematic to accept at face value Henri Bergson's quest for the unitary "basal element in the laughable," the "common ground" that we can purportedly "find between the grimace of a merry-andrew, a play upon words, an equivocal situation in a burlesque and a scene of high comedy" (61). Or, perhaps the basal element is a mere matter of muscular contraction. I sat one day as a guest in Marshall McLuhan's tiny seminar, and there came a moment, when suddenly he raised a book to show the class—rather, thought I, like a touter in a television commercial waving his product in hunger for a sale—that I burst into laughter. "Why are you doing that?" he snapped, gazing intently into my eyes. "I'm terribly sorry, Professor," I blurted. "No, no, no!" said McLuhan, now with his eyes afire. "I mean: *why* are you doing that? Is it a spasmodic contraction of the diaphragm? Somehow affecting the muscles around your mouth? . . ." And so on. It is fascinating to consider how McLuhan's approach worked both to grasp and to lose the situated meaning of my release.

Oliver Wendell Holmes, Stephen Miller tells us, was careful in his *Autocrat of the Breakfast Table* (1858) to stipulate that the smile or laugh was essential to good conversation. "One man who is a little too literal can spoil the talk of a whole tableful of men of *esprit*" (Holmes, qtd. in Miller 217). The good conversationalist, for Holmes, is good-natured and has a sense of humor. Holmes follows in the tradition of Erasmus, who in *The Praise of Folly* (1511) "ridicules the fanaticism of monks and the pomposity of theologians . . . telling Christians, in effect, to lighten up" (54). In the Freud of *Civilization and Its Discontents*, De Certeau finds "an ironic and wise madness . . . linked to the fact that [Freud] has lost the singularity of a competence and found himself, anyone or no one, in the common history" (4); Freud, then, has become ordinary, and the taste of ordinariness produces a laugh. As we will see, for some significant character in cinematic narrative, the laugh functions as Certeau's *perruque* (wig): it is work performed for the self, to humanize the self, in such a way that it appears to be addressed to others (a gang) in a context dominated by them. Time is diverted "from the factory," that is, the site of socially organized labor, "for work that is free, creative, and precisely not directed toward profit" (25).

In the end, utterances have meaning that is not fixed to the abstract form of a common code but inheres transformatively in the

play of speech—who performs it, when and where, with what timing, intonation, timbre, melody, inflection, posture, and pose. As Paul Goodman reminds us in *Speaking and Language*, "The 'person' who speaks is largely made of words—*persona* is an actor's mask equipped with a megaphone—so he must find that his experience is largely verbalized, for he puts words into what he experiences and therefore finds them there. Personality consists (largely) of one's speech habits—learned because they have worked in spontaneous acts of speech on many occasions—plus the introjection of the common code, mother's and father's voices, voices of childhood peers, and social institutions" (75). Free to a significant degree from the constraints of definition, and working as language, laughter retains the powers of invocation and the music of feeling.

Outside of gag situations, laughter is something frequently elided onscreen. In open-mouthed laughter, the face is not at its most photogenic, and as a dramatic possibility the laugh is perhaps too full of implication, too likely to seem like mockery, since viewers do not participate intimately and directly enough in the consciousness of the laugher to be truly sharing the humorous inspiration of his moment. We are always "outside." As a performative stratagem, laughter has its own problems: it rapidly and automatically emphasizes, even where emphasis isn't desired, drawing an excess of attention to one's characterization. The laughing character is always, while laughing, a distinctive "I." We do find laughter, but not frequently, and not in an elementary way, the way we find walking, staring, kissing, shooting guns, smoking cigarettes, driving cars, rolling over in bed. This is true even in comedy. In *You, Me and Dupree*, Owen Wilson makes an entrance to the home of Matt Dillon and Kate Hudson with a huge moose head under his arm. The moose is grinning, and when he sets it down all our attention goes there, away from him. In non-comedic film, moments of outright definitive laughter are distinctive and special merely by virtue of their existence, and are almost always accounted for by some diegetically established deficiency of character or press of event: at the end of *Swing Time* (1936), Georges Metaxa is laughed at first by Victor Moore and Helen Broderick, then by Fred Astaire and Ginger Rogers, because he can't find his pants; in *Citizen Kane* (1941), Dorothy Comingore giggles because she is on laughing gas, and Orson Welles giggles back to be entertaining; James Mason

laughs at Judy Garland's "new face" in *A Star Is Born* (1954) because he has been taken completely off-guard; Akim Tamiroff's pathetic wheezing grins in *Ocean's 11* (1961) betray his generally insipid obsequiousness; in *The Manchurian Candidate* (1962), Khigh Diegh laughs about yak dung, but he is attempting in a formal "comedic" moment to win over a suspicious audience; Anne Bancroft's derisive grins at Dustin Hoffman in *The Graduate* (1967) make plain her regrettable condescension; Strother Martin laughs uncontrollably in *Cool Hand Luke* (1967) because he is demented; in *Batman: The Dark Knight* (2008), Heath Ledger laughs out of psychopathy, and so on. Most typically, film characters behave as though their situations are always to be taken seriously, while *we* are permitted, from our removal, to laugh in judgment or recognition or discomfort. Gravity, indeed, is the prevailing dramaturgical tone in cinema.

This is especially the case, indeed, in gangster films, where strangely—because, pretending realism, these movies claim to depict persons who are "actual" and "truly situated"—laughter almost always seems neurotic and excessive. Not only do most screen gangsters not generally laugh, they are typically dour, melancholy, bitter, anxious, fearful, cautious, and aggressive. Further, gangsters and gangsterism imply seriousness, invoke seriousness, and beg for seriousness in critical consideration, as we see from Thomas Doherty's (witty) report of the anxiety felt by Will Hays and the MPPDA at the possibility that John Dillinger might gain popularity with viewers even through straightlaced depictions on film. Further, after Dillinger escaped from confinement in Crown Point, Indiana, "motion picture audiences chortled when a slow-talking garage attendant named Edwin J. Saager went before Pathé News cameras to tell how Dillinger took him hostage during the brazen jailbreak. Inspiring 'more laughs than chills' with his droll account, Saager recalled that he thought Dillinger was kidding at first" (137–38)—in short, Saager found Dillinger as serious as could be.

We expect gangsters to signal their nefarious intent or character not by way of chuckles, guffaws, and giggles but through narrow ocular focus, aggressive movement, brutish attitude, posturing in shadow, and so on. Thus, typically screen gangsters speak in order to command, direct, and threaten more than to comment, evoke, or vent. Think of George Raft in *Some Like It Hot* (1959), arranging for a mass murder in a garage; Broderick Crawford in *Born Yesterday* (1950), verbally pushing

his girlfriend, lawyer, barber, and pet senator around; Al Pacino in *The Godfather* (1972), calmly introducing his fiancée to the dark workings of the Corleone clan as they sit at a shadowy table at a wedding in the sun; James Cagney "chewing the scenery" (Messenger 248) in *The Public Enemy* (1931); Edward G. Robinson in *Little Caesar* (1931); the ratty Humphrey Bogart desperate to get out of his skin in *High Sierra* (1941—a part the actor keenly wanted to play [Bogart to Wallis, 4 May 1940, in Behlmer 127]); Pacino again in *Donnie Brasco* (1997), assassinating a former co-worker (Bruno Kirby) now suspected of being a police stooge; Robert De Niro in *Casino* (1995), haggling with his wife (Sharon Stone); or that prince of curmudgeons, Lawrence Tierney, as the malevolent Sam Wild in *Born to Kill* (1947) or the prototypical public enemy in *Dillinger* (1945); even the buoyant Johnny Depp as a pensive, morose, hopelessly tender Dillinger for Michael Mann (2009): all these are men who are taciturn, depressive, and darkly introspective in their presentation of self and their action within the story, dark and essentially silent and profusely serious. Perhaps too dark, silent, and serious: Edward G. Robinson wrote to Hal Wallis that he'd agree to do the gangster part in *Brother Orchid* (1940), "but I feel that I should not be forever circumscribed within these limits. I want the gamut broadened, not from conceit or actor's temperament, but in order to do justice to my capacities, as a whole" (20 October 1938, in Behlmer 82). Against these brooding, negative types, the figure of the giggling gangster, he who couples violence and abuse with a smirk, a joke, a moment of intentional irony, or an outright laugh can stand out with the contrast and clarity of a flamboyant virtuoso in a big band.

The gangster's laugh can testify to an ultimate and transcendent humanity (think of Warren Beatty's boyish smile in *Bonnie & Clyde* [1967]). Pascal thought that man's intellectual capacity was limited, but his "greatness," man's ability to see himself, was beyond intellect. "Man knows that he is wretched. He is wretched, then, because he is wretched; but he is great, because he knows it" (*Pensées* 6, 416). And further, we can stand above our circumstances. "Were the universe to crush him, man would still be nobler than that which slays him. For he knows that he dies and that the universe has the better of him. But the universe knows nothing of this" (347). Pascal could be writing here about the end of *White Heat* (1949), when Cody Jarrett (James Cagney), his life undone, his beloved mother gone, his world reduced

to a memory, stands at a chemical plant with a berserk grin on his face and fires off his machine gun at the abysm that is the camera (on berserking, see Farrell). The gangster's moments of laughter, few and far between, seem directed not merely at the limited and degrading social reality of his predicament, in which he is manifestly not equal to other men because he has stood up against their values and proscriptions, but at a frame of reference that is universal and harmonious in Pascalian terms. The gangster laughs because he knows he is only human, whereas society laughing *at him* is a way of condescendingly rejecting him as alien. The gangster's giggle is thus a kind of existential discourse upon the self *sub specie aeternitatis*, a language that only universal forces can fully comprehend and the ultimate response to which is, and must be, his own death. That death, and its proper place in the scheme of things, is what the gangster is giggling about.

Being linguistic in form, laughter is musical and can be textually coded. It is probable that no two vocalists laugh in exactly the same way, and implicit taxonomy and explicit mimicry of a person's laughing style can be a basis for discourse or for art. As to the former, the comedian Shelley Berman once created a taxonomy of laugh styles and used it as the text of a performance on "The Ed Sullivan Show"; as to the latter, the composer Luciano Berio composed laughing arias for his partner Cathy Berberian, in which her pristine soprano voice raced up and down scalar tonal passages. Written in Hebrew, "a-ha" can be found as far back as Jeremiah, coming out of the "mouth" of the Lord. "Ha-ha" is attributed in the O.E.D. as far back as the year 1000, with further variants dotting usage in the Middle Ages. For thousands of years we have indicated and referenced laugh moments as textual points, notating and sharing them in, *and as*, language. In "The Honeymooners" (1955), Ralph Kramden (Jackie Gleason) repeatedly issued a sarcastic and critical laugh, a laugh that was the negation of laughter, by bellowing "Hardy har har!" In film, the inscription and textuality of the laugh are done by way of an actor's posture and enunciation in performance: the laughing face is "inscribed" for (and in) us through being entered as a brief glimmer on the screen.

The gangster's giggle is rare onscreen. Prototypically, the more powerful he becomes, and the more he can demand or produce the suffering of others, the more seriously he seems to take himself. For the gangster who commands, brutalizes, and exploits his world, nothing is

explicitly funny, everything is business. Forced to potency, gravity, and introspection, he is a merchant whose cheek muscles won't contract (rather as though he exemplifies an occupational form of Parkinson's Facies). What generic taciturnity does for us analytically, of course, is highlight and frame signal dramatic instances when gangsters *do* laugh, by making their sneers, chortles, and grins seem potently and revealingly denotative as a form of situational speech.

GANGSTER LAUGHS

The epitome of gangster laughter is Richard Widmark's as Tommy Udo in *Kiss of Death* (1947), frequently throughout the film but most memorably in the famous scene where he straps crippled old Mildred Dunnock to her wheelchair and then shoves her down a flight of stairs. Preparing to execute this stunning act of cruelty, he paces around her apartment, teasing her with questions and comments about her missing son while he erupts again and again into a signature staccato, "machine-gun" giggle that stereotyped Widmark, here in his movie debut, for the rest of his long career. Even if giggling Tommy appears insane in his laughter, the laughter itself must have expressive, rather than just organic, connotation. Through it, he is saying something there is no other way to fully say, leaking his dastardly thoughts, his ugly plan, his relation to this old woman who will give him no information, his status as it is and as he would like it to be. The laugh is a speech act in itself. And acting through laughter, Tommy is expressly *not* killing this woman silently; or acting as a purely animalistic venter whose laughter makes no indication at all. That laugh does indicate Tommy's uncertain self-regard and his matching contempt for the victim and the surround, contempt felt because of his own self-loathing and the accompanying need to raise himself above a scene in order to prompt himself for action there. "The laughter," Richard Widmark admitted with irony, "partially came out of nervousness. When in doubt, I'd laugh. And since this was my first picture and the mechanics of picture-making were new to me, I laughed a lot" (Holston 4). The laugh isn't there to function as a hydraulic that lowers Tommy morally to the level of a killer. He is already always base. Even were Tommy to commit his murder in silence, we would perceive him as contemptibly contemptuous, a moral nadir against which Victor Mature's protagonist, a former crook, can

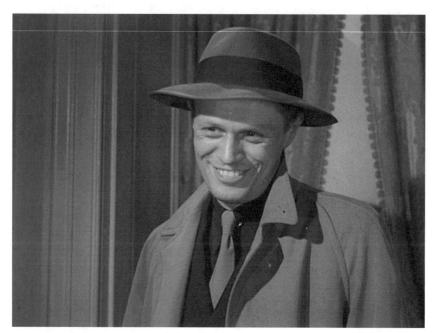

The irrepressible giggle of Tommy Udo (Richard Widmark) in *Kiss of Death* (Henry Hathaway, Twentieth Century Fox, 1947). Digital frame enlargement.

seem to rise in stature as is dramatically necessary. Tommy's giggling bespeaks his own knowledge that he is unprepared, ungrown, and low, bespeaks the perspective of a second fully internalized, fearful Tommy, evaluating the actions his twin is carrying out. The giggle indicates the schizoid situation of doubling and doubting, and also turns commenting upon an action into an action itself. One Tommy nervously paces, gazes, twitches, binds, and hurls while a second Tommy cheers the first one on, keeps the rhythm, does the publicity.

A certain dramaturgical incoherence also aids the curious characterization in Tommy's scenes. He is dressed for business, with a jacket and tie, a nifty fedora, a nice clean shirt. But the degrading and uncontrolled, unshaped energy of the laugh belies the formality of economic exchange, turns Tommy into a clown and a social outcast at once. In Spielberg's *The Terminal* (2004), Tom Hanks uses fractured English to accomplish the same spontaneous eruption and self-exile, moving his interlocutors instantly to categorize, downgrade, alienate, and confine him away from what they deem to be the precincts of

civilization. Tommy Udo's laugh is like pus from a festering scar, revealing the kind of psychic wound we don't wish to reach out and heal but feel, instead, the urgent need to withdraw from lest its effluvium infect and destroy us.

Similarly pathological, yet more eloquent, is Roman Polanski's chilly grin in *Chinatown* (1974), when at the Oak Park Reservoir he corrects Jake Gittes's (Jack Nicholson) nosiness by swiftly slicing open the man's nostril with his switchblade. "Next time, you lose the whole thing . . . cut it off and feed it to my goldfish." It's impossible to discern, as in the evening lamplight and beneath his dapper straw hat this thug forms half a smile, whether his expression of pleasure is a reaction to the neat surgical move he has just made or to the culinary fantasy he is envisioning; whether his smile is aimed at the now humbled Gittes and therefore reflexively at his own crass power, or at the absent—even invented—goldfish who may be presumed to bring a little charm into his sordid life. A centerpiece of cinematic process is the afterimage residue (see Yumibe), our ability to continually "visualize" an image that is technically no longer before us, and through such retention to imagine continuity and motion; here, the nose job is so uninvited, so brutally unannounced, so definitive, and so pointedly emphasized through Polanski's "laugh" that it becomes indelible, lingering in our memories as the film progresses. Gittes now has a brilliant, white, upside-down U of a bandage on his nose, the inversion of a smile, and every time we see him we are reminded of Polanski's malevolently grinning face. "The nose scene," said Robert Evans, "helped [Polanski] exorcise his anguish about Hollywood" (qtd. in Kiernan 243).

Any discussion of giggling screen gangsters must include Joe Pesci's substantial turn as Tommy DeVito in *Goodfellas* (1990), as he yo-yos the uninitiated young Henry Hill (Ray Liotta) at a nightclub at 49th Street and Broadway with a horribly pathological smile. After telling what is unmistakably a joke and producing a vibrant, toothy, natural laugh from Hill, Tommy sharply changes tone: "I amuse you? I make you laugh? I'm here to fucking amuse you?"—this invoking for me a theorization of Darwin's: "Laughter is frequently employed in a forced manner to conceal or mask some other state of mind, even anger. We often see persons laughing in order to conceal their shame or shyness. . . . In the case of derision, a real or pretended smile or

laugh is often blended with the expression proper to contempt, and this may pass into angry contempt or scorn. In such cases the meaning of the laugh or smile is to show the offending person that he excites only amusement" (212). The sweet-tempered Henry is not the only "offending person" in this interchange, however, even if he *does* find Tommy amusing (as we certainly do). Tommy's laugh can be seen, Darwin's writing suggests, as evidence that he finds Henry amusing, and not in a way that can openly be affirmed. Henry is mortified by Tommy's apparent anger now: taken aback, terrified, and embarrassed; and Tommy lets the moment stretch for several torturous seconds before breaking into a grin himself, as though to boast, "Got ya!" In this scene, the dramatic crux of Tommy's laughter is his ability to control it at will, to slice it off coldly or bring it on in full flower with no warm-up or visible development. Through the control of his laugh, Pesci renders it performative and offers his Tommy as a character who can "do" humor without experiencing it: a comedian. Since DeVito is often connected in the film with moments of extraordinary violence and brutality, we get a glimpse here of the dark side of comedy, that those who systematically (and mechanically) produce it need not be either happy or good-natured and might in fact be "laughing" out of a particularly malicious darkness.

More balletic is the icy, mocking silence of James Cagney's Cody Jarrett in Raoul Walsh's *White Heat*. Cagney offers only one genuine smile as Jarrett, this to his girlfriend when he tells her she's so beautiful she'd look good in a shower curtain (a line that might well have inspired Alfred Hitchcock), but his persistent dry wit, entirely a straight-faced production (John McCabe refers to his "quiet, tight little smiles when he discusses his murderous plans as if he were setting up golf dates" [252]) is designed to spice and punctuate a practical approach to everyday life. With a pistol at the throat of a prison doctor in the middle of an escape, he hisses wryly, "No slip-ups, or *you're* gonna need a doctor." What makes this line funny is that linguistically it would fit a number of situations entirely remote from this high-tension escapade: Cody is showing a certain powerful intellectual acumen by thinking to speak it here, offering an ironic comment upon what he is doing, warming the doctor with a little pleasantry that is simultaneously a warning (it doesn't hurt to be entertaining). Cody's

official criminality, as we may think it here, is of a kind that underlies the Hollywood gangster film, which is typically an epic account of an underdog's attempts to rationalize socially unacceptable behavior according to a prevailing moralistic consensus. Jack Shadoian calls him "humanity's last stand in a romantic rage of selfhood" (149). Escaping from prison, Cody schleps along Parker (Paul Guilfoyle), an inmate who had earlier tried to kill him and is now locked in the trunk of the getaway car. Safe, and with the vehicle parked (he's a parker himself), he walks up to the trunk where Parker can be heard complaining about how stuffy it is in there. Chewing a chicken leg, Cody leans over and shouts, "I'll give you a little air—," then plugs the car with bullets. Another moment, another laugh. For Shadoian, *White Heat* is "generally very funny in a callous way": "Walsh remains unfazed by the character's abnormalities, looping many a madcap moment into the drama (Verna spitting out her gum before kissing Cody, Cody chewing on a chicken leg while giving Parker 'some air,' Ma recommending that Evans try *Task Force* at the drive-in—a film Warner Bros. released a few weeks later . . . and dozens of other instances of a crude, lively humor). Walsh's carefree attitude and the absence of a moral context create an unusual mix of brutality and fun more disturbing in the long run than a heavy seriousness" (167). But in the world of the gangster protagonist, everything that is comical is also serious, and so it is that Cody's laugh line—a text that is a derisive laugh—is performed straight; thus by inversion the seriousness of orthodox life becomes nothing but a joke (the criminal's view of bourgeois propriety), and to laugh is to express one's deepest critique of the everyday. The laughing crook is aware of his exclusion, and of the sheer weight of ordinariness by virtue of which he is excluded.

Of *Some Like It Hot* Gerd Gemünden observes that the film begins "in Al Capone's wintry city during the time of Prohibition, the speakeasy, organized crime, and gang warfare," but that "as soon as Joe (Tony Curtis) and Jerry (Jack Lemmon) enter the film . . . we have firmly arrived in the world of comedy" (100–101). Epitomes of slapstick grace are George Raft's hilarious obsession about his spats in the context of recently having committed a cold-blooded murder; the paralyzing rictus on the face of his deaf killer (Nehemiah Persoff) when Spats is gunned down at a birthday celebration; and the panic of Joe and

Jerry, trembling beneath the table where Spats falls—but even more interesting is an implicit suggestion overarching Gemünden's comment, that the brutality of gangster films is funny on the face of it; that gangster films are always comedies. Billy Wilder's gangsters in this film are notable for a certain dignified, *gemütlich* stiffness of posture, very Prussian, very nineteenth century, which tends to humorously (ironically) contradict the modern, jarring, colliding, spontaneous, effervescence of their acts. But gangsters are always styled to laugh in the face of authority, convention, and seemliness. "Get outa my way," says Paul Muni's always chuckling Tony Camonte to Johnny Lovo (Osgood Perkins) in *Scarface* (1932), "I'm gonna spit!" He unleashes his brand new machine gun on the gang boss's office with an insouciant grin, as though handing out cigars. In this moment of complete release, the boss's uptight world is exploded in a young man's optimistic delirium, a grand joke. Howard Hawks recounted to Joseph McBride how he had talked about the film with a man who had acquired his own private copy of it, Al Capone, and how Capone found hilarious the methods Hawks had used to reconstruct gangster life (49). "True drama is awfully close to being comedy. The greatest drama in the world is really funny," Hawks said. "Would you rather see something dead serious or laugh at something?" (65).

We might laugh silently in the face of every great gangster moment, so ambiguous and pithy are the expressions to be found among these types who live on the knifeblade of marginality. In *Little Caesar* (1931), for example, Edward G. Robinson ends the film with the epigram "Is this the end of Rico?" as his character drops dead, answering his own query. When in *Chinatown* Polanski cuts Nicholson's nose open, it is true that, as Dana Polan astutely suggests, the detective is "becoming caught up bodily in the story he is investigating" (116); but something hilarious is happening, too: Jake Gittes is being converted into a bloodhound who cannot smell—analogous to Bill Baucom's Trusty in Disney's *Lady and the Tramp* (1955)—a paragon of well-meaning impotence now caught up in an intrigue that is imbricated with the familial and political machinations of Los Angeles and its dark history with water (see McWilliams 183–204). Gittes must now meander through the film threatening to reopen his perfectly characteristic wound with every breath; it is a wound that on anybody but a detective,

a perfumer, or a chef—and he is, after all, cooking up his solution to the puzzle—would seem inessential.

LAUGHTER AND DOMINATION

To understand the gangster and his laugh, I think we need to go further than Colin Wilson's important realization that crime can make us aware "that there is such a thing as morality" (Spurgeon 70). Like the wolf in "Little Red Riding-Hood" or the figures in the early twentieth-century paintings by Cassius Coolidge of dogs playing poker, the gangster is typically presented, in a view from above, as it were, as an ultimately ridiculous foil for higher interests, a low-life nobody whose dark career is a vain attempt to climb to a social position that will never be his (on ascent narratives more generally see Wartenberg). He is "as much the plaything of blind destiny as his victims are," Richard Schickel wrote of Cagney's Jarrett (141). But such a downward perspective is ultimately cultured by what Stephen Jay Gould calls a "traditional view of human domination," one in which evaluators always envision themselves as the acme of creation (245). Although some gangster narratives— Martha Nochimson has pointed out the case of Hong Kong produc- tions—feature police as "models of law-abiding behavior but not of righteousness. . . . It was the gangster who served a higher law" (226), classical Hollywood amusements work strictly to presume the unques- tionable dominance of rational-bureaucratic propriety over the feudal moral poverty—purportedly obvious—of gangster life. Even in films such as *The Maltese Falcon* (1941), where the protagonist detective (Humphrey Bogart), scornful of the thugs he must deal with, appears at some moments to be disconnected from, disrespectful of, the police, he is finally their pawn in all his acts, a force acting from a position of presumptive superiority to Gutman (Sydney Greenstreet, whose conde- scending smiles indicate effete and aloof genius), Joel Cairo (Peter Lorre, whose smiles are unctuous), Wilmer (Elisha Cook, Jr., who doesn't smile), and even the black-hearted Brigid (read, Frigid) O'Shaughnessy (Mary Astor), whom he claimed to love and promises to wait for after she gets out of the prison he is going to send her to. "The gang lead- er's desire for acceptance in 'society' and his attempt at securing 'class' were particular areas at which the comedic thrusts were aimed," notes

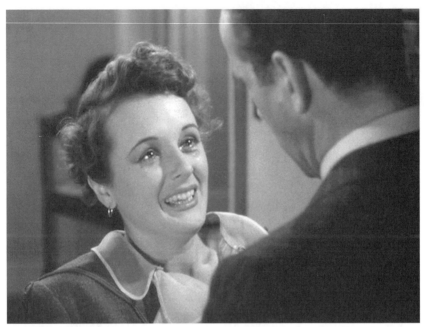

The manipulative giggle of Brigid O'Shaughnessy (Mary Astor) in *The Maltese Falcon* (John Huston, Warner Bros., 1941). Digital frame enlargement.

Stephen Karpf, discussing the "Little Caesar Syndrome" (113). In short, in the gangster film as generically conceived, there exists a dominant perspective and the gangster's isn't it; he is always fighting upstream in the face of forces that proffer a natural claim to rightness, reward, and purity. Against the pervasive background of hopelessly but feverishly climbing hooligans, whose every successful step upward leads them to chortle unsympathetically at those who are immediately beneath, a film like *Chinatown* is chilling in its structure, since the greatest gangster here, as in actual Los Angeles history, is someone who doesn't need to climb at all, a man who goes bad by spitting into his own legacy. This multimillionaire, Noah Cross (John Huston), wears his smile as a badge of social power and moral prerogative, thus sensationally masking his true status and worth.

That the gangster's laugh does not mean he is having fun, but attests instead to a quintessentially rational commitment to success at any cost—that it affirms his capitalist pieties—is shown in Don Corleone's last moment, when, to make his little grandson happy he

The dying laugh of Don Vito Corleone (Marlon Brando) in *The Godfather* (Francis Ford Coppola, Paramount, 1972). Digital frame enlargement.

dons not a grin but a fake grin (Brando uses a piece of orange rind, in a trick he had been shown by Phil Rhodes), making a maw that frightens the child instead of amusing him. The old man is a pussycat at heart, deeply ashamed at having alienated the little boy, and, running after him to apologize in the sunny garden, sustains the heart attack that brings him down. That huge orange "movie monster" mouth (Bosworth 179) at the finale of *The Godfather* is nothing if not a pronouncement: "Normal people smile, but I take life seriously. I wear a grin, but underneath I am always at work."

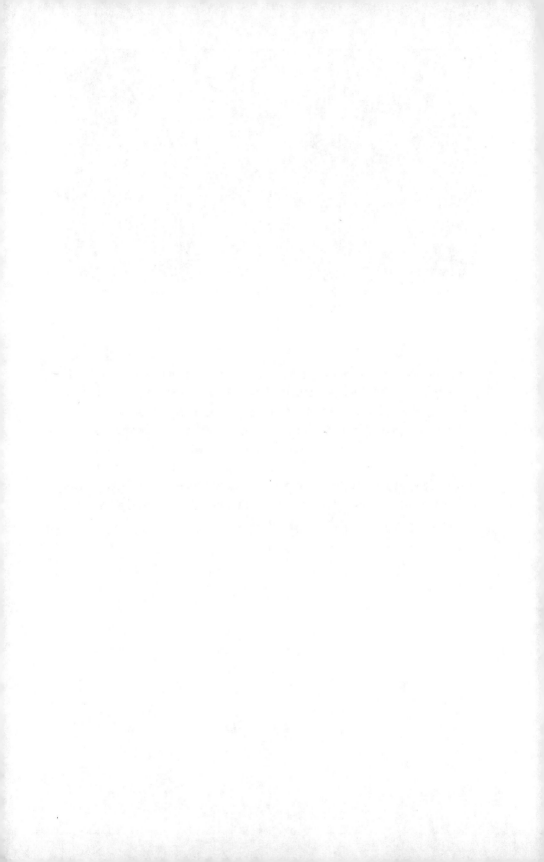

ADRIENNE L. MCLEAN

If Only They Had Meant
to Make a Comedy

Laughing at Black Swan

Several years ago a friend and I were in a movie theater watching the generic backstage ballet film *Center Stage* (2000) in which young ballet hopefuls (some played by dancers, some by actors) spend a summer trying to make it into a fictional but world-renowned New York ballet company where they hope to become stars. There was the usual stereotypical cast of characters—the anorexic perfectionist with the really pushy stage mother, several small-town innocents of each gender, and assorted sarcastic but talented misfits. At one point the main female misfit (she's working-class, non-white, she talks back to her teachers and other authority figures), played by Zoë Saldana, gets in trouble in ballet class for chewing gum and not having her hair done up tidily enough. I turned to my friend and stage-whispered, "Oh *no*, now she'll *never* get into the company!" Then we cackled like maniacs. We would perhaps have felt stupid later if it turned out Saldana's character never got anywhere, but instead, as our laughter was acknowledging, the film had just telegraphed, very loudly, that she was going to end up on top. It was a species of backstage musical, after all, and we knew the rules—rebellious but talented characters always become stars—even if the film seemed to think we did not. But others in the audience took things more seriously; although this was hardly the only moment at which we giggled or hooted, most of the time we did so alone.

Almost everyone has probably had the experience of finding a film funny for what might be construed as the wrong reasons—what

we're laughing at is not supposed to be funny, we're laughing *at* rather than *with* the film, and so on. And, as above, we often laugh at things that are not precisely comic but are nevertheless hilarious *to us*— something is funny in ways that seem to run counter to a film's intended effect, creating a sense of ironic humor that undermines the solemnity or narrative intensity of the project at hand. ("If only they had meant to make a comedy," my friend e-mailed me later.) Why is it funny when something about a film simultaneously complements and undermines what seems meant as intended profundity? And why do some people laugh but not others?

To date, such dissonance has been studied primarily as an effect of camp or kitsch, which are often conflated as forms of unintentional burlesque. A film like *Center Stage* certainly can be understood as Camp as well as camp. "Camp" refers to the "queer praxis" of a text's production by gay labor and the concomitant reading strategy that such a text demands (which would emphasize *Center Stage*'s spectacularization of the male as well as female body and its use of gay male performers and production personnel). By comparison, "camp" is a coopted and mainly parodic "Pop camp" that attempts to deny the queer basis of a text's production but which can nevertheless become, in Moe Meyer's words, "the unwitting vehicle of a subversive operation that introduces queer signifying codes into dominant discourse" (13). To other viewers, *Center Stage* would be kitsch, an example of what Gillo Dorfles calls "the world of bad taste" (Kleinhans 182), of formula repeated without variation or concern, a film that uses the "high art" of ballet to make itself "serious" but in a context that has no use for art as such. *Center Stage* might also be "self-aware kitsch," in Chuck Kleinhans's words, a film whose "implicit assumption is: We all know this is fun, just a good piece of entertainment" and one that understands that spectators can be "engrossed by the situation and the exaggeration simultaneously" (Kleinhans 184). Indeed, laughing at the film's many implausibilities didn't keep us from tearing up a bit when Saldana's dancing double performed gorgeously on the climactic opening night, replacing the anorexic girl who had decided to defy her mother and leave ballet for a "normal" life of heterosexual romance.

There are many pleasures that a film like *Center Stage* can produce for spectators, in other words, depending on how many other, similar films one has seen, whether one knows anything about the ostensible

subject matter or how professional ballet companies operate and how classes are run, whether one can recognize a truly proficient dancing body from one that we are being told is great but that performs amateurishly except when his or her dancing double is filling in. In making it funny as we did, my friend and I were reacting to the film's ignorance, as it were—its ignorance sometimes of the subject matter (it just didn't care that much about being correct about ballet) but also its ignorance of us and the fact that we might know things that would render the film's self-importance and reliance on stereotypes and cheap sentiment ludicrous.

In fact, with the exception of the frameworks provided by scholarship on C/camp and kitsch and ubiquitous claims about the social nature of comedy and laughter (laughter is thought to require the company of others, whether that company is real or implied by the laugh track of a sitcom), not as much attention has been paid to how films are made funny by audiences rather than by film directors, star performers, or writers (Chaplin, Keaton, Mae West, Preston Sturges, Jerry Lewis, Woody Allen, et al.). Most of the analysis of film comedy has also focused on comic genres, or the means by which genres can be made comic through manipulations of narrative and spectacle, bodies and voices, sight gags and jokes, and the creation of incongruity or surprise through film-specific formal devices like camerawork or editing. Here, I am interested in how, and why, even serious dramatic films—films that both take themselves seriously and are taken seriously by critics, and that are substantially devoid of what is usually called "comic relief"—can also be really funny, and whose status as comic derives in complex ways from the interaction of a film with its promotional and publicity materials (what it is "supposed" to mean, according to its director, stars, and so forth) and its reception contexts (how critics evaluated it, what audiences generally made of it). As my title suggests, the primary focus of my study is Darren Aronofsky's *Black Swan* (2010)—a film that, like *Center Stage*, purports to be about "the world of the ballet" but, rather than following the musical's utopian rules, ends with the death of its ballet-hopeful star and includes gory scenes of self-mutilation and graphic violence in addition to what quickly became a notorious bout of lesbian sex between its two female leads, Natalie Portman and Mila Kunis. Although, as will be discussed, most critics raved about *Black Swan*'s highly stylized mixture of

psychological drama and horror and it won at least forty-three awards (including the Best Actress Oscar for Portman) and was nominated for many others, for a small but significant cohort among critics and vocal audience members it was risible, hilarious, parodic without apparently meaning to be.[1]

Some critics, even those who thought the film a masterpiece, did invoke camp (though never Camp), but this does not do much to explain why it is so hard for me to take *Black Swan* as seriously as I "should." Indeed, when critics use the term in their reviews it is rarely in relation to humor production but instead to the film's heightened visual expressionism, overwrought emotionality, and lurid intensity. This essay, then, is a rumination on how *Black Swan* is funny, where my laughter as well as that of others might be coming from, and what, in the end, it means. I am not claiming that *Black Swan* is an incompetently shot or unaffecting film on many levels. Rather, my point is that there is an interesting disjunction between the film that Darren Aronofsky claims he made and the one my laughing cronies and I—and we were not always laughing at the same things, mind you—found at our local multiplexes.[2]

WE ALL KNOW THE STORY

Black Swan opens with a dream sequence featuring Natalie Portman being pulled around by a man who becomes a monster, to an arrangement of Tchaikovsky's music for the ballet *Swan Lake*. Portman plays Nina, a principal dancer for a New York company whose hawk-nosed director, Thomas Leroy (Vincent Cassel), wants to mount a "new," "more visceral, more real" version of the nineteenth-century warhorse and is seeking a "fresh face to present to the world" from among the company's dancers; in so doing, he will also replace, or displace, the company's reigning but aging star, Beth (Winona Ryder). As Leroy tells his dancers as he surveys them during a class that turns out to be an audition, "We all know the story. Virginal girl, pure and sweet, trapped in the body of a swan. She desires freedom but only true love can break the spell. Her wish is nearly granted in the form of a prince, but before he can declare his love her lustful twin, the black swan, tricks and seduces him. Devastated, the white swan leaps off a cliff, killing herself, and, in death, finds freedom." Leroy chooses Nina to play the dual role

of Odette, the virginal white swan, and Odile, her seductive black twin, but tells Nina that she's not convincing as the black swan—she isn't sexual enough, in his mind, so he tells her to go home and "touch herself, live a little." ("Honestly, would you fuck that girl?" he later asks the lead male dancer.) Nina lives at home with failed ballerina "Mommy" (Barbara Hershey) and a bedroom of stuffed animals, but she dutifully complies (her sleeping mommy is actually in the room with her as she does so). When a potential rival from San Francisco joins the company, Lily (Kunis), who seems to possess all that Nina lacks in the dancing *and* fuckability departments, Nina begins to come unhinged, practicing harder and harder and becoming more and more obsessive about perfection. Ostensibly to be friendly, Lily takes Nina out for a drugged and drunken night on the town in defiance of Mommy's wishes, and the two girls end up having sex in Nina's bed. Lily, however, denies the encounter the next morning, and as opening night approaches Nina has further visions of Lily's duplicity (she sees Leroy having sex with Lily from a distance) and becomes very upset when Lily is made her alternate.

Strange physical things have been happening to Nina all along—she appears to be growing feathers, her legs bend backward like a chicken's at one point, her eyes turn red, she develops bird-like skin markings—and on opening night she apparently kills Lily, who has shown up in her dressing room to taunt her, by stabbing her in the stomach with a piece of broken mirror glass. Then Nina hides the body in her bathroom (but later it, and all the blood, disappears). Nina has literally become a black were-swan (she grows enormous black wings onstage to prove it), and her performance as Odile is completely successful. In her dressing room again, as Odette, Nina realizes she's been impaled by a piece of mirror glass too; but she finishes the ballet, Odette leaping to her death and Nina floating backward in slow motion onto the mattress hidden behind the set. Only then does blood gush forth from her middle, and Nina dies on the mattress after whispering, "I was perfect," with everyone in the company huddled around her, the film fading to white and out. Whether Nina's visions were "true" or not is never made clear, although the many scenes featuring computer-generated imagery and special effects seem designed to be read as fantastical, as Nina's visions or feelings about what's happening to her rather than scenes with a more plausible or exterior

cause-and-effect logic. But most of the film's inconsistencies are left open to interpretation—was Lily Nina's enemy or friend? Did Nina really pull her own skin off, or develop webbed toes, or grow pinfeathers? Was Nina crazy or merely obsessive, trying to become an adult while living with an impossibly controlling mother? When Nina went to visit the bitter Beth in the hospital, did Beth really stab herself in the face repeatedly with a nail file? And finally, did Nina really dance a full-length *Swan Lake* with a hole in her midsection?

As wacky as some of these plot elements may seem in the retelling, I do not think it's fair or useful to criticize any film for not being "realistic" if it is obviously not intended to be, and it is perfectly okay for any film to trade in ambivalences and ambiguities and improbabilities and to mix formal devices, tropes, and even clichés from a number of different genres. Certainly one could make fun of the classic 1948 ballet film *The Red Shoes* on similar levels—does the ballerina really fall through the air in the ballet she dances on an ostensible theatrical stage, does a piece of newspaper really turn into a dancing man, does she throw herself in front of a train at the end because her red shoes force her to against her will or because she has been driven insane by a domineering ballet impresario and a demanding husband? *Black Swan* has been called a psychological thriller, a horror film (a young girl turns into a monster), a backstage "musical" gone wrong. *The Red Shoes*, to which *Black Swan* seems to be paying homage, was also called a horror film by some reviewers, its big ballet a "lurid visual tone poem" that was confusing because it was more cinematic than "theatrical" and things took place onstage that couldn't possibly occur in "real life" (see McLean chap. 4). At the same time, its writer/directors, Michael Powell and Emeric Pressburger, wanted to make the Hans Christian Andersen fairytale the basis both of the film's ballet set piece and the film's framing narrative, something that *Black Swan* also does with *Swan Lake*, and both films include scenes in which an impresario tells the story of the big star-making ballet that is also the film's plot. Although far less sexually graphic than the later film, *The Red Shoes* was met with scorn or laughter from some quarters, too, because the existing context for the film *was* the Hollywood musical, in which talented girls become successful in love and show business together at film's end; they don't end up lying bloody and dead on railroad tracks. Generic conventions like this no longer

Adrienne L. McLean

Above, Vicky (Moira Shearer) about to die near the end of *The Red Shoes* (Michael Powell/ Emeric Pressburger, The Archers, 1948). Below, Nina (Natalie Portman) near death at the end of *Black Swan* (Darren Aronofsky, Fox Searchlight, 2010). Digital frame enlargements.

pertain, or not as much, and of course *The Red Shoes* was registering postwar changes in classical genres even as it was creating them itself, and quickly became recognized as an auteur-driven masterpiece.

But the issue is not that *Black Swan* is hilarious and *The Red Shoes* isn't, or even that the places that make me giggle in *The Red Shoes* are mostly tied to changes in fashion or to Camp—the (gay) male premier danseur's pot-bellied body encased tightly in a maillot, his skinny legs

ending in white ankle socks, his heavily made-up face framed by a scarf, for example. *The Red Shoes* may in fact be humorous to some for many of the same reasons that *Black Swan* is to me, even leaving out the issue of Camp, or what Moe Meyer calls the "camp trace" and Chuck Kleinhans "Het[erosexual] Camp"—the films' "extravagant theatricality, love of artifice, and extreme emotional range" that can be signs of gay labor or instead represent "nongay appropriation" (Kleinhans 188). It is, however, specifically *Black Swan* that is the topic here, and the rest of my discussion considers the following three points: first, that *Black Swan* is kitsch, but not *self-aware* kitsch; indeed, it is precisely its ignorance about its subject matter that makes it funny. Second, and related to this, is that it is pretentious; pretentiousness as such is frequently the target of comedy, and it is no accident that virtually all the negative reviews of the film are sardonic reviews with titles like "Black Swan Down," "Swan Dive," or my favorite, "Natalie Portman Goes Batshit in a Tutu." And finally, it is important to know not only what we are laughing at but what kind of laughter it is that we produce, and what sorts of power structures or social communities it might be responding to or serving in support of.

Will They Dare Be That Obvious?

For Chuck Kleinhans, the significance of self-aware kitsch as a descriptive category is its relation to a text's apparent intentionality, or how a text "gives evidence that the makers themselves were aware of their 'bad taste.' Contemporary culture objects," he states, "are often highly self-conscious of their own de-based status," and the signs of a film's self-awareness include the excessive use of "recycled clichés" of narrative and visual style and a literalness or directness that can produce a "comic-book simplicity." The primary question we keep asking ourselves as we watch such films, he writes, is "will they dare be that obvious?" For people with "high-culture tastes or backgrounds, [such films] can be received as total parodies. It is especially easy for media people (who can spot the formal clichés that underline the content conventions) to do so. But these films function in a different way with the general mass audience: spectators are engrossed by the situation and the exaggeration simultaneously" (184).

Adrienne L. McLean

Even appreciative reviews of *Black Swan* mention its excessive literalness, use of stereotypes, and recycling of clichés. It isn't just that Nina starts over-identifying with Odette or Odile; she literally becomes avian, in ways that have already been described. Many films give their protagonists dopplegängers, but Nina has her own vicious id-like mirror image (who operates independently of her), the two swan roles, Lily, her mother, and Beth—that's a lot of doubles, and, in David Denby's words, as "sinister elements" they become "shtick. . . . After a while, you realize that the film is a case of ersatz formalism disguising chaos" (*New Yorker*, 6 December 2010). Sarah Kaufman, writing for the *Washington Post* (10 December 2010), gleefully lists the film's clichés—that ballerinas are "frigid" and "high-strung emotional wrecks," that "as soon as they land a great part, they will have to fend off a rival hellbent on sabotage," that "ballet directors are cocksure Casanovas who lust after their dancers," and that "nobody's crazier than an aging ballerina," except, perhaps, "a smothering, psychotic stage mother—especially if she's a former ballerina." And of course there's the cliché that is *Swan Lake* itself, whose "arm-flapping" has been featured in more movies than Kaufman can count.

But while Kaufman links the use of such stereotypes to Aronofsky's "general strategy of bleeding dry every plot device about ballet life that others have beat him to first," there actually is little evidence that Aronofsky was aware that he was repeating anything. On the contrary, in interview after interview he points to the novelty of his film and of his inspiration for it: "I had the idea of the ballet world and I was thinking of doing something with *The Double* with [*sic*] Dostoevsky. I saw *Swan Lake*, I had never been to the ballet, and suddenly I saw a black swan and a white swan played by one dancer and I was like 'oh.' It was a eureka moment, because it was *The Double* in the ballet world. I was like, 'Ok, I've got something.'" Nor does he admit to having seen other films whence he might have derived the stereotypes that pervade *Black Swan*: "My sister studied ballet as a kid, so I was really interested in it. When I started to think about things for features, I was like, 'wow, it would be really interesting with the ballet world, because no one has done anything really serious in that world since *The Red Shoes*, unless it's a kind of romantic *Turning Point*: you see a dancer spinning and then it cuts to Anne Bancroft and she's at the bar, like sweating.'

It's a little silly" (Anne Thompson, "Thompson on Hollywood," blogs. indiewire.com, 15 September 2010).[3] But *The Turning Point* was made in 1977, and its success generated quite a few other films that used ballet as a backdrop or major plot element in the decades that followed. The sheer number of ballet films in just the ten years prior to *Black Swan*, in addition to *Center Stage—Billy Elliot* (2000, which ends with a freezeframe of a male dancer as a swan in Matthew Bourne's updated distaff version of *Swan Lake*), *Save the Last Dance* (2001), Robert Altman's *The Company* (2003), *Step Up* (2006)—make it hard to believe that Aronofsky could think that he was "on to something" that had never been done before. But it appears that he did.

Another of the anecdotes Aronofsky repeats most frequently about *Black Swan* is how hard Natalie Portman worked to "become a ballerina," taking "dance classes for a year, eight hours a day"—which most professional dancers don't even do, much less those the bulk of whose serious dancing will be performed by doubles, as was the case with Portman. In fact, promotional and publicity materials from the earliest days of the ballet film had always claimed that their non-dancing stars had transformed themselves into "real" ballerinas for the films they made, too—Vivien Leigh in *Waterloo Bridge* (1940), Margaret O'Brien in *The Unfinished Dance* (1947), Gene Tierney in *Never Let Me Go* (1953), all of which are brimming with swans and Tchaikovsky as well. There are dutiful testimonials from Joffrey Ballet dancers and ballet masters about what a "beautiful and dedicated artist" Neve Campbell was in *The Company* and how "hard" she worked to become a "real" ballet dancer, just as there are from Portman's co-stars and the choreographer of the film (by whom Portman became pregnant and whom she later married).[4]

Given this evidence, one reason *Black Swan* is funny is its pomposity about its own aesthetic status and uniqueness; it is kitsch, but not really conscious of the fact. Thus, despite Aronofsky's self-professed hipness, *Black Swan* ends up somewhat akin to *Reefer Madness*, "the earnest anti-marijuana film of the 1930s that was recirculated to stoned audiences in the 1960s," in Kleinhans's words, and that, "if not actually Camp, certainly facilitates a Camp reading because it invites scornful laughter due to its ineptness" (Kleinhans 186). Aronofsky has said that he just wants to "create images and ideas that people will remember," and both he and critics have pointed to *Black Swan* as a companion

Adrienne L. McLean

piece to his *The Wrestler* (2008) in their emphasis on the mortification of the flesh in pursuit of the perfection of an image. But there is an element in both of these films of what Kleinhans calls "the media world's cannibalization of subcultures," to which filmmakers are drawn "precisely for their difference, their newness, their not-as-yet-commercialized qualities" (188). If ballet is hardly "new" as a feature of commercial cinema, given the large number of films that have centered on it, it is frequently *thought* to be—and Aronofsky is not alone in neither having looked for nor paid attention to the films that came before his. Nor is he the only filmmaker to assume that his audiences are as untutored as he is. Neve Campbell, who produced *The Company*, wanted to "dramatize the dichotomy" in ballet, "between the intenseness and the pain and what you see onstage—which is someone pretending to be a butterfly" (Joan Acocella, "No Bloody Toe Shoes," *New York Review of Books*, 26 February 2004); but this is of course what everyone who makes a ballet movie wants to do. Robert Altman, after watching his first ballet class, called Campbell to exclaim, "The dancers, they pick their leotards out of their butt all the time! And they've got holes in their tights and their feet are so bloody. I love that stuff!" (Acocella). And not surprisingly, those who are familiar with ballet weren't so impressed with *The Company* either; dance critic and historian Robert Gottlieb couldn't figure out "why movie and dance critics are taking *The Company* seriously," and decided they were "impressed by Altman's reputation and naïve sincerity" (*Observer*, 3 January 2004), and Joan Acocella called it "a lazy movie all around." Although laziness is not exactly the same as ineptness, the result can be just as funny, producing what Elizabeth Bowen calls "the *gaffe* that [you] cannot pass" (Bowen 215)—images or situations that are silly or unlikely, even insulting, and that one has seen a million times before.

In addition to being cliché-ridden, then, *Black Swan* is funny partly because of the promotion and publicity contexts that surround it and that include Aronofsky's pompous remarks about how he saw *Swan Lake* "one day" and had his "eureka moment" and so on. But his earnest ignorance also makes him part, if an oblivious part, of a long-lived tradition. Back when MGM chose to use the music from *Swan Lake* in their 1940 film *Waterloo Bridge*, it appeared that nobody involved had actually seen the ballet. Nevertheless, they decided to add a ballet background to the film and to make its main character a ballerina

who, like Odette, dies for love. But after consulting a "comprehensive book on ballets," they found that *Swan Lake* also included "quite a large number of male dancers as well as girls," which they were not expecting. Rather than fix the film to correspond more closely to reality, MGM assumed that its audience would be ignorant of the ballet too and simply turned *Swan Lake* into an all-girl revue. Naturally, no one watching *Waterloo Bridge* learned much about ballet other than that it was tragic, amorphously romantic and beautiful, and linked to death (although I'm sure there were aficionados who hooted at *Waterloo Bridge* in 1940, too); and while *The Company* is more educated and matter-of-fact about life in ballet being *life*, rather than death, *Black Swan* returns us to the literalness of all those other films in which the fate of the protagonist mirrors the roles she dances on the stage. No matter how well entrenched or famous ballet gets, in commercial cinema it is still treated as a subculture (it is art, after all) that surely few know much about (see McLean).

LAUGHS IN THE CROWD

To get at why pretentiousness, exaggeration, and a reliance on clichés or cartoon-like images and situations can make us laugh, I turn to philosophies of humor production and where different forms of laughter come from. All humor appears to be generated by "culturally appropriate incongruity," in anthropologist Mahadev Apte's words, with three factors reflecting the "cultural bases of humor" and its "institutional development: shared cultural knowledge, shared rules for interpreting it, and agreement on the cultural appropriateness of the incongruence and exaggeration involved" (261). Humor therefore "depends upon the perception of an incongruity," according to Elliott Oring, that may or may not be resolved or made sense of; it "calls upon individuals to invoke an extant body of tacit, everyday knowledge in order to recognize and make sense of an incongruity. Humor succeeds only if individuals are made to access concepts, associations, and values with which they are already familiar" (56). *Black Swan* is funny to me because I know a lot about ballet, and I recognize incongruities in what the film (and, as above, its director) claim or show about its topic and what I understand to be true about it. Thus, I laugh at the haughty impresario's notion of a "more visceral, more real" *Swan Lake*

Above, the close-up of Nina's big-toed clown foot in *Black Swan*. Below, the bloody ballet foot of Emilia (Leslie Browne) in *The Turning Point* (Herbert Ross, Hera/Twentieth Century Fox, 1977). Note Browne's "correct" bunion at the major joint of the big toe and the calluses on the others—Browne had been a ballet dancer for most of her life—although the blood was probably movie makeup. Digital frame enlargements.

that will star the perpetually weepy and whiny Nina rather than, say, Lily (as one reviewer noted, "Lily has what Nina lacks, as dancer and woman, though this is not a distinction the film recognizes" [*Times Literary Supplement*, 28 January 2011]). I laugh that Lily has a giant set of wings tattooed on her shoulders that nobody seems to notice (poor Zoë Saldana in *Center Stage* got in trouble because her hair was messy!). I initially cringe at the loud crack on the sound track when Nina is practicing in her apartment studio—is it a broken bone?—but then laugh at the flipper-like bunion-free (latex?) foot shown to us in close-up and that bears no resemblance to that of a ballet dancer. I laugh at the dancing of Natalie Portman, and find pleasure in all the

sequences where she looks more like Margaret O'Brien in *The Unfinished Dance* than a professional ballet dancer, much less one on whom the weight of a major company's future presumably rests (Portman's eight-hour-a-day classes were wasted, as far as I can tell, although she certainly dieted herself into the physical appearance of a dancer). I laugh at Nina's opening-night dressing room scenes, because I imagine how difficult it would be for her to fight and kill a rival *or* herself were she to be bothered by a dresser, costume master, or mistress, and the other assorted personnel required (by unions if nothing else) to mount a big theatrical production, even one that turns out to look, in James Wolcott's words, as if the set "were constructed at Home Depot" (*Vanity Fair*, January 2011).

Some might argue that laughter of this sort is not properly in response to humor, that instead it is derision or scorn. But if humor is "an amusement-provoking stimulus that is recognized as such by someone who smiles or laughs, is disposed to smile or laugh, or even rejects the enticement to smile or laugh" (Oring 163n1), then *Black Swan* is funny. But it is true that my *overall* amusement at the film is connected to a feeling of scorn, or frustration, and philosophers of humor point out that "in many instances an initial laugh is supplanted by an expression of rejection and disgust at the underlying joke image or thought" (Oring 174n2). For me, the frustration arises from how seriously *Black Swan* was taken, not because I disagree that it is a "hotblooded, head-spinning erotic thriller" (Peter Travers, *Rolling Stone*, 10 December 2010) or even that it is, in spots, "a terrifying tale that juxtaposes the grace of a dance film against a twisted horror backdrop" (Claudia Puig, *USA Today*, 3 December 2010) or "a movie where boundaries have a way of slipping and sliding into one another" (Ann Hornaday, *Washington Post*, 3 December 2010), but because it reifies the same old myths about ballet being an effete art in which women are ruled by men and that is incompatible with ordinary life (again, many glowing reviews noticed this but weren't bothered by it). Moreover, Internet user reviews of the film show me that I am not alone, that others were insulted by the film's "abundant factual errors in depicting a dance company" and its "complete lack of respect for its subject matter"; "not only is such an approach rather pompous and shallow," wrote one poster, "but it is also inadvertently funny."[5] In other instances, my—or rather our—laughter is in response to a more straightforward

　　　　　　　　　　　　　　　　Adrienne L. McLean

appropriate incongruity and not connected to the pretentiousness or naiveté of the film's relationship to the dance world.

Why, for example, did so many of us laugh at Portman weeping? Especially at the scene that the *Washington Post* lauds as "by far the most memorable" in the film, the moment "when Nina calls her mother from a bathroom stall to share a piece of important news. Before that episode and after, Portman delivers an uncompromising performance, whether she's called on to be fragile or recklessly bold. But that moment on the phone bespeaks complete emotional transparency, conveying vulnerability, terror and surpassing joy all at once" (3 December 2010)? "He picked me, Mommy! I'm the new Swan Queen!" Portman emotes tearfully, but even when this moment was replayed during the Academy Awards ceremony at which she was awarded her Oscar I swear I heard snickers from the audience. "My boyfriend and I made jokes through the whole [movie]. Nina looks like she is going to cry throughout the whole movie and when she actually did, we cheered," wrote one poster; another refers to the "laughs in the crowd at some of the overdone/hokey 'Thrilling' scenes." Are we all heartless in the face of human suffering, or immune to appeals to our emotions? Portman is obviously "suffering"; and those who were deeply moved by the bathroom scene might accuse us of what Elliott Oring calls the "modernist attack on sentimentality," that tolerates sentimentality "only in quotation marks, as a kind of self-conscious, ironical expression—that is, as 'camp' or 'kitsch'" (Oring 77). Humans "continue to experience feelings of tenderness, affection, admiration, and sympathy," and "to be moved by the display of these qualities in others. But as modern people, they have also learned to discount these sentiments as 'mawkish,' 'maudlin,' 'corny,' 'cornball,' 'hokey,' 'schmaltzy,' 'sloppy,' or just plain 'sentimental.' Those who would claim for themselves any measure of urbanity, education, and sophistication have had to suppress the least trace of their sentimentality" (78).

I do not think, however, that those who laugh at the display of emoting in *Black Swan* are necessarily "suppressing" their sentimentality, rather that the sentimentality itself is perceived to be based on something spurious or unconvincing, perhaps because, as Henri Bergson points out, comedy, in contrast to drama, "depicts characters we have already come across and shall meet with again. It takes note of similarities. It aims at placing types before our eyes" (166). And it is also possible that our reaction is employing what Oring calls one

of the "special channels for [the] expression" of sentiments and sentimentality, namely humor (72). I do not discount the possibility that rather than cry along with Portman we instead laugh because it is too uncomfortable, too un-hip, to do otherwise. But in this case, I'm more convinced that it is the one-note nature of the emoting—Portman's "facial expression *never varies* from sad, purse-mouthed and leaky eyed," wrote one poster [italics mine]—and its links to clichés and stereotypes of weeping women that we have seen in so many other films that are the basis for the laughter. Henri Bergson points out that images of "*some rigidity or other* applied to the mobility of life, in an awkward attempt to follow its lines and counterfeit its suppleness," become "ridiculous" or "laughable" (85); a stereotyped rendering of suffering, in other words, repeats, in a machine-like fashion, something that ought to be felt as individual. "*We laugh every time a person gives us the impression of being a thing,*" Bergson exclaims (97), and this occurs "when we perceive anything inert or stereotyped, or simply ready-made, on the surface of living society" (89). Thus the similar response by a poster to the scene in which Nina "pulls feathers out of her back in horror! Oh no! That was the cheesiest thing I have ever seen": a human becoming a bird in a film about a human becoming a bird that copies previous films in which humans become birds in an endless refraction of the same "cheesiness." The crying scene may well make us uncomfortable because it is an excessive display of private emotion that takes place in a toilet stall, but it might also be hilarious because, in the theater, we join together in ridiculing the stereotype: "When the audience started to laugh about 1/3 of the way through, I knew it was all hopeless," a poster writes. "I joined in, that's how appallingly bad it all was. In the final scene, the laugh meter topped out. It is that unbelievable and unintentionally comedic."

Clichés, stereotypes, pretentiousness: we laugh at them, but in the end there's the problem of whether there is anything to our laughter other than a release, a momentary enjoyment—"everyone in the cinema laughed when Nina dragged the body across the floor—I think it was the tutu that did it"—or our own vanity in being able to point out that something is "pompous and shallow." As should be clear by now, much of the humor of the film *is* linked to our derision or scorn. Although humor is generally thought to be "social, exhilarating, and liberating" (Morreall, *Comic* 54), there is a bitterness that comes from

Adrienne L. McLean

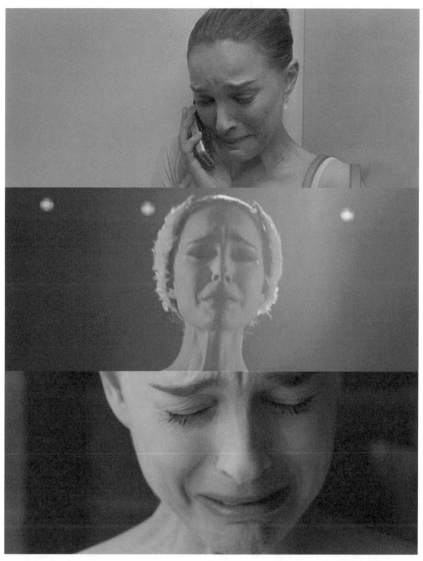

The weepy Nina—from top to bottom, the "He picked me, Mommy!" scene; onstage performing Odette; and in her dressing room realizing she's got a shard of mirror glass in her stomach.

the sense that one is being played by someone who has not earned, as it were, the credentials with which to do so. Aronofsky himself told one interviewer, after the film had been out for several weeks, that *"Black Swan* might be dark compared to what else is out there in the marketplace; it's certainly sexy and scary. But there's plenty of humour in it and what's been most exciting for me is how many people are saying the film is fun. I've never had that before. . . . 'Fun' is a good word. I like it" (Amy Raphael, "I Wanted to Push Her into Womanhood," *Times* [U.K.], 8 January 2011). It is tempting to posit that his acknowledgment of the film's humorousness is a belated response to the laughter of audiences or some of the wittier unfavorable reviews.[6] And while his characterization of the film as "fun" could signify that Aronofsky had successfully created and marketed a film of "psycho-aesthetic pluralism," in Kleinhans's words, deliberately constructing it to be "open to a great deal of very different fantasizing," it is more likely that the humor was inadvertent, the "possibilities for fantasizing . . . so simplified that they seem isolated and ridiculous" (Kleinhans 186).

John Morreall, writing about Bergson's work, notes that when we laugh at people who are not trying to make us laugh "we do feel superior to them, and we are humiliating them, but that humiliation spurs them to think and act more flexibly, less like a machine. So, while laughter stings, it brings the ridiculed person back to acting like a human being" (8). *Black Swan* is not a person, and there is little that our laughter can do to sting it or to alter our own knowledge that, once again, a film has been made in which "ballet itself signifies little to nothing" (*Vanity Fair*, January 2011). While our laughter is a sign of our own vanity as well, our superiority to what David Denby calls a "pompous, self-glorifying, and generally unpleasant interpretation of an artist's task" (*New Yorker*, 6 December 2010), it is not necessarily laughter that rings hollow. We may all have paid to see the film, but we didn't "buy" it, nor will we the next time—Darren Aronofsky is not the first director to think he knows more than he does, and he won't be the last. So we'll just keep on laughing.

NOTES

1. Among the many reviewers who greatly admire the film are Roger Ebert, *Chicago Sun-Times*; Peter Travers, *Rolling Stone*; Andrew O'Hehir, *Salon*.

Adrienne L. McLean

com; Mick LaSalle, *San Francisco Chronicle*; Ann Hornaday, *Washington Post*; Rene Rodriguez, *Miami Herald*; and Peter Debruge, *Variety*. Reviews may be accessed through imdb.com, *Black Swan*, external reviews.

2. If the ballet-educated public is relatively small in the United States, it is my point that this is partly because of the long history of films like *Black Swan* that continue to portray the art form as effete and vaguely difficult and its professionals as deranged, perverted, and so on; see McLean.

3. In some interviews Aronofsky claims he "only became aware of *The Red Shoes* recently because of Marty Scorsese's restoration. I was pretty stunned with the similarities" (Lorenza Muñoz, "*Black Swan*: An Interview with Director Darren Aronofsky," filmindependent.org, 10 November 2010), and that he didn't actually know about *The Red Shoes* until he was "very, very deep in the development of the movie. I think ballet hasn't changed that much as a classical art form that there are similarities which can show up" (in the same interview Aronofsky refers to Powell and Pressburger's 1951 opera/ballet film *The Tales of Hoffmann* as "*Hoffman Tales*") (Talia Soghomonian, "Darren Aronofsky Discusses *Black Swan* at Length in Paris," collider.com, 11 December 2010).

4. There remains some controversy about how much of the dancing Portman actually did in the film; her face was digitally pasted onto the body of Sarah Lane, an American Ballet Theatre soloist who claims she was ordered not to discuss her contributions to Portman's performance during Oscar season. See "Ruffled Feathers," *Entertainment Weekly*, 8 April 2011. See also Richard Brooks, "Ballet Stars Leap on *Black Swan* 'Lies,'" *Sunday Times* [U.K.], 16 January 2011.

5. All user reviews quoted are from imdb.com, *Black Swan*, user reviews. As of August 2011, of 884 users, a bit less than half gave it five or fewer stars (out of a possible ten). Some were irked that they couldn't give the film a negative number.

6. See, for example, David Denby, "Fancy Footwork," *New Yorker*, 6 December 2010; J. Hoberman, "Natalie Portman Goes Batshit in a Tutu in *Black Swan*," *Village Voice*, 1 December 2010; Sarah Kaufman, "The On-Screen Ballerina: Emotional, Competitive and Painstakingly Cliched," *Washington Post*, 10 December 2010; James Wolcott, "Black Swan Down," *Vanity Fair*, January 2011.

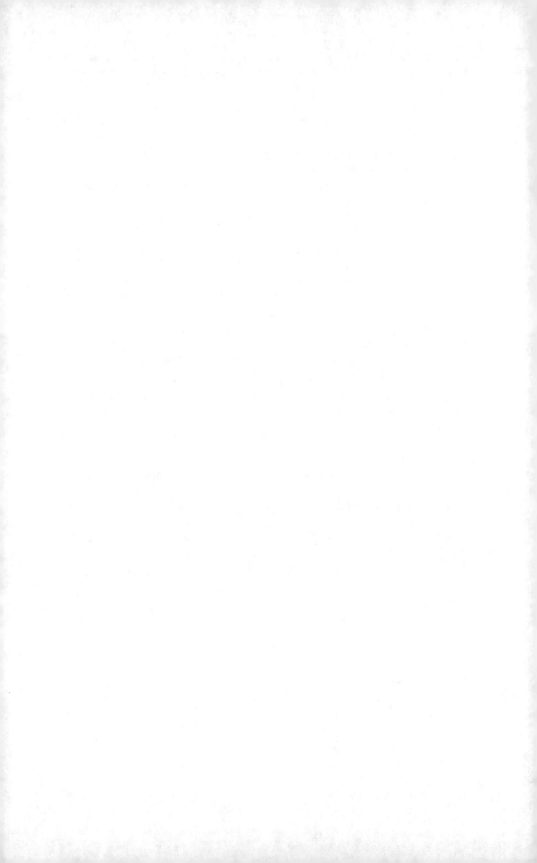

David Martin-Jones

Foolish Bum, Funny Shit

Scatological Humor in Hal Hartley's Not-So-Comedic **Henry Fool**

"I made up lists of disgusting stuff to include."

Hal Hartley

A man named Henry Fool (Thomas Jay Ryan), drifter, pedophile, ex-con, and alcoholic womanizer, bursts into a suburban bathroom where a woman is taking a shower. He hurriedly pulls down his trousers and sits on the toilet, his underwear caught unglamorously around his shins. Henry farts and defecates uncontrollably. He is experiencing the after-effects of drinking seven double espressos in quick succession, not realizing the likely consequences. As the sound effects continue for a prolonged period, and Henry contorts physically, the woman escapes the bathroom, only to return and kneel before Henry. She is Fay Grim (Parker Posey), a resident of the house where Henry is lodging in the basement. She is pregnant with Henry's child. She holds what she believes is a ring (in fact a gasket from an old fridge, a piece of industrial waste) that she has just found in Henry's hand, and places it on her finger saying, "Oh! Oh Henry!" She kisses his hand in acceptance. Henry, however, had no intention of proposing. It was in part the news that Fay was pregnant with his child that brought on his diabolical squits.

Thanks to Rosemary Martin-Jones, John Duckworth, and Soledad Montañez for assistance with research into John Falstaff; and to Andrew Murphy, Alex Davis, and Neil Rhodes for advice regarding literature on the fool.

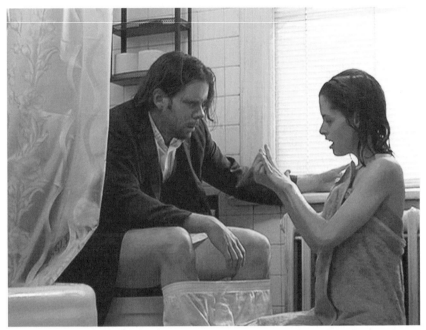

Henry's (Thomas Jay Ryan) body says "I do" to Fay Grim (Parker Posey) in Hal Hartley's *Henry Fool* (Shooting Gallery/True Fiction Pictures, 1997). Digital frame enlargement.

Henry, suddenly a husband- and father-to-be, comically registers on his face the surprise of both his intense physical sensations and the unexpected nature of his betrothal.

When I first saw U.S. independent auteur Hal Hartley's *Henry Fool* (1997) in the Cameo Cinema in Edinburgh, I spent the majority of the film enjoying trademark Hartley. It was witty, quirky, surprising, and charming at times, but it was certainly no comedy in the generic sense. However, I vividly remember laughing to the bursting point at this bizarre toilet-proposal scene. I laughed so hard, in fact, that I had to cradle my stomach in both arms. This reflex was as much a result of the physical pain of the laughter as it was a response to the need to calm my body, which was threatening to retch in response to this revolting scene. This was not only funny, it was also, and simultaneously, repulsive. So: was I laughing, exactly, or vibrating hilariously on the verge of illness? This chapter focuses on this standout moment of scatological "comedy" in *Henry Fool*, which is otherwise as "un-comedic" as Hartley's previous droll, talky films. Exploring how it is at once laughable and

David Martin-Jones

disgusting, I analyze the broader implications of this grotesque moment. The initial theoretical direction taken in analyzing this scene is, perhaps unsurprisingly, that of Mikhail Bakhtin's concept of the carnival. I say it is unsurprising not only because of how well known this idea is, but also because the film invites exactly such an understanding of its scatological humor. Again following the film's lead, this analysis of the carnival incorporates related discussion of the role of the character of the fool in theatrical, and here filmic, critiques of institutional power. In this way, *Henry Fool* is seen to deliberately mix the sacred and the profane, and through the base figure of the fool to juxtapose such institutional regimes of power as the normative role of the family against the more scatological aspects of the human physique.

I conclude by examining the greater extent to which *Henry Fool* uses its scatological comedy to play to, but also in some respects to critique, the expectations of the target audience for such U.S. indie films. The so-called "bobo" (bourgeois-bohemian) audience has become a key demographic for U.S. indies. Its presence as such goes a long way toward explaining the presence and function of the character of the fool in *Henry Fool*, a theatrical figure traditionally associated with the ability to unite, often through physical, carnivalesque comedy, audiences as disparate as royalty and peasantry. Finally, this interpretation of the comedic nature of bodies in *Henry Fool* is enhanced when it is read in conjunction with Hartley's far more obviously politically engaged sequel, *Fay Grim* (2006).

FOOLISH BUM, FUNNY SHIT?

Henry Fool opens on Simon Grim (James Urbaniak), a young garbageman and socially inept loner who likes to drink and is something of a casual peeping tom. He lives with his nymphomaniac sister, Fay, and their mother, in a suburban house in the Woodside section of Queens, New York. Into his dead-end life walks Henry Fool, along an ordinary suburban road, with a suitcase in each hand. Although seemingly little more than a bum (he has spent seven years in prison for the statutory rape of a thirteen-year-old girl), Henry believes himself to be a great writer, perhaps as great as a Henry Miller or a Charles Bukowski. Henry encourages Simon to start writing, and Simon becomes an overnight critical, and ultimately commercial, success. Simon's verse

has the extraordinary power to give voice to the mute, to bring on early menstruation in Fay, to cause the suicide of his mother, and to provoke schoolchildren in Boston to burn down their school. In comparison, however, Henry's magnum opus, his memoirs, or "confessions," turn out to be utter rubbish. This leads to a falling out between the two men after Simon's sudden rise to fame. Nevertheless, Henry and Fay wed and raise their son, Ned (Liam Aiken). The film ends several years later, with Henry, likely to face reimprisonment for seemingly accepting an offer of sexual payment from a minor in return for killing her abusive father, fleeing the country with Simon's help. Simon gives up his passport on the eve of flying to Stockholm to receive a Nobel Prize so that Henry may escape using the identity of a great writer. The final shot shows Henry running across the airport tarmac carrying his two suitcases, a visual match of his entrance into the narrative. However, the direction in which he is running is rendered ambiguous by the medium shot used, such that the audience cannot tell if he is approaching the plane, returning to his family, or simply escaping altogether in a different direction.

Hartley's sixth feature, *Henry Fool* was made on a meager budget of $1 million (Wyatt and Hartley 5). It was not particularly successful commercially, although it was nominated for the Palme d'Or and won the award for Best Screenplay at Cannes in 1998. Until this point in his career, Hartley's U.S. independent films were anything but comedies in the generic sense. Their often extremely verbal nature, lack of action-driven narrative, and minimal camera work ensure that the director with whom Hartley is most often associated (among a long list of mainly European auteurs evoked by critics) is Jean-Luc Godard (Andrews; Andrew Sarris, "Hal Hartley's *Henry Fool*: A Study in Rejection," *New York Observer*, 21 June 1998, online at www.observer.com/node/40660; Deer 168). In terms of comedic value, the best you could say is that Hartley's early films contain moments of droll dialogue or occasional black comedy. *Henry Fool* stands out from Hartley's previous shorts and features in its grosser moments, one of which, the toilet-proposal scene, offers a strange form of disgusting physical comedy. Indeed, this is not the only moment of physical expulsion in the film. The opening is characterized by Simon's initial spells of vomiting, which are integral to the development of his character. How do these scatological moments function in the film?

When asked specifically about the purposes of the bodily functions featured in *Henry Fool*, from vomiting to defecation, Hartley comments: "I think I was trying to do exactly what [François] Rabelais did when he said, 'Let me blast out a book where I can have an enormous amount of philosophical discussion and psychological insight in a world that's completely disgusting, and somehow the philosophy and the psychology will benefit from being rendered that way rather than if the setting was more highfalutin.' . . . I made up lists of disgusting stuff to include" ("Responding to Nature" xxiv). Here Hartley equates his own intentions with the work of the sixteenth-century writer best known for drawing social satire using bawdy and scatological humor. The Rabelaisian nature of *Henry Fool* was not lost on reviewers at the time of the film's release (Macnab 53), something I revisit when I examine the toilet-proposal scene in more depth below. However, when discussing the levels of humor attached to the different bodily functions that appear in the film, I draw a distinction between Simon's vomiting and Henry's defecation. The major difference is that the vomiting scenes do not carry anything like the same comedy value as the toilet-proposal scene. This is the case even though these respective uncontrollable bodily expulsions suggest similarities between the two men. Simon's two puking episodes can be usefully understood as symptoms of his abject state, within both his family and society more generally. I use the term abject in the manner famously described by Julia Kristeva in *The Powers of Horror*, as the construction of a border—very often demarcated by the distancing of the subject from its environment through acts of revulsion such as vomiting—that separates the self from the world. Simon is clearly intended to be a socially abject character by profession, a garbageman whose job is to dispose of society's waste. In addition, as I now demonstrate, his vomiting demonstrates his abjection in relation to normative heterosexual family roles. It is this same alienated social position that Henry's body negotiates in his far more hilarious defecation episode. A discussion of Simon's two puking scenes, then, provides an informing prelude to my analysis of the toilet proposal.

THE ABJECT FAMILY

The first of Simon's vomiting spells occurs early in the film. After Simon arrives home from work unable to eat an unappetizing gruel

his sister has prepared for him, he drinks sour milk from the refrigerator and is sick on the kitchen floor. Clearly Simon's family home does not provide him with maternal succor. After all, an aversion to milk is one of Kristeva's first examples of abjection in relation to familial roles (Kristeva 2–3). Simon's vomiting thus demonstrates his abjection from his dysfunctional family (absent father, suicidal mother, nymphomaniac sister). It is Henry's arrival as a male mentor figure that provides Simon with the route to a stronger character. Shortly after Henry's arrival, Simon's second puking episode occurs. A young heterosexual couple, whom Simon previously spied on having sex, attempts to publicly humiliate him. His face is forced toward the exposed backside of the young woman, Amy (Diana Ruppe), and she commands him to kiss her ass. Simon's reaction is to vomit on her bottom. Again this expulsion does not have a massive comedic impact. In fact it might be considered a rather misogynistic moment in the film. However, it is presumably intended to show Simon's physical rebellion against heteronormative societal desires, as he is vomiting on a member of the couple he previously spied upon. This rejection is signaled as motivated in part by his sister Fay's nymphomania. Immediately following his first vomiting incident, and just prior to his second, Fay leaves for town declaring to Simon, "God I wanna get fucked." These two vomiting scenes, then, demonstrate that Simon is abject in relation to such norms as heterosexual couplings and the bourgeois family unit. The timing of Henry's arrival is therefore crucial to Simon's development from an anxious puking weakling to an internationally acclaimed writer. It is through writing, the inspiration that Henry brings him, that Simon will learn to express himself without vomiting, and engage with the society that otherwise positions him as abject.

Neither puking scene, then, is particularly funny, in comparison to Henry's toilet-proposal scene that follows later. The reason for this distinction is not the respective orifices or types of expulsion involved on each occasion, but the function of their excretions. As noted, Simon's vomiting demonstrates his character's abjection. Admittedly, Henry's later defecation also illustrates his body's position on the frontlines of his battle with the establishment, but—and this irony is where much of the comedy stems from—his temporary loss of control of his body also

Warren (Kevin Corrigan, l.) and Amy (Diana Ruppe) cause Simon's (James Urbaniak) abject body to reject socially normative desires. Digital frame enlargement.

propels him into the acceptable institution of marriage. This is funny because it goes entirely against his chosen character and lifestyle. By contrast, the physical damage that Simon's abject body receives throughout the film is far less comical, and goes well beyond vomiting. He is bullied and beaten by his contemporaries (the young couple even attempt to immolate him) and scalded with boiling water by his sister. Simon's body is at war with societal norms, and he remains intellectually at war when he becomes a celebrated but reclusive controversial writer. His vomiting is simply an early expression of his distancing of himself from society. What makes Henry's defecation funny by comparison is that his loss of control tips him physically over the border from his intellectually chosen abject position in relation to society into a forced conformity to the acceptable role of father and working husband. It is for this reason that the toilet-proposal scene can be explored using Bakhtin's theory of the carnival.

In his analysis of Rabelais's literature, Bakhtin details various forms in which folk carnival humor, which characterized the Renaissance and the Middle Ages, opposed the norms of official culture: "A boundless world of humorous forms and manifestations opposed the official and serious tone of medieval ecclesiastical and feudal culture. In spite of their variety, folk festivities of the carnival type, the comic rites and cults, the clowns and fools, giants, dwarfs, and jugglers, the vast and manifold literature of parody—all these forms have one style in common: they belong to one culture of folk carnival humor" (Bakhtin 4). In particular, this carnivalesque humor is characterized by its capacity, indeed its aim, to suspend or invert normative hierarchical relations within society. A major component of this process, for Bakhtin, is a form of "grotesque realism" derived from folk humor that emphasizes bodily functions, in particular consumption, defecation, and fornication (18). This accounts for the emphasis on bodily functions found in the works of Rabelais. However, Bakhtin is at pains to point out, this focus on the physical in folk culture has a positive, rejuvenative character, and celebrates above all else fertility and rebirth (19).

In Bakhtin's formulation of the carnival it is possible to locate the double reaction I experienced when watching the toilet-proposal scene in *Henry Fool*. On one hand, normative, learned registers of disgust and withdrawal are triggered by the noises of uncontrolled defecation. On the other hand, laughter is prompted not only by the act of defecation itself (which may not, admittedly, be considered humorous per se), but also by the manner in which its juxtaposition with the traditionally romantic act of proposal—here also inverted in terms of gender roles, with Fay on her knees before Henry—turns societal norms on their head. Bakhtin argues: "The essential principle of grotesque realism is degradation, that is, the lowering of all that is high, spiritual, ideal, abstract: it is a transfer to the material level, to the sphere of earth and body in their indissoluble unity" (21–22). In *Henry Fool*'s toilet-proposal scene, the rejuvenative aspect of hetereosexual reproduction is detached from its sanctified role within the family. The marriage proposal is reduced to an inverse, base, comic parody. This is achieved through the juxtaposition of the "ideal" of a proposal with the act of defecation, the inversion of typical ceremonial roles (who is sitting and

who is kneeling during a traditional proposal), and the replacement of the symbolic ring with a gasket from an old fridge.

Indeed, *Henry Fool* invites just such a folk understanding of its scatological humor. Henry Fool's name is clearly intended to indicate the role of the fool played by the film's eponymous character. As Simon studies Henry's luggage tag on his arrival, Henry comments, with reference to his surname: "Centuries ago it had an 'e' at the end." Thus Henry's character is associated with the role of the fool in the theatrical tradition, and he is clearly intended to function as a modern manifestation of the long social history of the fool. As Enid Welsford describes the character in her seminal study, *The Fool: His Social and Literary History*, this figure dates back at least to the medieval period and is defined, precisely in a manner that can easily be applied to Henry, as "a man who falls below the average human standard, but whose defects have been transformed into a source of delight" (xi). In this respect it is no coincidence that Hartley's *Henry Fool* is set in the midst of an anonymous, sprawling suburb. The notion of the fool as the "lord of misrule," which we associate with Bakhtinian societal role reversals (in which fools become kings for a prescribed day each year, and vice versa), developed in the Middle Ages due to "the growth of towns" and "the increasing importance of the bourgeoisie" (Welsford 198). Woodside, then, is the most appropriate contemporary context in which to question normative bourgeois values by demonstrating their uneasy physical fit with the lives of its inhabitants. In such a context, several centuries of bourgeois tradition associated with marriage are exposed as normative conventions through their juxtaposition with Henry's uncontrollable shits.

"What's Scatological Mean?"

In interviews, Hartley has cited numerous literary inspirations for *Henry Fool*, from *Faust* to *Don Quixote*. Most pertinent for this discussion of the comedic impact of the toilet-proposal scene, Hartley acknowledges the similarities between the Henry/Simon relationship and that between Falstaff (who displays numerous characteristics of the vice or fool) and Prince Hal in Shakespeare's *Henry IV* (Hartley, "Responding to Nature" xi). Like Shakespeare's play, *Henry Fool* delights in mixing the sacred with the profane, moving seamlessly between matters of

state and lowlife, drunken, and debauched characters. This contrast of registers occurs on numerous levels, including the dialogue, actions of the characters, and even the film form.

The dialogue switches continually between philosophical, political, and cultural discussion and scattered commentary on matters physical. Perhaps the clearest comical instance of these different registers abutting against each other occurs when, in the immediate wake of a priest's candid confessions as to his existential doubts, Henry asks him: "Listen, father, have you got any money? Let's go have a drink." Again, although less amusing, the empty rhetoric of Congressman Owen Feer's (Don Creech) political campaign purportedly aims to restore the U.S.A. to its previous status of "unmatched wealth, power, and opportunity" (along with a return of its "cultural, moral standard") presumably through the power of such bland and meaningless statements. Yet this rhetoric contrasts sharply with the down-to-earth everyday lives of the characters in Woodside. In particular Warren (Kevin Corrigan), after campaigning for the losing Congressman Feer, becomes disillusioned with life and returns to his former, inarticulate world of drink and drugs, before descending into wife-beating and child sex abuse.

In terms of such contrasting registers in the action, Simon's rise to fame in the literary world is juxtaposed with the everyday banality of his work as a garbageman, and the generally debauched drinking and sexual activities of those around him (Fay is undiscerning in her choice of sexual partners, Henry pauses in the midst of seducing Fay to sleep with her stupefied mother, and so on). The institutions that determine normative cultural standards are thus derided for their pomposity through simple contrasts between ideals and physical realities. For example, Simon's poetry receives a ban from the Board of Education after a section is published in a school magazine, the Parents Association of the local high school considering Simon's verse pornography. This prompts Amy, now transformed from a crack-smoking hooligan into an editor of the high school newspaper and budding groupie of Simon, to ask Henry, "What's scatological mean?" In a simple physical response to this news, and one of the funniest moments of the film, Henry silently congratulates Simon by simply proffering him his hand to shake.

Finally, these contrasting registers also appear in formal terms. At a pivotal moment in the film a striking parallel montage juxtaposes

David Martin-Jones

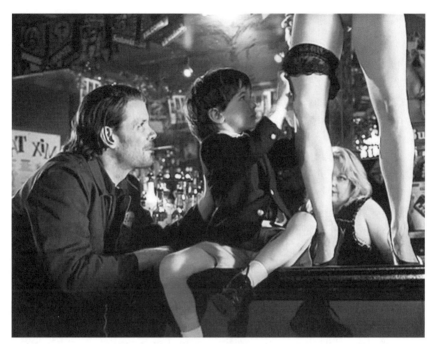

The rendering base of sacred institutions: Henry takes his son, Ned (Liam Aiken), to a local bar. Digital frame enlargement.

Simon discovering the suicide of his mother with Henry and Fay fornicating in the basement. Poignantly, yet also somewhat grotesquely, Henry and Fay's cries of ejaculation are audible to Simon as he drags his mother's body out into the street and cradles her in his arms.

This mixing of normative ideals with brutal physical realities culminates in a scene toward the very end of the film in which Henry takes his young son Ned to a bar and gives him a drink and a smoke. Once again, as was demonstrated in the toilet-proposal scene, all that is sacred about societal norms (here childhood and the sanctity of the family in the private sphere) is rendered base through its juxtaposition with a public space associated with drink and debauchery. On this occasion, however, there is far less to laugh about, for while Henry's roguish actions are framed in a way that renders him more irresponsible than evil, they still expose the danger associated with his easy transgressions of conventional borders, such as his previous conviction for the statutory rape of a minor.

Henry Fool's carnivalesque juxtaposition between baser bodily activities and idealized institutional norms also reflects upon the desires of its target audience. As David Andrews notes astutely in *Film Criticism*, the scatological moments in *Henry Fool* are not accidental or deployed solely for shock value: "The narrative significance of the bathtub next to the toilet [is] variously connected to Simon's scalding hence Fay's 'rebirth,' the suicide of Simon's mother, the engagement of Fay and Henry, and Ned's birth." Andrews concludes, "What is shocking about *Henry Fool*, then, is not its scatology but its mastery—which is apt in view of the film's depiction of the shock that greets a masterpiece." As Bakhtin notes, the all-inclusive laughter of the carnival "is also directed at those who laugh" (12). Given that Hartley is provoking his audience to question their own laughter at these Rabelaisian scenes, we might ask the identity of this audience, a demographic that has become easier to identify due to the rise of actors like Parker Posey (facilitated by her association with nonmainstream directors like Hartley) to something that can be equated with indie stardom.

Discussing Posey's niche star persona as "queen of the indies," Diane Negra argues that her success "is crucially tied to her ability to perform the reconciliation of bohemian and bourgeois sensibilities that, as David Brooks has argued, now widely characterizes the privileged class of taste makers (a disproportionate segment of the independent audience) in American culture" (71). Negra is referring to David Brooks's book about bourgeois bohemians, *Bobos in Paradise*. Brooks argues that a centuries-long distinction between the bourgeoisie and bohemians has been reconciled by the rise since the 1960s of a dominant U.S. social class, whose values combine a meritocratic careerist drive inherited from the bourgeoisie with a bohemian alternative lifestyle. For Brooks, Bobos are "enchanting paradoxes . . . grounded but berserk, daring yet original, high-flying yet down to earth" (16). It is precisely this audience that Hartley engages in *Henry Fool* through his story of a garbageman's sudden rise to fame for writing scatological poetry.

"I wanted to set up a situation where enough people call it art, and enough other people call it crap, and then pay attention to that

conversation," confesses Hartley (Anthony Kaufman, "Hal Fool: The Push, Pull and Play of Hal Hartley," *indieWire*, 1999, online at www.industrycentral.net/director_interviews/hh02.htm). This is true of both Simon's scatological poetry, the film's subject, and the film itself. Yet the film's indie critique of audience tastes is much easier to see in retrospect, by viewing *Henry Fool* through the filter of its sequel. *Fay Grim* appeared eight years later and directly engaged with the U.S.'s position in the post-9/11 world, the emphasis shifting away from juxtaposing bawdy reality against idealized norms to exploring how sexual content, and the publicity it engenders, can distract attention from the more concrete ramifications of global geopolitics. The foregrounded narrative of media taste seen in *Henry Fool* is further developed as Hartley provides a remarkable back story for Henry, portrayed as a revolutionary figure who incites oppositional thinking among lowly characters down through the ages (his marriage certificate lists his year of birth as 1591). Of all the literary inspirations for his characters, Hartley most often cites Goethe's *Faust*, aligning Henry with Mephistopheles (Hartley, "Responding to Nature" xi; Hartley, *True Fiction* 94; Wyatt and Hartley 3). Accordingly, *Fay Grim* delights in the idea that Henry is a demonic rather than a human figure, a living legend from antiquity known as the "Harem Fool," who infiltrated a sultan's harem and seduced the wives therein, after which his life was saved only by recounting his fabulous life as a lengthy confession.

The way in which the figure of the fool functions in this process to some degree alters our understanding of the previous interaction between the body and societal norms seen in *Henry Fool*. It demonstrates much more obviously the extent to which public discussion of depictions of baser activities (sex in particular) can be used as a distraction from the political machinations of governments in the international sphere. In this process a meta-cinematic device is used to further question the audience's role in cultural production. Henry sends Ned a hand-cranked "what the butler saw" viewfinder depicting an orgy in a harem. This object leads to Ned's expulsion from school. In the raunchy scene depicted, on the wall behind the figures engaged in sexual activity is a motto, in Turkish. Several religious figures of different denominations are called upon to translate the slogan, which is finally deciphered as "An honest man is always in trouble." This was Henry's favored saying in *Henry Fool*, and, we are told by Simon,

the first line of his confession. In *Fay Grim*, however, that confession is refigured as a coded manuscript, a surface of debauched sexually explicit adventures obscuring a deeper narrative of Henry's involvement in Cold War political intrigues, including in Chile in 1973 and Afghanistan in 1989.

When reconsidered in light of *Fay Grim*, *Henry Fool*'s scatological, carnivalesque comedy is clearly used to meditate on such idealized institutions as marriage, childhood, family, and the broader political sphere. The film thus confronts the bobo audience with its own complicit laughter in the moralizing media circus that surrounds cinematic depictions of the body, and the way it can distract from concrete geopolitical issues like foreign policy. Ultimately, perhaps this is not-so-funny shit.

R. Barton Palmer

Homeric Laughter in *The Treasure of the Sierra Madre*

> Though by definition inarticulate . . . [laughter] is nonetheless a means of communication. . . . Though typically fugacious in its vocal and facial manifestations, it can also serve as a highly charged medium of personal and social relationships.
>
> Stephen Halliwell, *Greek Laughter*

> When gold commands, laughter vanishes.
>
> Jean Renoir, *The Golden Coach*

Uproariously Uncomic

Like many a Hollywood film, John Huston's *The Treasure of the Sierra Madre* (1948) ends with a rapidly moving pursuit that, its object attained, unties the knot of events that constitute the narrative, resolves the plot, and permits a central revelation, which is neatly summarized by a main character, Howard (Walter Huston). For commercial films of the era, his closing speech, and the brief dialogue it prompts, constitutes a form of closure that, if not *de rigueur*, is deeply conventional. But *Treasure*'s conclusion is otherwise far from ordinary, engaging as it does with political and ethical questions customarily avoided in the typical Hollywood production and conforming to Huston's express desire that his filmmaking engage with "broad social conditions" and so encourage viewers to "reflect upon the significant ideas about place and time" (qtd. in May 238). *Treasure* is an adventure story otherwise filled with

exciting action. But this climactic moment involves no derring-do, no physical encounter between protagonists and antagonists contesting for possession of a fabulous treasure—sacks heavy with gold dust mined from the nearby mountains. This treasure motors the narrative, in the manner of countless fairytales, and yet the plot turns instead on Howard's surprised realization that the gold is only *apparently* of unchallengeable worth and may in fact have no real value, especially for him and his partner, Curtin (Tim Holt). For the viewer, this transformation reveals that the gold is a cunningly deployed MacGuffin, a plot-motivating object that, if not here forgotten or bypassed as in Hitchcock's films, is drained of its presumed value and displaced (at the very last moment) as a narrative goal. In an interesting correlative to this unexpected shift, the gold actually disappears, or, to be precise, reassumes a form that prevents its further possession. In the end, what was once treasure is now only dust scattered by a relentless wind. Henceforth it can and does belong to no one but the natural world whence it came and to which it returns.

The climactic pursuit ends with deep irony for Howard and Curtin. In the manner of typical Hollywood protagonists, they regain what is "theirs," but this is only to recognize at the same time the renewed and now irrevocable loss of all they had striven to possess. Finally the gold is present all around them, but it has become ungraspable and hence strangely absent. To be sure, the two men get their hands on the sacks once again, but these are now empty of the fabulous wealth they once contained. Even more strange is that human hands worked this seemingly inexplicable destruction. And so, in a typically Hustonian gesture, the characters' success in their quest signals an unexpected form of failure. But all is not lost. Moving beyond the simple fact of loss, the film's ending also reveals how this failure grounds a different form of understanding that comes from Howard's productive contemplation of the fate to which chance and human weakness have delivered him and his partner. *Treasure* does not conclude simply with the frustration of the quest with which it began. As in many Huston films, with *The Maltese Falcon* (1941), *Wise Blood* (1979), and *The Dead* (1987) as perhaps the most notable examples, failure is not the outward sign of an impotence leading to paralysis and stasis that it initially seems. Failure instead energizes the renewed assertion of the self that for Huston comes to an end only with death or the complete loss of freedom of

R. Barton Palmer

action. The revelation of a fundamental contradiction in the treasure endorses the pointless indispensability of all that has gone before, as the plot closes by rejecting the acquisitive intention that set it into motion. This conclusion, however, clarifies what ends of greater (because immaterial) value might be pursued.

The Treasure of the Sierra Madre is hardly a film in which what we might broadly call the comic figures prominently. And yet, central to its complex thematic development is that Howard's moment of confused contemplation of the empty gold sacks suddenly ends in an outbreak of unrestrained and riotous laughter that B. Traven, in the source novel, terms "Homeric": "Then he let out such a roar of Homeric laughter that his companions thought him crazy" (305). As Joseph William Hewitt suggests, this term refers primarily to the quality of the laughter, "a loud and long-continued burst of merriment," and certainly, in an unforgettable visual rendering, Huston emphasizes how Howard's laugh is, to use the Greek term, *asbestos* or "inextinguishable," as the man finds himself rocked uncontrollably by paroxysms that seem to come from deep within (436). In the scenes of laughing represented in the *Iliad* and the *Odyssey*, as Hewitt points out, "sinister elements predominate heavily." Here, however, while it is neither cruel nor mocking (like much of the laughter in Homer), Howard's uproar is mirthless, prompted by profound misfortune rather than humor. How else might we describe the revelation that months of slavish effort have come to absolutely nothing?

In these circumstances is it crazy for Howard to laugh? Perhaps. Interestingly, the term Homeric laughter enjoys not only literary but also medical currency, as it is used to describe a symptom that often indicates some disease process. *Segen's Medical Dictionary* defines Homeric laughter as "uncontrolled spasmodic laughter induced by mirthless stimuli, a symptom of organic brain disease that indicates a poor prognosis. Homeric laughter may occur in multiple sclerosis, pseudobulbar palsy, epilepsy, intracranial hemorrhage, frontal lobotomy, and kuru, which causes 'laughing death'" (http://medical-dictionary.thefreedictionary.com/Homeric+Laughter). True to Traven's account of the episode, in the film both Curtin and the accompanying villagers initially regard Howard's seemingly inappropriate outburst with stupefied disbelief, obviously wondering if the man has lost his mind. He has not, as soon becomes evident. The laughter expresses

not the more complex lack of control that would lie behind "laughing death" but instead his surrender to the moment.

Standard notions of laughter, that peculiarly human phenomenon (at least according to Aristotle), do little to explain mirthless spasms like those that overtake Howard. These spasms seem a violation of the protocols of decorum that demand, as much in life as in literary texts, some kind of separation between high tragedy and low comedy. Such a physical reaction masters the very subject who is its source and ground of being, and so the Homeric laugh, if only momentarily, constitutes a possession of the self by the very body in which it finds a home. Involuntary, such mirthless laughter finds its source in neither the puzzling incongruity so carefully anatomized by Henri Bergson (the discovery in things and people of a certain mechanical inelasticity) nor the genial but wry social reflectiveness at the heart of George Meredith's understanding of the comic. The approaches taken by Bergson and Meredith are immensely useful in diagnosing the kind of affect offered by the physical displays of silent screen comedians like Charlie Chaplin and Buster Keaton, or the more sophisticated, class-based dramatizations of Molière or Wilde. But Homeric laughing demands a separation from the concept of humor as such. In the case of Huston's film, Howard's sudden roar turns out to be highly serious, for it drives the story toward a crucial moment of recognition. Values shift and the object of life itself alters completely in the wake of Howard's laughter. This movement of consciousness and tone certainly reflects Homeric narrative, distinguished by those "slight turns of the prism [that] bring into focus tragic, epic, humorous, satiric, or comic elements, always incipient, now and then evident, sometimes latent, intimately related, and strangely mixed" (Bell 116).

Outbursts of the Homeric type, though they are literally if only temporarily *asbestos*, involve much more than either the complex, varied display of easily observable symptoms or the identification of a specific instigating object (see Halliwell). The inextinguishable, mirthless laugh is often deeply semantic. It is laughter *at* but also laughter *for*. Laughter, of course, is relentlessly social, a phenomenon—one might almost say a performance—that cannot arise from and in solitude. Unlike the sardonic thought, the humorous perception, or the anger that takes shape as silent inner dialogue, it cannot exist for us alone. "Our laughter," Bergson observes, "is always the laughter of the group, not only a

R. Barton Palmer

shared physical phenomenon, but a shared perception" (64). The social aspect of laughter is perhaps paradoxically more intense when the message (if that is the right word for something that seems pre-conscious) is deeply involuntary, when it actualizes some surge of emotion that overcomes the somewhat puzzled subject in a fashion that is truly—as Halliwell so well puts it in the epigraph to this essay—fugacious (5). Such laughter, though transient, is not fleeting but taking flight, as if under the control of some unknowable agent that is both in and beyond the self. Especially as in passages like this one in *Treasure*, where it is at first resolutely singular, but then richly dialogic, Homeric laughter constitutes a form of the paralinguistic that displays in order to be read for its interpersonal meaning. In *Treasure*, this dramatic and public onrush of an incongruous expressiveness, thoroughly unanticipated, provokes sharing, interpretation, and a discussion that bends the characters toward radically different forms of action. Such a reorientation of collective/individual thinking is at the heart of Traven's novel and Huston's filmmaking, both of which are characterized by a never subtle high-stakes didacticism.

ALL THAT GLISTERS IS NOT SAND

Although B. Traven's identity remains something of a mystery, his anti-capitalist politics, developed in an impressive series of writings, are not; it would be an understatement to suggest that Huston found these politics congenial (for details see Treverton). Like its best-selling source novel, *Treasure* becomes an economic morality play that anatomizes the civilized urge for pure riches—specifically gold—as value, indeed as the measure of all other value, simply because it has been constituted by the mysterious involuntary collectiveness of advanced culture. In Western culture, gold has long set the standard for what material worth, otherwise emerging only from a constantly fluctuating comparability, might be understood as being, apart from any and all questions of utility other than its function in complex forms of exchange. Like its source, Huston's film assumes from the outset an allegorical abstractness that controls, even as it does not overwhelm, the story's inherent realism. Because its characters pursue gold in its most natural and basic state, *Treasure* inevitably references the pursuit of wealth in any and all its different forms, tracing the search not for a

thing of intrinsic value but rather for a potentiality. What those who seek it so desperately—and correctly—understand is that gold constitutes the key to possession itself, the exquisite aesthetics of its shining appearance figuring as the appropriate signifier for a kind of transforming and universal power. Gold's beauty is an effect of the value it is postulated as embodying (a point memorably made in Huston's earlier film about another quest for the most precious of metals, *The Maltese Falcon*, in which the gold is promised in what gives the film its title, an enigmatic objet d'art that loses its interest for a group of pursuers once they discover that its black outer coat of paint conceals only base metal within).

Cast in the form of an adventure tale built around the surprising twists and turns characteristic of the genre, Huston's *Treasure* occupies itself with the difficult, dangerous, and ultimately fruitless attempt to find and hold onto a small fortune of the gold that is there for the taking. A shared desire to "strike it rich" forges a partnership between three drifters, Americans who find themselves penniless in a Mexican town where opportunities even for marginal survival are few and far between. Dobbs (Humphrey Bogart) and Curtin meet up when they sign on with a contract boss supplying roughnecks for oil exploration. Cheated of their wages by the contractor after weeks of grueling labor, they act together to beat the man into submission and collect only the money owed them, leaving his wallet otherwise stuffed with bills. Frustrated by the malfeasance they've suffered as wage laborers, a state in which they are subject to the power of the boss, Dobbs and Curtin determine on a different plan to make the money they imagine they need to be happy, and this, they hope, will provide more certain rewards. Now possessed of capital that could at least partially finance an independent venture of some kind, the two decide to rejoin an old prospector, Howard, whom they had met the night before at a flophouse and who had regaled them with stories of his years of sometimes successful prospecting. Howard, they conclude, possesses the experience and knowledge needed to make a successful strike ("I've dug in California and Australia . . . all over the world practically"), but the old man also, by way of issuing a warning, details to his eager interlocutors "what gold does to men's souls."

In part, as Howard hints, the danger of devoting oneself to the pursuit of riches in their purest, most symbolic form is that success is

R. Barton Palmer

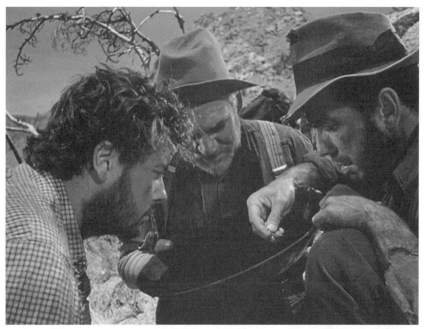

Close cooperation marks the purposive male partnership of (from left) Curtin (Tim Holt), Howard (Walter Huston), and Dobbs (Humphrey Bogart), the three gold prospectors in John Huston's *The Treasure of the Sierra Madre* (Warner Bros., 1948). Digital frame enlargement.

always already haunted by the failure that attends the endlessness of the acquisitive urge, especially once it has been whetted by the excitement of a find: "Never knew a prospector that died rich. If he makes a fortune, he's sure to blow it in trying to find another. I ain't no exception to that rule." But even more potentially disastrous, as Howard goes on to remark, is that the desire for gold can easily overwhelm even the most deeply held and sacred of moral principles. If partners strike it rich, then "all the time murder's lurking about." Enunciated, this warning has no effect, not even on the man who issues it and who has seen and done it all before, so unreasoning is the powerful lure of gold's possible discovery (a point that could be amply illustrated from the history of the various nineteenth-century gold rushes). Curtin and Dobbs both agree that such risks are worth running, but the expedition gets underway only after Lady Luck seems to be shining upon it: a lottery ticket Dobbs had bought pays off, and the winnings provide the

trio with the money for equipment and supplies once Howard kicks in with his own meager savings.

Luck continues to be on their side once the expedition gets under way, or so it seems. In rather short order, the eager prospectors, carefully tutored by Howard, discover a rich vein in the remote northern Mexican wilderness. The film details the back-breaking and potentially fatal labor that working this strike requires, an aspect of their quest dependent, like the financing of the venture itself, on the continued cooperation of the three partners. Only working together can they wrest the minutely fragmented metal from the depths of the earth and then separate it efficiently from the worthless surrounding dirt it otherwise so closely resembles, at least to the untaught eye. In fact, as the narrative of seeking, of loss and gain, plays itself out, *Treasure* works over the fraught relationship between gold dust and dirt that is physically reoriented, if only provisionally as it turns out, by considerable skilled labor. Tellingly, in the end the efforts of the prospectors are defeated—and not only by *bandidos* who threaten them at every turn with death and dispossession, or by the fear, betrayal, and, eventually, robbery that break the bond of their partnership (which is nearly ended by homicide).

Like Huston's justly famed caper film *The Asphalt Jungle* (1950), *Treasure* focuses on the replication of archetypal forms of skilled human work, even as it delineates and dramatizes one of the most basic, if foundationally paradoxical, of social forms: the purposive ad hoc male partnership pursued mutually as the means for collectively satisfying separate but interchangeable acquisitive urges. This tale of wilderness mining, to put it another way, is about getting and having in their most essential and reductive forms. And, given the structural instability of the prospector trio, it is hardly surprising that the film's ethical concern becomes the greed that can destroy all of them once the improbable goal of attaining great riches is reached, once each partner possesses what the others desire and self-interest, narrowly conceived, might no longer provide any reason for continued cooperation. The gold they have mined together and now divided equally is fungible in the extreme, bearing no marks of ownership, personal connection, or manufacture. In the primitive society the film depicts, where the state is largely absent, success would mean the onset of the war of all against all. Like all precious metals, this gold is a substance as neutral as air or

water, and as convertible to being used or owned by anyone. If other items such as pack animals and hides can be identified through their particulars, communicating in their very form the story of their ownership and thus, once the signs of possession are read, unmasking any thief, gold is inherently different, the very universality that makes it an ideal medium of exchange flowing from an abstractness that invites possession by one and all. As the novel and film depict gold, it is always already there in the mountains where geological forces have concentrated it, inviting its collection and possession by those lucky and energetic enough to possess themselves of it. No property rights attach to whatever is found and taken in the kind of pre-capitalist society the film conjures up.

In the role that it came to play in the developed world (the source, it seems, of the very concept of money itself, for which, in some languages, it is a synonym), gold occupies an unquestioned primacy of place, having been long used until quite recently to "back" the value of promissory currencies whose "actual" worth in economic exchange can simply be postulated. In more primitive cultures, however, the value of gold is far from self-evident to those who are cut off from an economic life carried on through money, however compelled they may be in poverty to be ruthlessly acquisitive in order to meet the most basic of needs. An interest in gold and the field of social meaning it controls, in other words, is hardly universal, or so *Treasure* reminds us. But the novelist and filmmaker agree with political thinker Thomas Hobbes that acquisitiveness is not the historically specific product of capitalist reification but a constant of human nature (at least absent a consensus or power that forces its suppression). Particularly as ore or dust, gold in its thingness must be recognized as the social concept "gold" in order for its preeminent worth to come into focus. Thus, unlike other things—natural and manufactured—that are of obvious sustaining value (food, cloth, drink, and tools), gold's function within human society eludes the untutored phenomenological grasp.

While those things of evident utility can be the object of self-serving and conscienceless acquisitiveness (as the film illustrates by putting at its center not just the internecine conflict of the three erstwhile partners enriched with their own sacks of gold dust but the competition between the miners and the impoverished gang of *bandidos* then ravaging the countryside), *Treasure* suggests the joke that, with its utility

largely exhausted by the decorative beauty it achieves once refined, gold otherwise counts as nil wherever simple survival is at the apex of the hierarchy of needs. What dominates are those things found in nature or produced by human hands, whose core values—best provided for through productive or rapacious collectivity—are not fungibility, but rather nurturance, comfort, and protection.

Treasure does not meditate simply on the all-too-obvious discontents of greed, which in this narrative does not easily divide the virtuous from the venal. If, as many suspect, the novel's source is Geoffrey Chaucer's "The Pardoner's Tale," our trio of adventurers, compelled to the same rivalry and mistrust as their medieval models, goes beyond discovering that the gold they seek is nothing but death itself. Here lies the truthfulness of the teller's closing moral, intriguingly altered from its Scriptural original, which makes pride the deadliest of sins: *radix malorum est cupiditas* (the root of all evil is greed) (for further details see Kirby 269–70). Like the novel, the film contests the Hobbesian truism that the war of all against all, however unavoidable its outbreak, must disastrously prevail when inherent equality is not superseded by individuals who surrender their sovereignty to some master. In this tale that tests the resources of individuals rather than institutions, duly constituted authority appears only fleetingly and is not to be surrendered to: mounted *federales* give chase to the *bandidos,* and the soldiers appear sporadically in a barely settled Durango to execute malefactors apprehended by the villagers. But these representatives of a government that otherwise does not make its presence felt cannot otherwise guarantee the rule of law; self-preservation is the order of the day in a world that promotes the very kind of radical individualism that eventually dooms the erstwhile partnership of the three white men.

Ironically enough, it is because the ad hoc trio attains its object that things fall apart. The cooperative bond that joins Dobbs, Curtin, and Howard is severely tested as Dobbs is driven by paranoia and greed to steal his partners' goods. Afraid to be robbed, he shoots down Curtin in cold blood after Howard leaves the group temporarily. But then, as he makes his way back to civilization so that he can turn "his" goods into money, Dobbs is himself killed by three bandits because he now lacks the protection that his erstwhile companions, those supposed rivals, might have afforded. A man alone, the narrative suggests,

cannot survive even in possession of unbelievable riches (a fortune that—to further the irony—the brutal men who strike him down are incapable of recognizing). The killers are cunning enough to recognize the relative strength in their numbers, an advantage that Huston makes clear by his staging of their attack to show how Dobbs's pistol offers no advantage because he can kill only one of them before the other two seize and kill him. If not interested in a gold whose nature or value they cannot recognize, the bandits are attracted to the array of Dobbs's useful items, including and especially his boots. Curtin, it turns out, was not mortally wounded and crawled off into the brush, thus escaping an attempted morning-after *coup de grace*. And, in a coincidence typical of the plot's rather melodramatic elements, he soon happens upon Indians who treat his wounds and reunite him with Howard. The two depart for Durango, toward which they know Dobbs must also have been heading, as a first stop on the road back to civilization. It is as a mutually supportive pair that Curtin and Howard survive the morale-challenging onset of mutual distrust (which is shown to affect them both, if not as devastatingly as it did Dobbs). Once again following Traven, Huston here dilates upon Hobbes's more limited understanding of the possibilities available to humankind for the transcendence of a simple-minded self-interest.

Treasure deconstructs the consensual basis of value, for the story makes clear that gold is the unmistakable sign that value, like other forms of meaning determined by the impersonal workings of the collectivity, is always already conventional, not a quality resident in things themselves. Social histories determine the basis of value, and gold does not emerge everywhere and at every time to a place of unchallenged eminence. In fact, *Treasure* dramatizes how gold may not be seen as meaningfully distinct from the undifferentiated dirt in which it is always found. Part of the genius of Huston's film is that in his screenplay he carefully follows Traven's Rousseauan lead in making this point, staging a complex interaction between a modern society where gold is unquestioned king and the "primitive" culture of the Indians who live where the big strike is made but are ignorant of its supposed value. It is the final and most revealing of those cross-cultural encounters that unintentionally destroys the treasure the three *gringos* have only with great effort and sacrifice amassed, prompting Howard's mirthless but spiritually renewing burst of laughter that acknowledges, if in some

sense involuntarily, that the Indians and bandits are right in thinking the gold of no value.

OTHER ROADS TO TRAVEL

Consider the complexity of the film's finale, its unconventional conventionality, its provision of a happy ending based on profound loss and deprivation. After shooting Curtin, Dobbs had taken the several burro loads of gold dust that were hidden from view by the hides of wild animals that the miners had killed during their weeks of work in the distant mountains. His wounds only superficial, Curtin had crawled to safety in an Indian village, there to be eventually reunited with Howard, who is being regaled by the same tribe because he had earlier served as their doctor, bringing back to consciousness a young boy who had almost drowned. Following Dobbs's trail, Curtin and Howard enter the village, and the Indians inform them of the recovery of their goods from the *bandidos* who had taken them. But there is nothing but the animals, the hides, and the mining equipment; the gold is nowhere to be seen. However, a young boy who had happened on the scene of the robbery told Curtin and Howard that he had seen muslin sacks on the side of the road. With their somewhat puzzled Indian companions the white men hasten to the scene, thinking their substantial riches were simply abandoned in error by the three thieves.

The thieves, the Indians relate, thought the sacks to be full of sand. The opportunistic robbers left them behind, taking only the burros and the other material goods that possessed a value they could understand. This mistake (if that is what it is) seems incredible to the white men. It is perhaps fitting, then, that the attempt of the thieves to sell these goods to the villagers ends in disaster. Their pretense to ownership is quickly seen by the villagers for the lie it is because the burros bear a brand recognized as belonging to the *gringos* while one of the thieves, incongruously but understandably enough, is wearing Dobbs's sturdy boots. Resigned to their fate, the thieves are quickly executed by a troop of *federales*.

The thieves did not intend to destroy what Howard and his partners struggled for weeks to possess, but destruction has been the result: a discarding of what is considered irrelevant and useless. For the *bandidos* the gold dust was just another kind of dirt, and they were puzzled

to discover that the "dirt" hid nothing of "real" value within. Taking the burros, the hides, and the boots from their victim, they had briefly felt triumphant in securing something they could exchange to acquire what they needed to live. For such a petty theft (or so at least it seems to Curtin and Howard), they had suffered with surprising alacrity the loss of all they owned, digging their own graves in an actualization of the proverb that Huston handles with characteristic irony and good will, as one of the robbers asks permission to put his sombrero back on before being riddled with bullets. In a turning filled with deep irony, then, the increasingly paranoid Dobbs, terrified that his "goods" might be stolen by his erstwhile partners, was murdered by thieves who never recognized what his burros were actually carrying.

Howard looks intently at the disemboweled sack, an object both familiar and strange. It belongs to him and his partners and was used by them to carry away the fruit of their labors, but now—and by some strangely directed human agency—its presence has come to signify the absence of value. He seems intent on divining the significance this sack has unexpectedly assumed. The condition of ravaged emptiness contrasts so starkly with the treasure it once contained. And yet his look communicates a profound uncertainty and incomprehension; his expression registers shock and loss, to be sure, but there is something more. Although surrounded by others—the Indian villagers who have guided him to the spot and his partner, who also seems lost in bewildered contemplation—he says nothing. There seems to be nothing to say, as Howard seems to feel the pressure of the moment to pass some kind of judgment, to evaluate in some fashion the sudden onset of valuelessness. It is at this moment that he is suddenly convulsed by deep and overpowering laughter. Not knowing why he laughs (or indeed why he should even be distressed), the Indians join in with him. Laughter is infectious and so difficult to resist, a gesture of human solidarity that confirms in the most elemental terms the all-too-human impulse toward brotherhood and fellow feeling.

Howard's laugh restores a sense of community that can exist even in the presence of incomprehension and unknowability. Their loss, Howard now explains to Curtin, is a monumental joke played on them by whatever metaphysical power has control over human life. He means that the joke is not just the loss itself, but the emptying of the value of the gold before it is unwittingly given back to the natural order. What

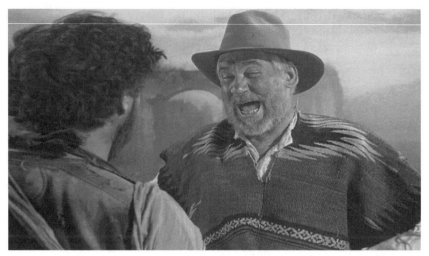

Howard's burst of inextinguishable, mirthless laughter follows his discovery that the treasure of gold dust he and his partners had worked so hard to obtain has been discarded by marauding *bandidos* as worthless. Digital frame enlargement.

the thieves have done carries a double meaning, whose obvious incongruity must in some sense generate Howard's uproar. They have taken something from him and Curtin that they did not mean to take, in the process contesting, if involuntarily, the value that the two of them had put on the "treasure" they had risked so much to amass. And Howard and Curtin have lost something that just might not matter. This loss leads them to reconsider what they do have or might want to have that might be of more lasting value. Like many of Huston's heroes, from Gay Langland in *The Misfits* (1961) to Gabriel Conroy in *The Dead*, the two have succeeded in their failure, a finale that merits the dismissive acceptance that Howard's laugh comes to signify.

The moment of enlightenment is meaningfully inner, appropriately communicated by the Homeric laughter that comes from deep inside, from that part of the self that is not strictly under the self's control. What Howard and Curtin come to value depends not on some new form of knowledge but rather on an internal seizing of the opportunity to know what they in fact already know. Howard, as he now understands, has a future with the Indians who have come to accept him as a medicine man of great power. Curtin, as Howard suggests, would do well to return to farming. Curtin had thought of that possibility,

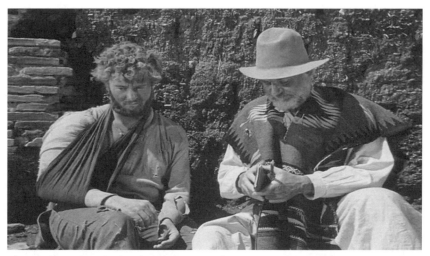

After sharing a cleansing laugh at their strange fate, Curtin and Howard determine together how life can be lived with more profit closer to nature and in company with loving others. Digital frame enlargement.

that it would be right to stay more in touch with ineffable goods—meaningful work, the pleasure of watching things grow, the company of a loving spouse. Intent on having the gold, however, he had dismissed the possibility of this transformation, which he now accepts as a path to follow.

Traven and Huston both recognize that the movement of consciousness that Howard experiences is best expressed by the involuntariness of an unrestrainable laughter that first affects Howard and then, its significance explained by the man it has overcome, Curtin, who himself is immediately caught up in its spell and begins to laugh himself. This laughter is at turns symptomatic and communicative, both an unsummoned and uncontrolled reaction to a reconsideration of what is true. The impressive yet unintended physicality of the laugh authenticates the message that Howard assigns it. This epistemological turn both completes and undermines the impressive assertion of the protagonists' energy and ingenuity. As it turns out, Howard's burst of mirthless laughter is truly *asbestos*, an unavoidable and enduring signpost pointing toward how life might be better lived, in the fellowship and intimate connection that the film otherwise so movingly dramatizes. To be sure, *The Treasure of the Sierra Madre* is constructed, as

Lary May suggests, on a stark contrast between the self-destructive individualism (read: the greed behind the capitalistic urge) embraced by Dobbs and the "communal values" that have an enduring appeal for both Curtin and Howard (246).

But in the end this conflict in moral philosophies is as forgotten as Dobbs's corpse, with whose disposal the film is unconcerned. Howard and Curtin reject materialism and embrace a return to the primitive, not because of the negative example furnished by their partner's surrender to paranoia, perhaps the most destructive form of self-concern. In their plans for the future, the two ex-miners give expression, as May argues, to a potent form of "vernacular instincts" that lie far beyond the populist politics of the older directorial generation's engaged directors, notably Frank Capra (247). The focus of Huston's film is not on the ordinary man of good will who, having reached the end of his resources, is saved either by the hallowed forms of republican government (*Mr. Smith Goes to Washington*) or by the aroused compassion of the neighbors he had always treated fairly (*It's a Wonderful Life*). Howard's Homeric laugh, in contrast, testifies to the indomitable power of the individual spirit on its own to effect a radical turning away from demonstrably false goods toward, as May appropriately terms it, "life's true 'treasure': a republic of love, community, and *independence*" (247, emphasis added).

Dominic Lennard

"Why So Serious?"

Battling the Comic in **The Dark Knight**

Our first glimpse of the caped crusader in Christopher Nolan's cele-brated *The Dark Knight* (2008) is not quite as impressive as we might have expected. The setting is a car-park after dark, where a posse of bemused drug dealers confront their supplier, Dr. Jonathan Crane (Cillian Murphy), a.k.a. the Scarecrow—the psychedelic rogue from Nolan's earlier *Batman Begins* (2005)—over a noxious batch that in-duces terror rather than pleasure in its users. Then Batman appears. Or *a* Bat Man, anyway: awkwardly dressed, hand showily on hip. Yet another Bat Man lopes behind the crooks' parked van, captured in a split-second cutaway; then another one—rifle toting, incongruously overweight. The Scarecrow notices the discrepancy immediately upon being fired at by the first of these masked men: "That's not him . . ." Assailed by another of the Batmen, he adeptly counters by filling the imposter's face with the fear-inducing fumes that formed the primary threat of the earlier film. The real Batman (Christian Bale) arrives shortly afterward, thundering through the car-park wall in his ultra-militarized Batmobile before dispensing with the dealers as well as the vigilantes. "Don't let me find you out here again," he tells the men, once they are roped and stacked together in a sorry chain that implies the equal guilt of the criminal and the imitator. However, as Batman ceremoniously leaves, buoyed by an orchestral swell, the overweight imitator speaks up with a question that threatens to disrupt the dark and momentous rhythms of the scene that have positioned Batman as

an awe-inspiring spectacle: "What gives you the right? What's the difference between you and me?" If the question is serious—phrased in a righteous warble—the response is not: "I'm not wearing hockey pads," bellows the Dark Knight as he clambers into the armored car, leaving the "Fatman" to consolidate the quip by gazing pitifully down at his makeshift duds.

This scene clearly informs us that the fake batmen are easy prey for the Scarecrow's fear gas, that they haven't the experience of Bruce Wayne. We also see that their vigilantism employs guns—weapons that Batman has unflaggingly eschewed, given his parents' death at the end of a pistol. The Dark Knight's objection to his awkwardly fanboyish imitators, however, is on the grounds that they make him *look silly*—that is, they turn Batman into a joke. Batman's response to the chubby copycat is, of course, unserious itself, a sarcastic dismissal of the question rather than an answer to it; but it is serious enough in that it draws attention to the problem of unseriousness.

Unseriousness in *The Dark Knight* is a problem indeed, one that is flagged for us in general by this prefatory episode filled with buffoons and a somewhat pedagogical Batman but then developed with real gravity and considerable elaboration as we meet the film's primary villain, the Joker (Heath Ledger), an explosive and menacing manifestation of the potential danger of silliness and costumery. In his celebrated performance Ledger abjured the stagey prancing used by Cesar Romero in the 1960s TV series, as well as the more calculating, vulpine absurdity of Jack Nicholson in Tim Burton's *Batman* (1989). His Joker is a grim wild man, deranged and whimsical but making few actual gags. His makeup is smeared haphazardly over his face like worn chalk on a pavement, an exaggerated clown smile physically sliced and scarred into his face. The film's critical reception almost universally singled out Ledger for praise, and at the eighty-first Academy Awards the star received a posthumous Oscar for Best Supporting Actor. Aside from praise for Ledger's performance, another consistent theme in discussion surrounding the film, both positive and negative, was its austere mood. Chris Tookey of the *Daily Mail* felt the filmmakers had "lost their sense of humour" (24 July 2008, online at www.dailymail.co.uk). Similarly, for the *Austin Chronicle*'s Mark Savlov the film was "shrouded in grim portent" and, overall, "a stuffy downer" (18 July 2008, online at www.austinchronicle.com). David Denby of the *New Yorker* complained

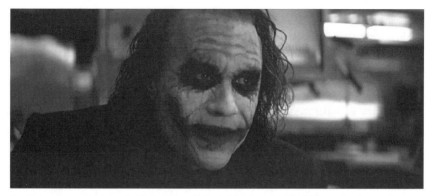

Heath Ledger as the Joker in Christopher Nolan's *The Dark Knight* (Warner Bros., 2008). Digital frame enlargement.

that the film "drain[ed] the poetry, fantasy, and comedy out of Tim Burton's original conception for 'Batman'" (28 July 2008, online at http://www.newyorker.com). "There's never any doubt about the movie's deadly seriousness," wrote the *Wall Street Journal*'s Joe Morgenstern (18 July 2008, online at online.wsj.com), while for David Ansen of *Newsweek* the film was "relentlessly serious" (11 July 2008, online at www.newsweek.com); Roger Ebert admiringly opined that with the release of *The Dark Knight* "Batman [wasn't] a comic book anymore [but] a haunted film that leaps beyond its origins and becomes an engrossing tragedy" (16 July 2008, online at rogerebert.suntimes.com). Curiously, none of the critics who commented on the film's seriousness thought to connect their reflections with its antagonist—to consider the coincidence of a humor-themed villain in a film whose tone is relentlessly austere.

Discussion of Ledger's performance has tended to fixate on its raw energy, describing his Joker as a senseless "force of nature" (Josh Tyler, review, *Cinema Blend*, 14 July 2008, online at www.cinemablend.com; Evrim Ersoy, review, *Monsters and Critics*, 25 July 2008, online at *www.monstersandcritics.com*; Christopher Nolan, qtd. in Andy Khouri, "Directing *The Dark Knight*," *Comic Book Resources*, 20 June 2008, online at www.comicbookresources.com), a characterization conspicuously similar to that of Javier Bardem's mop-topped, monotone psycho Anton Chigurh in *No Country for Old Men* (2007)—or otherwise as an "agent of chaos," after the crazed clown's self-description within the

film itself. More interestingly, Randolph Lewis sees in Ledger's Joker a terrorist of bourgeois apathy, whose random violence carries the frightening and thrilling prospect of complete social overhaul ("*The Dark Knight* of American Empire," *Jump Cut* 51 [2009], online at www. ejumpcut.org). Given his deranged persona, psychiatrists Mary E. Camp et al. seize on him as a straightforward stigmatization of those with mental illness.

Taking nothing away from these analyses, in this chapter I want to extend discussion of the Joker by focusing on him as a representative of humor within a film in which humor is very much at issue, thus as an emblem of the film's powerful preoccupation with seriousness. I want to explore how he can also be understood as a monstrous vision of cultural perspectives that threaten to deflate the film by labeling it "silly," making it an object of embarrassment or ridicule—perspectives implied in Batman's stunning entrance. I don't intend for this discussion to encompass every aspect of Nolan's film—nor even of Ledger's character—but to examine how the Joker functions in the film's desire to resist phrasing itself as an "unserious" comic book picture.

The Burden of the Comic

The Dark Knight was one of 2008's best-reviewed films and its so-called overall "seriousness" was centrally pointed out by critics. *Rotten Tomatoes* informs us that ninety-three percent of the reviews were positive (www.rottentomatoes.com). A frequent footnote to this praise was reflection on the film's potential to be nominated for Best Picture, specifically in light of what was perceived to be a preexisting and unfair bias against superhero pictures. John Scalzi of *Filmcritic.com* anticipated what he felt would be a well-deserved nomination, but he expected the film's handicap would ultimately be insurmountable: "Will it *win* Best Picture? No. In the end, I expect giving the Best Picture to a movie about a guy in a bat suit will still be out of the mental comfort zone of the Academy" (31 July 2008, online at www.filmcritic. com). In an article titled "Why Superhero Movies Get Snubbed," David Bentley of the *Coventry Telegraph* wrote, "It does seem to be the case that superheroes get the cold shoulder on awards night. Comic books just don't seem to be seen as anything serious, even if the film versions rise far above the source material" (28 February 2009, online

at *http://blogs.coventrytelegraph.net*). Regarding the Golden Globes, Brandon Valentine of *Blogcritics* speculated that "maybe the 84 [Hollywood Foreign Press Association] active members believe that any film with a comic-book superhero as its protagonist cannot be taken seriously as award-worthy drama" (16 January 2009, online at http://blog critics.org). During the lead-up to the Academy Awards, a website called *Dark Campaign* was launched to rally for the film to receive Best Picture. This campaign found its explicit motivation in anxiety over the Academy's treatment of comic book films: "The alternative option [to giving the film the award]," organizers write, "is that Hollywood writes it off as just another . . . comic book summer blockbuster" (www.darkcampaign.com). While any number of writers and reviewers noted the film's seriousness, they were also acutely aware of its potential for an unfairly flip dismissal. Accordingly, when *The Dark Knight* failed to secure even a nomination for Best Picture, many fans and reviewers vocally attributed this to an ignorant perception that films based on comic book characters were—not inherently and inevitably bad but—inherently and inevitably *unserious*.

Even for *The Dark Knight*'s most ardent admirers, Batman's comic origins seem to have been awkwardly irrepressible. Despite the tortured seriousness of Batman comics like Frank Miller and David Mazzucchelli's *Batman: Year One*, Alan Moore and Brian Bolland's *The Killing Joke*, or the aptly titled *Arkham Asylum: A Serious House on Serious Earth* by Grant Morrison and Dave McKean, *The Dark Knight* inevitably contends with frameworks of interpretation grounded in what Josh Heuman and Richard Burt call "the persistent devaluation of comic books with the cultural image of their immature audience" (154). On the film's mood, David Ansen implies it is Nolan's specific goal "to prove that a superhero movie needn't be disposable, effects-ridden junk food." Following this, *The Dark Knight* works to promote its "seriousness" in intriguingly detailed ways, anticipating and managing audience perspectives that would dismiss it as "immature," betraying a deep anxiety around humor, theatricality, and childishness. The apex of the film's suspicion of the comic is, of course, the Joker. The Joker is traditionally Batman's most lurid, theatrical, and juvenile opponent. Although he is a mainstay of Batman mythology, he is also able, as with any comic character, to convey different meanings according to different artistic and commercial contexts, and the screenplay's

choice of this particular villain allows *The Dark Knight* to provide a villainous internal reflection of the destructive, infantilizing power of humor and its ability to reveal "costumes."

Our formal introduction to the Joker positions him as an envoy of childishness—not merely through his own exceedingly unkempt appearance, but through his ability to emphasize childishness in others and dangerously reduce meaning to costumed theatricality. The scene is a mob meeting, where nervous gangsters address the problem of their money having been stolen by the Joker and their remaining funds being tracked by the Gotham police. In the middle of the conversation, a cackling disperses through the room like a strange smell before the Joker sways in, his laughter undercut by a self-deprecating lurch, his head sunk stiffly into his shoulders. Unexpected though it may be, the Joker's presence in the room (then at the gangsters' table itself) is neither a surprise nor an intimidation, as we learn when, with a casual sideways gesture and without rising, an especially suavely suited gangster, Gambol (Michael Jai White), levels the rhetorical question, "Gimme one reason why I shouldn't have my boy here pull ya head off." The laxity of this remark is incongruous: after all, the Joker has just executed a daring, violent heist of $68 million in mob money. The threat, however, is restrained and procedural, acknowledging a violation of accepted criminal codes in expected, familiar, and internally "criminal" ways. As Gambol gives his man the signal, the Joker swiftly deals with the anonymous thug, making a startlingly brutal literal "joke" of his disposal by jamming a pencil through his cranium in a parody of a magic trick and mocking the indifferent enforcement of the gangster code. Perhaps more interestingly, though, after the Joker seats himself at the table, he specifically answers an offhand insult made by one of the men before he entered the room by remarking that his suit "wasn't [as they had derisively supposed] cheap: you oughta know, you bought it"—his curious delivery of the line to Gambol in particular causing the gangster to stand bolt upright with dignity offended.

In this scene, the obvious and impressive transgression of the stolen money appears strangely obscured; more flagrant is the Joker's impertinent intrusion on rituals that legitimize criminality as a "fraternity"

and a "business": at this conference (complete with makeshift video link), the mobsters are professionally dressed, indicating their position in a criminal hierarchy that seeks to emulate the capitalist hierarchy it transgresses; while their chic professional attire and baroque chairs degradingly contrast with their soup-kitchen surroundings in a clear indication that these criminal-entrepreneurs are under pressure. In his grotesquely opulent, royal purple suit, complete with waistcoat and tie, the Joker parodies the corporate fashion on display. The clown's remark about the suit does not merely stress the frivolous squandering of the group's stolen money, but self-reflexively repeats the ways in which organized crime purchases and displays signifiers of its capitalist legitimacy: that is, the Joker's costume embarrassingly reveals Gambol's own.

After the Joker explains his plan to kill Batman for half of the Gotham mob's fortune, he makes a seemingly minor quip, again at the hapless Gambol's expense—failure to deal with Batman would mean that "pretty soon, little Gambol here won't [even] be able to get a nickel for his grandma"—that sees the hood explode with fury. The jibe specifically evokes the crook's childish dimension. In fact, the focus on and humiliation of Gambol in this scene (and the following scene in which the gangster is killed) is also significant for its repetition of his name, because the word "gambol" carries connotations of frivolous, childish play, meaning, according to the *Oxford English*, "to leap or spring, in dancing or sporting" and being a word "now chiefly [used] of animals and children" (www.oed.com).

In this scene, the Joker is not merely an asocial, random force of nature, or a nihilistic terrorist of organized, bourgeois society, but an exposer of masquerade and degrading immaturity. His confrontation with Gambol insultingly implies that no matter how financially successful the gangster is, and no matter how he conveys his success sartorially, he is finally and ultimately a man costumed—no more than a child playing dress-up. In fact, Gambol's death later comes precisely because of his inability to recognize a "costume," when he automatically assumes that the body bag brought to him like a Trojan horse contains a safely dead Joker.

The most pointed and monstrous ridicule, however, is the Joker's proclivity toward carving a clown smile into the faces of his victims, slicing their mouths hideously wide, a "comical" disfigurement that,

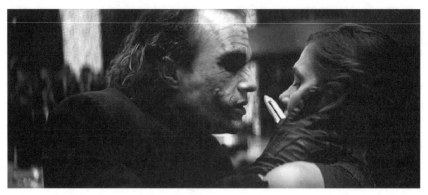

The Joker threatens to carve a clown mouth into the face of Bruce Wayne's sometime lover Rachel Dawes (Maggie Gyllenhaal), thereby making her an object of cruel humor. Digital frame enlargement.

repeating the cut made on Conrad Veidt in *The Man Who Laughs* (1928), evokes humor's ostracizing potential. Seizing the victim's head and with knife poised he commences—at breathy, horridly intimate proximity—to recount the origin of his scars. His stories, centering on domestic violence (an abusive father, a gambling addict wife), culminate with his hissing, "Why so *serious?!*" to his victim before he makes the terrible incision. In this we again find a violent extension of the "looking foolish" that foregrounds Batman's debut, the threat to literally inscribe foolishness on one's face. The Joker's origin stories have a disturbing side effect, however; their real "joke," we might say (and one his victims, who have not seen this scene before, cannot get), is that, for all their apparent sincerity, the stories cancel each other out—vacating meaning and mocking our sympathy, becoming nothing more than manipulative, actorly performances. His victims are in no position to discern as much, but the discrepancies in his story come as an affront to the film's audience: our curiosity about the Joker's origin, about his reality, is derided. What is precisely frightening here is the Joker's flagrant exploitation of our willingness to take something in earnest. In these scenes, far from a mere "agent of chaos" the Joker is a mocker of the audience's seriousness, of our humanistic willingness to imagine a "realistic" reason for his criminality.

Let us return, though, to the problem implied by Batman's imitators, since they return in a more vicious demonstration of the film's anxious

In an al-Qaeda–style video, watched by Bruce Wayne and his butler Alfred, the Joker (off-camera) mercilessly taunts a chubby Batman imitator—his eyes screwed shut in terror—repeating and augmenting the embarrassment dealt out to the same man by Batman at the beginning of the film. Digital frame enlargement.

conflation of costumery and childishness, embarrassment and terror—and one ultimately emblematized by the Joker. Failing to heed Batman's discouragement, the Fatman is captured and murdered by the Joker—dramatically hanged from the roof of a building while still in his Batman costume, although with Joker makeup curiously smeared over the exposed part of his face. The Fatman's murder precedes the release of an al-Qaeda–style video in which we see him, his cowl removed, tormented by the Joker. "Are you the real Batman?" the Joker leers from beyond the frame. The man snivels a negative and the clown rallies with sadistic glee: "Then why do you dress up like him?!" "He's a symbol that we don't have to be afraid of scum like you," murmurs the prisoner. This is an admirable and slightly embarrassing response. First, there is the embarrassment of his persistent misreading of Batman's deep motives, since we know very well the hero does not want to be imitated by his fans: earlier in the film Wayne snickers to his butler Alfred (Michael Caine), "That wasn't what I had in mind when I said I wanted to inspire people." Secondly, it is embarrassing for the copycat's too obvious inability to live up to the macho ideal of the Dark Knight. As the copycat sits, slumped and tied, we can recognize that the Joker's degrading humiliation of the man repeats—in terrifyingly amplified form—the very same humiliation dealt out by Batman himself earlier in the film, a vicious mockery of childish dressing up. "Look at me, look

at me!" the Joker bloodcurdlingly mocks, demanding the Fatman take in the clown's monstrously "silly" appearance, indeed forcing him to look in a way that echoes the man's contemplation of his own foolish costume earlier.

The purpose of the Joker's video is to broadcast a threat: every day that Batman does not reveal his true identity someone will be killed, starting with this copycat. Ostensibly, the Joker's demand for Batman to reveal himself threatens to put a stop to the Dark Knight's war on crime. Less obviously—but no less forcefully—it threatens to degrade Batman's status by exposing him as one who also merely "dresses up," demeaningly aligning him with the man he ridiculed earlier when he pointed out the imperfections of his costume. Following this, the clown paint smeared over the face of the dead Fatman reinforces the demeaning force of juvenile theatricality, drawing our attention to the similarities between the Joker and Batman by forcibly marking the latter's embarrassing simulacrum (crudely coloring him in) as a clown-ish, comical figure. Later in the film, the link between the comedic spectacle of the tubby imitator and the threat of the hideously comical Joker is confirmed. Profoundly distressed by the Joker's destructive spree, Wayne mournfully laments that as Batman "[he] was meant to inspire good . . . Not madness. . . . Not death." The appearance of a new species of crime fighter, the film suggests, has bred a new species of criminal; dress-up has bred dress-up (an escalation first postulated at the conclusion to *Batman Begins*). Earlier in the film, Alfred comments that Batman's crackdown on the mob has caused them to "turn to a man they didn't fully understand" in the Joker. These comments blandly construct the Joker as the antithesis and responsibility of Batman. Batman's radical way of fighting crime has precipitated a radical method of, and personality for, perpetrating it. Considered from this perspective, the Joker and Batman's comical imitators become again symbolically aligned. As a supervillain, the crazed clown is not simply the consequence of the superhero Batman but a nightmarish extension of a fear of looking silly.

GETTING SERIOUS: THE MONSTROSITY OF HUMOR

In his influential treatment of the horror film, Robin Wood describes the genre's tendency to focus on repressed elements of our society,

bringing them back in monstrous form. Adopting Gad Horowitz's distinction between basic and surplus repression, Wood explains that whereas basic repression founds one's most immediate and rudimentary identity, surplus repression is culturally specific and creates the preconditions for a legitimate and sanctioned social identity. Surplus repression shapes us in accordance with cultural ideals, imbuing us with ideological norms. From this repression, of course, arises the concept of the Other in horror, the monster that operates as an expression "not simply as something external to the culture or to the self, but also what is repressed (but never destroyed) in the self and projected outwards in order to be hated and disowned" (9). *The Dark Knight*'s unbridled Other, the Joker, is certainly a monstrous figure, his scarred smile playing on shared characteristics of laughter and horror such as bodily disintegration (see Carroll "Horror and Humor"). He is a figure who would certainly not be out of place in a horror film (with his constantly threatening short-blade, he is a "slasher" of sorts).[1] And, in this sense, we might say that he represents for the film both a terrifying and exhilarating "return of the repressed" of comedy, of childish frivolity, of the perceived silliness of Batman's comic origins. As its critical reception suggests, *The Dark Knight* is a film that urgently imposes its austerity on its viewers—its ideal viewer is one who affirms the reality and seriousness of what is happening onscreen, who resists ridiculing it, who suppresses his doubts over, as Scalzi put it, "a movie about a guy in a bat suit." In the Joker, we see the aggressive villainization of humor and theatricality, the articulation of a sinister dimension to dressing up, haunting us with anxieties over childishness, reproducing them in brutal and terrifying form, as well as the contamination of humor as a potential response to the film's "unserious" premise. In this film even humor is serious business.

The scene in which the captured Joker is interrogated is crucial to illustrating his role of threatening to reduce Batman's to a ridiculous and unsupportable performance. Batman appears elevated in the shadows behind the seated Joker, before introducing himself by swiftly slamming the clown's head into the metal table before him, violently signaling his desire for control of the conversation to follow. Erving Goffman writes that "the individual . . . projects a definition of the situation when he enters the presence of others [and thus] events may occur within the interaction which contradict, discredit, or otherwise

throw doubt upon this projection" (11) and, indeed, in this conversation the Joker threateningly shifts the frame, nullifying Batman's control. But first: as the two men face each other, in the grimily mundane context of the interrogation room, what become startlingly apparent are the characters' *costumes*—and that they are indeed costumes. Nolan ensures that in his previous appearances we see Batman's costume as militarized, darkly functional (that is, not just for looks); but in this scene the two men's costumes provide a reference point for each other. Each seems to embolden the other, the complement proliferating into a vibrant masquerade. The Joker amplifies this effect by provoking our knowledge of the veritable crowd of police officers watching from behind two-way mirrors surrounding the men, an objectifying gaze that doubles for that of the film's audience: "You're just a freak—like me!" he grins. The Joker constructs both Batman and himself as things to be looked at with a smirk, humiliating things; within the context of the film he provokes what Thomas Nagel calls "a view outside the particular form of our lives, from which the seriousness appears gratuitous" (14). On the one hand, this scene generically (yet vaguely) constructs the Joker as Batman's "other half"—the Joker, bizarrely quoting Tom Cruise in the romantic comedy *Jerry Maguire* (1996), tells Batman, "You complete me." More pressingly, though, the scene stresses the threatening humor of this contextualization, the anxious construction of Batman as a ridiculous figure by bringing his costume to the fore—a troubling rephrasing of the "comical" Batman.

This scene takes a decidedly darker turn when Batman commences brutalizing the Joker in quest of the location of his hostages, and it becomes apparent that the Dark Knight cannot defeat the clown through physical force. "You have nothing to threaten me with!—nothing to do with all your strength," the clown gloats. This narratively redundant scene (for the Joker gives up the information of his own free will) obviously demonstrates the chilling futility of Batman's impressive physical power. Implicit in this futility is the Joker's subversive reinterpretation of that power as unserious. As Batman hurls him across the table, the clown gleefully appraises his opponent's physicality: "Look at you *go!*" On the one hand, this line uncomfortably suggests that we are watching a mere action film, not a morally "serious" crime drama in the tradition of Michael Mann's 1995 epic *Heat* (a film *The Dark Knight* openly admires in tone and direction): it calls us out, awkwardly articulating

our pleasure in Batman as an action spectacle (harking back, even, to his debut, in which we do indeed delight in "watching him go"). As well—and much more problematically—coming so closely after the romantic "you complete me," the appraisal flaunts the ease with which such overt displays of machismo may be comically deflated through their homoerotic interpretation, evoking gay readings of Batman's relationship with Robin (perhaps tellingly absent in Nolan's Batman films). Jeffrey A. Brown points out that historically intertwined in the backlash against comic books as childish and immature was hysteria over their perceived homosexuality, the suggestion that "superheroes, those handsome muscle-bound men running around in tights, were obviously gay" (20). One might even say the Joker's snide remark provokes our awareness of the Batman sequels that preceded Nolan's helming of the franchise—*Batman Forever* (1995) and *Batman & Robin* (1997)—which were heavily ridiculed for both their camp tone and overt homoeroticism (including close-ups of rubber-clad crotches and bat butts). In this scene, we see this conflation of homosexuality and unseriousness coming back in disturbing form, the Joker's threatening reinterpretation of heteronormative male power against its intentions.[2]

CONCLUSION

Thomas Nagel writes that feelings of the absurd arise because of "a conspicuous discrepancy between pretension or aspiration and reality"; they are the consequence of "the collision between the seriousness with which we take our lives and the perpetual possibility of regarding everything about which we are serious as arbitrary, or open to doubt" (13). This neatly summarizes the problem to which *The Dark Knight* is peculiarly exposed, with the open secret of a comic-book premise that undergirds an unrelentingly serious production. And it is this knowledge—this imagined "outside" viewpoint—that invades the film in terrifying form. By continually underscoring self-consciousness and immaturity throughout the film, the Joker enacts the self-consciousness of the "serious" superhero film, that danger of "a view outside the particular form of our lives, from which the seriousness appears gratuitous" (Nagel 14). We cannot say, of course, that the Joker of *The Dark Knight* is purely a product of the film's desire for seriousness (however flexible his interpretation, the villain obviously predates the film);

however, the film fashions him in complex, specific unison with a fear of childishness and costumery, using him to express its battle for that seriousness. If the Joker is not more than an anarchic "force of nature" within the film, we might very well question why, of all the Batman villains, the antagonist of *The Dark Knight* should be the Joker at all. As by far the most grim and torturous large-scale representation of this character, Ledger's Joker dramatizes a monstrous threat of the comic (and the comic book), grotesquely animating the film's self-doubts, and polluting possible responses to it as merely a silly game of dress-up.

Nolan's film fittingly reinforces its rejection of childish unseriousness in its final scene, in which Batman positions *himself* for the inhabitants of Gotham as an Other, a monstrous figure who claims responsibility for the sins of "White Knight" district attorney Harvey Dent in order to preserve Gotham's hope for a better future. As Batman blasts into the night on his Batpod at film's end, Commissioner Gordon's young son calls out his name. The allusion to George Stevens's classic western *Shane* (1953) positions Batman as one who may use violence, like the romantic but isolated gunslinger, to solve society's ills yet can have no part in the continuation of that society. Violence may forge, but it cannot (or should not) sustain. Additionally, however, just as Joey Starrett (Brandon De Wilde) of *Shane* must embrace values beyond those of the gunfighter of whom he is so enamored, Gordon's son (Nathan Gamble) must accept something more complicated than the romance of the comic-book hero—who is similarly placed out of his reach, resisting the child's call. As Batman rides over a high-tech sunset of roadside lights, Gordon explains his new role in a concluding voiceover that gives the film its title. Batman, he explains, is "not a hero," but "a watchful protector, a silent guardian, a Dark Knight." After his struggle with the Joker, with humor, and with his embarrassing imitators Batman is redefined—now no longer simply an encouragement to childish mimicry, vulnerable to being labeled silly, but a persona to be taken seriously, and thus a real hero.[3]

NOTES

1. "He's like the shark in *Jaws*," Christopher Nolan tells *Wired* magazine. "The Joker cuts through the film" (qtd. in Scott Brown, "*The Dark Knight* Director Shuns Digital Effects for the Real Thing," *Wired* 16.7, 23 June 2008, online at www.wired.com/entertainment/hollywood/magazine/16-07/ff_darknight).

2. In Batman publications the Joker's depiction is conventionally homophobic: he is a lanky, prancing, effeminate villain who uses feminized epithets like "sweetie" to address his foes. His behavior in this scene, however, rather than familiarly playing up Batman's heteronormative masculinity, is more pointedly (and threateningly) directed toward evoking Batman himself as a homoerotic spectacle.

3. With the tragic massacre of cinemagoers at a premiere of the film's sequel, *The Dark Knight Rises*, on 20 July 2012 in Aurora, Colorado, a new and unexpectedly grim seriousness has engulfed Nolan's Batman films. Moreover, reports that the zanily red-haired James Holmes (at the time of writing the only suspect) announced himself to police as "the Joker" hitch to Ledger's iconic portrayal an altogether more hellish ill humor.

Linda Ruth Williams

The Laughter of Robots

I said of laughter, *it is* mad: and of mirth: What doeth it?
Sorrow *is* better than laughter:
 for by the sadness of the countenance the heart is made better.
The heart of the wise *is* the house of mourning;
 but the heart of fools *is* the house of mirth.

 Ecclesiastes 2:2, 7:3–4

Laughter has a cultural significance which has elevated it far above the corporeal convulsions of hilarity. It has been diagnosed as a symptom of insecurity, of repressed desire, of horror, and of spite; it has been read as a psychological safety valve and as a form of social glue. Laughter is often contagious—in its most hysterical form one can "catch it" from others, and one can also reinfect oneself when feebly failing to get over a bout of "the giggles." Intensely embodied, nevertheless laughter has come to symbolize the unique and "higher" state of being human. The ability to laugh is universal to all humans regardless of other cultural differences.[1] In its true sense laughter is performed only by humans, hence the oft-quoted opening sentence of William Hazlitt's 1819 essay "On Wit and Humour": "Man is the only animal that laughs and weeps" (410). If one were a Frankensteinian robot maker like Dr. Hobby (William Hurt) in Steven Spielberg's science-fiction masterpiece *A.I. Artificial Intelligence* (2001)—intent on manufacturing an artificial human indistinguishable in look and behavior

from a real human—one might place the ability to laugh convincingly and in context as a key desirable attribute. Since the synthetic humanoid (or, as the film calls it, "mecha") boy David strives to pass as a child-human, so he/it must demonstrate laughter.

I want to look at a highly incongruous instance of laughter performed to look fake, early on in *A.I.* Despite its insincerity, it provokes in others (those infected by its effects in the scene) genuine laughter that looks appropriate and natural, spontaneous and mirthful. In a simple, wordless, dinner-table scene a chain of laughter circulates between mecha son and human (or, as the film calls them, "orga") parents, which dances between real and faked, humored and cheerless. The performances of these different inflections of the laugh are central to our understanding the scene, and more broadly to the main characterizations in the film. What is clear is that this is laughter out of place: indeed—to put it mildly and in common parlance—*A.I.* is not a bundle of laughs. Despite its fairytale form it is far more likely to provoke Hazlitt's other human response (tears), for it is an anguished story of child abandonment and human cruelty.[2] In a future world of scarcity in which reproduction is severely controlled, mecha have become an indispensable social and economic resource. So, Dr. Hobby develops a new form of humanoid: a child-mecha who can fill a gap in the lives of childless orga. Once its proposed mother takes it through an imprinting ritual, the mecha-child will love the mother back, to the end of his (near-eternal and eternally childlike) existence. When their biological son Martin (Jake Thomas) is put into a cryogenic coma pending the discovery of a cure for his disease, Monica and Henry (Frances O'Connor and Sam Robards) take on David (Haley Joel Osment), Hobby's emoting mecha-child prototype. But as soon as Monica "imprints" with David, Martin is cured and returns home. With a fairytale combination of hope and heartlessness, Monica must cast David out into the woods, leaving him to face multiple horrors. *A.I.* then becomes a heartbreaking science-fiction Pinocchio tale; the lost mecha who has been let down so badly by humans/parents sets himself on a quest to become a "real boy" so that his mother might indeed finally love him. In an interview six years after its release, Spielberg called this his darkest film, darker even than *Schindler's List*: "It is the most tragic . . . because somehow *A.I.* is about the end of the entire human race" (Jim Windolf, "Q & A Steven Spielberg," *Vanity Fair*,

2 January 2008, online at vanityfair.com/culture/features/2008/02/
spielberg_qanda200802).

A.I. is one of those films that contain laughter but do not provoke it.
David laughs in only two sequences in the whole story—then again, he
doesn't have much to laugh about. Neither of these moments is funny.
Although characters around him are "infected" with mirth, it is hard
to imagine audiences joining in. The short scene I want to turn to (just
two minutes in duration, about seventeen minutes from the start of the
film) takes place as Henry and Monica are getting used to the strange
presence of the stilted, frankly robotic David in their home. Through-
out the film Osment plays David as a serious innocent abroad, initially
mechanical and overtly artificial. But once Monica has imprinted him
with her promise of love—quite soon after the scene under discussion
here—Osment changes his performance style, becomes more humanly
natural, less angularly android. He never loses the grave studied look,
but once it is underpinned by love and fear it becomes more fluid, like
that of a guarded animal. However, in the scene under question here
David is what we might call pre-human, an overly mechanical mecha
who hasn't yet softened into passing as a human in movement, speech,
and behavior.

The scene begins with a striking overhead shot, framing David
through a modernist-style, hoop-shaped pendulum light shade, which
both haloes him and separates him from his parents, who are ranged
to his left (mother) and right (father). As the (Jewish) Freud might have
pointed out and the (Jewish) Spielberg cannot fail to have noticed, such
Oedipal triptychs evoke the holy family of Christian iconography. Al-
though at this point in the film David has not yet stepped forward to
claim his place as its protagonist, the axis of action here runs from
mother to father, with child as the centerpiece: the table is oval but
the child is framed at its "head." Spielberg also references Leonardo
Da Vinci's Christ presiding at the Last Supper, but with many fewer
disciples. Mealtime scenes are legion in cinema; family mealtimes
might set up alienation between generations or spouses (the separat-
ing or claustrophobic tables of, say, *Citizen Kane* [1941] or *Eraserhead*
[1977] or *American Beauty* [1999]), or they might forge community and
reinforce domestic values (*The Gold Rush* [1925]; *Babette's Feast* [1987];
even, weirdly, *The Texas Chain Saw Massacre* [1974]). The consump-
tion of food in films can be more slapstick or grotesque than decorous

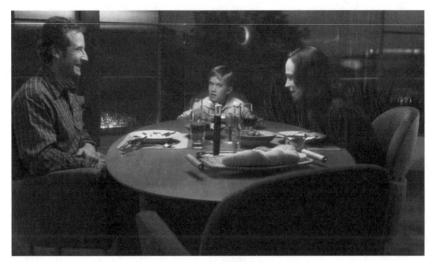

Opening up the Oedipal triangle in *A. I. Artificial Intelligence* (Steven Spielberg, Warner Bros., 2001): The breadbasket symbolically suggests the place which should be occupied by Martin the absent son, David's rival for Monica's love. Digital frame enlargement.

and obedient, so it is very frequently a staple source of comedy. Here, however, only Monica and Henry are eating: David has a place set for him, but his bowl is empty. Regular establishing shots also suggest a place set at the opposite side of the table (a breadbasket does service for the plate of the absent Martin). Having commenced, then, with a visual separation (the funky overhead light holding the image of David's face separate), the meal continues to reinforce David's difference. As a mecha, David *cannot* eat. The next meal scene in the film, by which point Martin has rejoined the family table, sees the robotic boy trying to do what humans do, but food catastrophically fuses his wiring. Where two years before this *The Matrix* (1999) had envisaged humans *as* food, an energy source for an ever-consuming race of self-interested A.I.s, *A.I.* presents a drowned world of scarcity in which its android beings—in the words of the opening voiceover—"were never hungry and did not consume resources." Joining in with the materiality of family life (i.e., trying to eat like other humans eat) provokes *A.I.*'s most dire moment of abjection: David swallows steamed spinach, his face begins to melt, and he just *stops*. Surgery is needed to rectify his error of consumption.

Linda Ruth Williams

But in the earlier meal scene under analysis here, laughter, not destruction, is the key. The conventions of continuity editing form the familiar grammar of the scene, with shots ping-ponging between over-the-shoulder shots of each parent to those establishing shots that frame David at the center, to close-ups of individual faces. Regular and simply orchestrated, this dining sequence is nevertheless a turning point in the film. At first, Monica and Henry eat awkwardly as David watches, with studied fascination, every forkful raised to their mouths, particularly Monica's mouth. This may be a film with a robot as its diminutive hero, but it is intensely concerned with bodies. Monica looks highly uncomfortable at being the object of scrutiny as she eats (who wouldn't?), but David doesn't know that he should look decorously away. Like many children, he stares when it is inappropriate to do so—his robot errors are really child errors, for this is a film in which the (disenfranchised) robot stands in for the (disenfranchised) child. Watching someone else eat may be OK when you are one year old, but it isn't when you are supposed to be eleven. The meal continues, imprisoned by the kind of ringing silence we might encounter in an empty restaurant with no atmosphere—no easy chatter, no background hum, no music, just the very audible chime of cutlery on crockery, and the would-be private sounds of masticating bodies. In the near silence, David mimics the physicality of eating with implements, as might a toddler learning to feed himself independently: he raises his empty glass to his lips, winds imaginary spaghetti onto his empty fork.[3] The scene is awkward, enshrouded in a reverential but thoroughly embarrassed hush.

Then, quite suddenly, David explodes with laughter, and everyone jumps. It is incongruous, exaggerated, shocking—the very definition of "bursting out." He booms a regular, repeated burst of noises that have none of the cadence or unpredictability of a recognizably human peal of laughter. It is a shouted performance of "Ha, Ha, Ha"s. Instantly, Monica jumps back, screaming so radically that David might have popped a balloon next to her ear. Perhaps Spielberg slyly instructed his twelve-year-old actor to shock the adults for real—clearly they didn't know precisely when the burst was coming (even directors with such angelic public profiles as Spielberg inject surprises to keep things fresh). The laughter initially seems inappropriate, but we soon see it as a response to a stray strand of spaghetti dangling from Monica's mouth, which she then plays with to extend the joke as she begins to laugh herself,

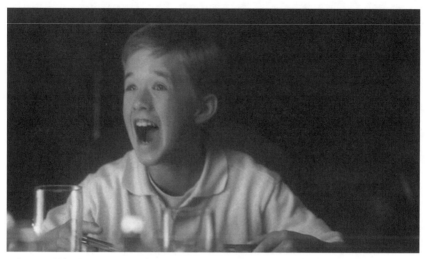

Robot David (Haley Joel Osment) laughs on cue, his face fixed in a mirthless mask that mimics human laughter. He could be screaming. Digital frame enlargement.

initially out of shock. With his sharp robot eyes and sharp robot intelligence, David has detected a case of out-of-placeness, typically a motivating form for ironic laughter. This aspect of David's laughter is thus "true": Hazlitt's famous line on laughter and humanity continues, "for [man] is the only animal that is struck with the difference between what things are, and what they ought to be." Monica ought to eat cleanly, but she eats messily; or the spaghetti ought to passively follow the guidance of her lips, but one strand of it has become a revolutionary. Philosophers of humor have long diagnosed laughter as a superiority response—in the seventeenth century Hobbes described that moment of "sudden glory" when the laugher rises above the laughed at.[4] However, what David "feels" at this instant remains a mystery, because his laughter sounds so very alien. He has surely been programmed to recognize that humans find such things humorous, and to display an appropriate response. Henry then joins in, laughing at first incredulously. As David's laugh extends it seems ever stranger and falser—a booming cascade of "Ha"s followed by an almost inaudible cackle, changes in cadence that mimic the ebbs and flows of real human laughter but here do it *too much*. David has the "script" but he is enduring performance troubles. The "boy"'s face is also set into an expression which

Linda Ruth Williams

could do double service as fear—without the audio track of laughter, he might be screaming (of course the phrase "screaming with laughter" is another way of expressing extremity of response).

Each person may have a different laughter style, and perhaps everyone has also at some point balked at another person's bizarre guffaws. Quite simply, some laughs sound funnier than others. But we learn here that even the strangest laughter—even the synthetic mode of the android—can be as contagious as that which sounds authentic or familiar, and David's laugh, indeed, proves highly contagious. First, Monica and Henry are laughing at their own shock—as the audience might also be doing after such a jump (the laughter of shock is a common response to horror films' "jumpers"). But their laughter does not die down once the adrenalin has subsided—they are quickly overcome, and perform at least two different forms of laughter that play out a slightly hysterical exchange, a wordless conversation of sounds. If David ejects bursts of sound mimicking the natural, the two parents are twisted by paroxysms. If David's laughter is from the neck up, delivered with a spooky, childish expression of opened mouth and fixed, shining eyes, the parents, by contrast, symptomatize a range of laughing styles that present them as creatures of individuality. The edit shows, in shot-countershot, the adults' whole upper bodies given over to a pantomime of happy helplessness—hands covering mouths, then opening up in gestures of delirious surrender, faces looking this way and that as if seeking rescue from uncontrolled hilarity, wrinkled noses and foreheads and eyes which close, then connect, then look around for further confirmation of the shared situation. In short, the adults lose control but the child does not. While their laughter starts as the effervescence of shock, it quickly runs away with itself, becoming funnier the longer it continues. Laughter breeds laughter. Like a disease-carrier who feels no symptom, David (another species) has contaminated Monica and Henry with a reaction that he does not himself seem to feel, and it circulates.

Philosopher Henri Bergson, speaking from a wider model valorizing animism, would argue that the laughter here continues because *"We laugh every time a person gives us the impression of being a thing"* (97, italics in original). For Bergson, the comical is precisely the stilted—a human mimicking an object. The valued aspects of life and being are movement, flexibility, agility, and for Bergson the comic is the opposite

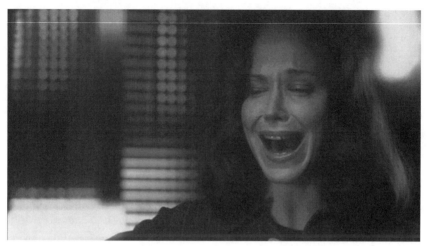

Mother Monica (Frances O'Connor) "catches" David's laugh; her happy loss of self-possession only intensifies her hysteria. She could be screaming. Digital frame enlargement.

of this: *"The attitudes, gestures and movements of the human body are laughable in exact proportion as that body reminds us of a machine"* (79). Of course, David is a machine, and laughs like a thing (in his analysis of *A.I.*, Sidney Perkowitz even refers to David consistently as "it" rather than "he" [148–49]). Monica may at first be the cause of David's Hobbesian "sudden glory," but she is humorously agile enough to get in on the joke. However, while Bergson would argue that it is David who then becomes the object, with Monica and Henry turning the laughter around onto his strangeness, what actually happens in the performance is that they lose themselves into laughing at laughter itself. The laughter here is critical, philosophical, meta-discursive, and not comedic. David has opened up the issue of what laughter actually is, and the laughs of his parents are commentaries from the sides.

But suddenly, in the midst of this three-way laugh-in, David stops as instantly as he started, as if a switch has been flicked. Robot laughter can be turned off like a switch; human laughter must trickle to a stop. As Monica and Henry slow to a halt, they betray an awkwardness that suggests it is *their* continuing laughter that is now inappropriate. David fixedly observes them as they put on the brakes: more unfamiliar behavior which he now has the opportunity to study. Then meaningful glances are exchanged between the parents, evidence that

something of real emotional importance has taken place. Perhaps this is the first time Monica has been happy, or spontaneous, since the decline of Martin, and Henry is mightily relieved about this. Although short and wordless, the scene is clearly an important narrative juncture in David's story, since—despite his strangeness, made even more manifest by this inappropriate baying—it signals a new acceptance of the cuckoo child by the parents. He may not sound like a laughing boy, but at least he has recognized the "joke." And recognizing what is socially deemed to be laughable is, after all, an elementary part of our becoming fully human in society. Straight after this, Monica is able to tuck him into bed for the first time, and the next day she imprints him as her own. *A.I.* as a whole mostly charts David's appalling impotence, but here at least he leads and then terminates this strange laughter party, at the same time sealing his own fate in the Oedipal triangle.

Paranoid Androids and Melancholy Mecha

If David has difficulty laughing convincingly it may also be because he is from a long line of melancholy robots. Eric Wilson sees the android as imbued with existential sadness because he expresses his maker's relationship to loss: very like Dr. Hobby, the fashioners of automata in cultural history are more likely to be compensating for a loss they can resolve only through manufacturing something (a child, for instance) to put in the place of an absence. It turns out that Hobby has made mecha David in the image of his own dead son David. He capitalizes on this fact by mass-producing identikit Davids (and matching Darlenes—the mecha girl-child version) to fill the gap in the lives of the childless. David can never be the thing he simulates, but knowing this brings about his self-consciousness. He cannot be Hobby's dead son (though he is his doppelgänger), and he cannot be Monica's living one. In Spielberg's highly philosophical screenplay (based on a story by Brian Aldiss), Hobby conjectures that creating the potential to love in his mechas will be the catalyst for their formation of a true inner life. Spielberg's representation of love has often been dismissed as superficially sentimental (as if sentiment were intrinsically a bad thing). However, here it becomes something of vertiginous potential, the key, argues Hobby, "by which [the loving, mecha child will] acquire a kind of subconscious . . . an inner world of metaphor, of intuition, of

self-motivated reasoning, of dreams." For Wilson, such robotic self-consciousness is a contagious response to the melancholy of its maker: "Humanoid machines reflect forms of melancholia that have resulted from what human beings have perennially called 'the fall'" (2). But, having created a being in the image of their loss, the automata-maker all too frequently casts it off into a hostile world of which the creature must then make some awful, incomplete sense.

David acquires self-consciousness not from love itself but from the pain that knots around unresolved love. Briefly, Wilson cites David alongside Boris Karloff's melancholic mummy (from Karl Freund's *The Mummy* [1932]) and his Frankenstein's monster (from James Whale's *Frankenstein* [1931]), as well as Rutger Hauer's too mortal fallen-angel replicant from Ridley Scott's *Blade Runner* (1982): "Each of these humanoids doubles the condition of human beings sundered between untroubled mechanism and organic turbulence. These divided figures are our siblings, our familiars, revealing the burdens that cleave to our souls" (125). No wonder laughter does not come easily to these artificial beings, and their mechanized kinsman the robot—the tragic, all-too-human humanoid. No wonder laughter is so rare in *A.I.*

But David's laugh in this early sequence is startling not only because robots see nothing to laugh about. Usually they simply *cannot* laugh, not, at least, convincingly; laughter becomes the touchstone of their artifice. Of course there is a substantial history of fleshly automata in visual culture, who, by dint of their elastic, muscular mouths, may have the ability to smile: David is one of these. However, the most common cinematic robot is a mechanical being with an unchangeable alloy face.[5] We usually read into its fixed visage a range of dark emotions—gravity, sadness, threat; more positive emotions such as delight or mirth are difficult to discern in the blank manufactured expression. This raises the question of why we read an essentially blank face such as that of *Real Steel*'s oddly forlorn Atom (2011) negatively rather than positively.[6] Unless it was cast that way by its maker, the metal robot cannot smile, and without lungs or diaphragm cannot articulate true laughter. It may be capable of sardonic humor: indeed, as with Marvin the Paranoid Android (Warwick Davis) from *The Hitchhiker's Guide to the Galaxy* (2005) or C-3PO (Anthony Daniels) from *Star Wars* (1977), depression and anxiety make it a source of humor for

others. A product of high science, historically the cinematic robot has been imbued with deep seriousness.

David does not look like a robot. His ability convincingly to pass as a human child gets him into trouble as well as (occasionally) saving him, and underpins the parallel racial story through which *A.I.* uses children/robots to stand in and speak for other persecuted minorities. Although inside he is "a hundred miles of fiber," his external appearance, his skin, is indistinguishable from that of humans; David's laughter is one moment when we tell the difference. This telling is also addressed by Frances McDonald, who reads cyber-laughter as usually threatening: "Representations of laughter in SF serve the therapeutic function of propping open the increasingly negligible gap between human and machine. In SF, natural laughter is coded as a signal of authenticity and sentience; artificial laughter is the synthetic being's 'tell.' " It is, then, entirely genre-appropriate that David laughs so badly. But what, in the end, *is* natural laughter? And why does David's laughter magnify his more generalized "unnaturalness"?

Clearly the question of what a "natural" human is (and how he or she must appropriately behave) is at the center of *A.I.* On one level the film is the story of a robot who looks so much like an organic human child it is hard to discern that he is not. On another level the difference between orgas and mechas is rendered as profound, and—to the orga/humans—profoundly threatening. Indeed, it is all the worse for the fact that one cannot tell the difference. (Spielberg's racial thread runs directly into this story from *Schindler's List*.) Before David is switched on to bond with Monica he is a less convincing simulation than afterward, and Osment's performance reflects this: the laughter must initially not look natural. At this stage he is a mere doll-child, a toy for adults (Henry calls him a toy even after he has been imprinted; he is certainly a luxury commodity) which can mimic childishness but not inhabit it. This is a sophisticated distinction for a twelve-year-old actor to carry off. In an interview on the DVD release, the young Osment discusses some basic principles of playing a mecha, such as not blinking, *ever*.[7] I have explored elsewhere the special skills needed for a child actor to perform tears on cue.[8] Clearly Hazlitt's two humanly defining emotional responses are at the fore of the actor's repertoire, and it may be that performing convincing laughter—if necessary again and again

for retakes, and with a sometimes humorless crew as audience—is even more difficult than gushing tears. In *A.I.* Osment does not cry because David cannot excrete tears, but he must show clearly distinguishable real and fake forms of laughter, and he carries it off brilliantly.

Early on the laughter is more subtly different, performed as out-of-place rather than excessive. It reveals not an underlying mirth but a programming that tells him to exude such signs and sounds when confronted with particular stimuli (perhaps this is true of us all). Osment does not perform the laughter scene as if David genuinely "feels" something funny. Rather, it is as if, having recognized that the spaghetti on the lip should be funny, David must display appropriate-seeming behavior. In the absence of being "tickled," laughter is just a display, not a humor-fueled response. David's is then the essence of hollow laughter, but not in the way that we usually understand it (to mean laughter tinged with blackness or bleakness; laughter fringed with darkness). David's laughter is hollow because it emanates from *knowing* something to be funny but not "finding" it funny. What Osment performs looks like forced laughter—the laughter associated with "humoring" someone (a child telling an unfunny joke, perhaps; someone who needs his comic aspirations to be flattered). It may, of course, be as genuine as the next seemingly human's: we may all have just been "programmed" to agree—within very broad limits—on what shall be deemed funny and what shall not. But David does not lose control. Perhaps he only ever "loses it" in anger when, toward the end of the film, he smashes up another production-line David, this something of a culmination in the emotional evolution he undergoes. In the dinner table scene he precisely does not "lose it" (though his parents do); instead this is an inappropriate bursting-out.

MECHA MIRTH, AND OEDIPUS FULFILLED

Who or what is David before and after this telling laugh? Before his imprinting, he smiles on cue and displays a bright desire to please. After his imprinting he is increasingly grave, fearful, wary. Behaviorally, he becomes more like a human child and less robotic as his journey develops. He does not laugh again until the concluding sequence of the film when, 2,000 years into the future, an advanced civilization of mecha are able to create a clone of Monica for him to play with for one perfect

day only. (*This* Monica will not abandon him, though she will die at the end of the day. But for one day she will love him unconditionally.) The clone Monica convincingly passes as his mother and, after his long learning journey, David looks like a happy child. This time the laughter is not "telling" of a difference, but seals the identity of the humanoid as human (by now, humans-proper have died out—mecha David and the simulated mother are the only images of humanity left). In this final sequence David laughs twice during play—that it is hardly noticeable in this brief bliss montage is testament to how natural it is. Where David's android laughter was directed outward, shot at the object his programming told him to find funny, the new "real boy laughter" is a shared experience and part of play with the mother. Because it fits so well, it is not as significant for the purposes of this essay (or the project of this book) as the "wrong" laughter David expresses early on—before he is humanized, before he is in pain.

Of course it isn't really Monica with whom David spends his perfect day at the end of the film, but his fantasy of her. That she can be reconstructed from his memory is fleshly proof not just that he can recall (any old computer can do that) but that he can play with the fantasy. After 2,000 years in frozen limbo, David comes back to life with a Freudian unconscious, for the film ends with the astonishing Oedipal wish-fulfillment of the son in bed with his mother. Stanley Kubrick, who first developed *A.I.* in collaboration with Spielberg,[9] observed in his notes for the film, "David wants to become a real boy, which is impossible, but he manages to turn Monica into an android" (qtd. in McBride, *Spielberg* 408). This may raise the question of why their shared laughter, at the end, sounds so natural, since both beings are now artificial.

Perhaps it reveals that what was wrong with David's laughter at the beginning wasn't that it "told" on his artificiality but that David laughed in a register foreign to that of his parents. Recall the experience of those whose laugh jars with our individual notion of what's funny, and what sounds right. Certainly the laughter in the final sequence is more recognizable to us twenty-first-century social orga. David has learned to laugh like his mother. Would he have been, or have sounded, as happy if, fulfilling Kubrick's note, the fantasy had turned the tables and Monica had instead learned to laugh like David? For the first (and last) time mother and son laugh the same laugh. That it is underpinned

by a shared mirth is more evident of love, and perhaps of the existence of an android unconscious, than anything else in this astonishingly post-human Oedipal story.

Notes

1. Manfred Pfister calls it the "human feature that has defined humanity as *homo ridens* or, at least, *homo risus capax*" (v).

2. David can laugh, but he cannot cry or, it seems, excrete body fluids of any kind (a bullying boy tries to look inside his shorts saying, "Let's see what you can't pee with"). Sue Short takes the machine's inability to cry as a baseline robotic definition (x–xi). I discuss the focus on David's body in greater detail in my forthcoming book, *Steven Spielberg's Children*.

3. Spielberg also made his actors mime with food ten years earlier in *Hook*'s imaginary food fight. See Murray Pomerance's fascinating 2008 discussion of this scene in the context of a wider analysis of food as a metonym for sex in Spielberg ("Digesting").

4. "The passion of laughter is nothing else but a sudden glory arising from sudden conception of some eminency in ourselves, by comparison with the infirmity of others" (Hobbes, *Elements* 32).

5. I am deliberately avoiding the word "cyborg" here because I take this to mean a hybrid being such as Robocop, who has some organic element of flesh or chemistry mixed in with the technology, metal, and programming of the science-fiction soup. David is mecha through and through—robot/android/ artificial humanoid, entirely manufactured.

6. Perhaps this is because many such narratives are underpinned by the common belief that artificial intelligence is a threat as much as a wonder. An aural version of this facial blankness in which we read negative intent might be the expressionlessness of HAL's voice in *2001: A Space Odyssey* (1968). Emotionlessness is read as threat.

7. Just why Hobby's highly advanced corporation, capable of producing a robot child who can love and a robot gigolo who presumably can sustain an erection, cannot produce convincing blinking is one of the glitches of the film.

8. See Williams.

9. Over many years, Kubrick developed the project with the intention of directing it, with Spielberg as producer. After much discussion he suggested that Spielberg was better placed to direct such material. When Kubrick died in 1999, Spielberg took the project over as director and screenwriter.

Contributors

Christine Cornea is Lecturer with the School of Film and Television at the University of East Anglia. She is the author of *Science Fiction Cinema: Between Fantasy and Reality* and has published widely on science fiction in film and television, including articles in the journals *Velvet Light Trap* and *Genders*. She has also published on the topic of screen performance, including her recent edited volume, *Genre and Performance: Film and Television*. She is now working on a monograph titled *Post-Apocalypse on the Small Screen*.

Jean-Michel Frodon is Professorial Fellow in Film Studies and Creative Industries at the University of St. Andrews, Scotland. He was a journalist and film critic at the weekly *Le Point* (1983-1990) and *Le Monde* (1990-2003) and was editorial director of *Cahiers du cinéma* (2003-2009). He now writes for the website Slate.fr and is editor-in-chief of the collaborative website Artsciencefactory.fr. He is a professor at the Political Sciences Institute, Paris, and a member of Bruno Latour's SPEAP educative committee. He is author or editor of many books, including *L'âge moderne du cinéma français*, *La Projection nationale*, *Hou Hsiao-hsien*, *Conversation avec Woody Allen*, *Print the Legend: cinéma et journalisme*, *Au Sud du cinéma*, *Horizon cinéma*, *Le Cinéma chinois*, *Cinema and the Shoah: An Art Confronts the Tragedy of the Twentieth Century*, *Robert Bresson*, *Le Cinéma d'Edward Yang*, and *Le Cinéma français, de la Nouvelle Vague à nos jours*.

Thomas Leitch teaches English and directs the Film Studies program at the University of Delaware. His most recent books are *Film*

Adaptation and Its Discontents: From Gone with the Wind to The Passion of the Christ and *A Companion to Alfred Hitchcock*, co-edited with Leland Poague.

Dominic Lennard is a University Associate in the School of Social Sciences at the University of Tasmania. He currently teaches in the sociology program, as well as lecturing on academic writing and research skills. His research interests include versions of masculinity in popular culture, genre film, and the representation of children on film. He is writing a book on the horror film's child villains.

David Martin-Jones is Professor of Film Studies at the University of Glascow, Scotland. He is the author of *Deleuze, Cinema and National Identity*, *Deleuze Reframed*, *Scotland: Global Cinema*, and *Deleuze and World Cinemas*. He is co-editor of the forthcoming *Cinema at the Periphery* and *Deleuze and Film*.

Adrienne L. McLean is Professor of Film Studies at the University of Texas at Dallas. She is the author of *Dying Swans and Madmen: Ballet, the Body, and Narrative Cinema* and *Being Rita Hayworth: Labor, Identity, and Hollywood Stardom*, and the co-editor, with Murray Pomerance, of the ten-volume Star Decades series for Rutgers University Press.

James Morrison is Professor of Literature and Film Studies at Claremont McKenna College. He is the author, co-author, or editor of several books on film, including *Hollywood Reborn: Movie Stars of the 1970s* and *Roman Polanski*.

R. Barton Palmer is Calhoun Lemon Professor of Literature and director of the film studies program at Clemson University. He is the author, editor, or general editor of more than forty books on various film and literary subjects. Among his recent film books are *Hollywood's Tennessee: The Williams Films and Postwar America* (with Robert Bray) and *To Kill a Mockingbird: The Relationship between the Text and the Film*; as well as several edited collections, including (with Steven Sanders) *The Philosophy of Steven Soderbergh* (with Murray Pomerance), *A Little Solitaire: John Frankenheimer and*

American Film, and (with David Boyd) *Hitchcock at the Source: The Auteur as Adapter*.

Murray Pomerance is Professor in the Department of Sociology at Ryerson University and the author, editor, or co-editor of more than twenty books, including *Michelangelo Red Antonioni Blue: Eight Reflections on Cinema*, *The Horse Who Drank the Sky: Film Experience Beyond Narrative and Theory*, *Johnny Depp Starts Here*, *An Eye for Hitchcock*, *A Little Solitaire: John Frankenheimer and American Film* (with R. Barton Palmer), *Cinema and Modernity*, *A Family Affair: Cinema Calls Home*, *American Cinema of the 1950s: Themes and Variations*, and *Enfant Terrible! Jerry Lewis in American Film*. He edits the Horizons of Cinema series at SUNY Press and the Techniques of the Moving Image series at Rutgers University Press, and co-edits, with Lester D. Friedman and Adrienne L. McLean, respectively, the Screen Decades and Star Decades series at Rutgers University Press. In 2009, he appeared on Broadway in connection with *The 39 Steps*.

Matthew Solomon is Associate Professor in the Department of Screen Arts and Cultures at the University of Michigan. He is the author of *Disappearing Tricks: Silent Film, Houdini, and the New Magic of the Twentieth Century* and the editor of *Fantastic Voyages of the Cinematic Imagination: Georges Méliès's Trip to the Moon*.

David Sterritt is chair of the National Society of Film Critics, film professor at Columbia University and the Maryland Institute College of Art, chief book critic of *Film Quarterly*, and co-chair of the Columbia University Seminar on Cinema and Interdisciplinary Interpretation. His writing on avant-garde film and related topics has appeared in such publications as *The Journal of Aesthetics and Art Criticism*, *The Journal of American History*, *The Journal of French and Francophone Philosophy*, *The Christian Science Monitor*, and *The Chronicle of Higher Education*. His books include *Mad to Be Saved: The Beats, the '50s, and Film*, *Screening the Beats: Media Culture and the Beat Sensibility*, and *Guiltless Pleasures: A David Sterritt Film Reader*.

George Toles is Distinguished Professor of Literature and Film and Chair of Film Studies at the University of Manitoba. He is the author of

A House Made of Light: Essays on the Art of Film. For twenty-five years, he has been the screenwriting collaborator of director Guy Maddin. Their most recent feature film is *Keyhole* (2011). He is currently writing a book on the films of Paul Thomas Anderson.

Linda Ruth Williams is Professor of Film in the English Department at the University of Southampton. She is the author and editor of books including *The Erotic Thriller in Contemporary Cinema* and *Contemporary American Cinema* (co-edited with Michael Hammond), as well as numerous articles on feminism, sexuality, censorship, and contemporary culture. She is now writing *Steven Spielberg's Children*, the first full-length study of childhood and child performers in Spielberg's films.

WORKS CITED AND CONSULTED

Altman, Rick. *Film/Genre*. London: British Film Institute, 1999.

Andrews, David. "Poking *Henry Fool* with a Stick." *Film Criticism* 24: 1 (1999), online at www.highbeam.com/doc/1G1–58049227.html.

Apte, Mahadev L. *Humor and Laughter: An Anthropological Approach*. Ithaca, N.Y.: Cornell University Press, 1985.

Aristotle. *The Poetics*. Trans S. H. Butcher. New York: Hill and Wang, 1961.

Bakhtin, Mikhail. *Rabelais and His World*. Trans. Hélène Iswolsky. Bloomington: Indiana University Press, 1984.

Barber, C. L. *Shakespeare's Festive Comedy: A Study of Dramatic Form and Its Relation to Social Custom*. Princeton, N.J.: Princeton University Press, 1959.

Bataille, Georges. *Visions of Excess: Selected Writings, 1927–1939*. Trans. Allan Stoekl. Minneapolis: University of Minnesota Press, 1985.

Bazin, André. *The Cinema of Cruelty from Buñuel to Hitchcock*. Ed. and with an introduction by François Truffaut. Trans. Sabine D'Estrée with the assistance of Tiffany Fliss. New York: Seaver Books, 1982.

Behlmer, Rudy. *Inside Warner Bros. (1935–1951): The Battles, the Brainstorms, and the Bickering—From the Files of Hollywood's Greatest Studio*. New York: Viking, 1985.

Bell, Robert H. "Homer's Humor: Laughter in *The Iliad*." *Humanitas* 20 (2007), 96–116.

Bergson, Henri. "Laughter." In *Comedy*. Introduction by Wylie Sypher. Garden City, N.Y.: Doubleday, 1956.

Billig, Michael. *Laughter and Ridicule: Towards a Social Critique of Humor*. Thousand Oaks, Calif.: Sage, 2005.

Borde, Raymond, and Étienne Chaumeton. *A Panorama of American Film Noir, 1941–1953*. Trans. Paul Hammond. San Francisco: City Lights, 2002.

Bordwell, David, Janet Staiger, and Kristin Thompson. *The Classical Hollywood Cinema: Film Style and Mode of Production to 1960*. New York: Routledge, 2005.

Boswell, Peter. "Bruce Conner: Theater of Light and Shadow." In *2000 BC: The Bruce Conner Story Part II*, ed. Michelle Piranio. Minneapolis: Walker Art Center, 1999. 24–82.

Bosworth, Patricia. *Marlon Brando*. New York: Viking, 2001.

Bowen, Elizabeth. "Why I Go to the Cinema." *Footnotes to the Film*. Ed. Charles Davy. London: Lovat Dickson, 1938. 205–20.

Brakhage, Stan. *Film at Wit's End: Eight Avant-Garde Filmmakers*. Kingston, N.Y.: McPherson, 1989.

Brook, David. *Bobos in Paradise*. New York: Simon and Schuster, 2000.

Brown, Jeffrey A. "Comic Book Fandom and Cultural Capital." *Journal of Popular Culture* 30: 4 (1997), 13–31.

Burckhardt, Rudy. "How I Think I Made Some of My Films." In *To Free the Cinema: Jonas Mekas & the New York Underground*, ed. David E. James. Princeton, N.J.: Princeton University Press, 1992. 97–99.

Caillois, Roger. *Man, Play and Games*. Trans. Meyer Barash. Urbana: University of Illinois Press, 2001.

Camp, Mary E., Cecil R. Webster, Thomas R. Coverdale, John H. Coverdale, and Ray Nairn. "The Joker: A Dark Knight for Depictions of Mental Illness." *Academic Psychiatry* 34: 2 (March–April 2010), 145–49.

Canetti, Elias. *Crowds and Power*. Trans. Carol Stewart. New York: Farrar, Straus and Giroux, 1962.

Carr, Jay, ed. *The A List: The National Society of Film Critics' 100 Essential Films*. New York: DaCapo, 2002.

Carroll, Noël. "Film, Emotion, and Genre." In *Passionate Views: Film, Cognition, and Emotion*, ed. Carl Plantinga and Greg M. Smith. Baltimore: Johns Hopkins University Press, 1999. 21–47.

——. "Horror and Humor." *Journal of Aesthetics and Art Criticism* 57: 2 (1999), 145–60.

Chandler, Raymond. *Stories and Early Novels*. New York: Library of America, 1995.

Clark, Michael. "Humour and Incongruity." In *The Philosophy of Laughter and Humour*, ed. John Morreall. Albany: State University of New York Press, 1987. 139–55.

Conrad, Peter. *Orson Welles: The Stories of His Life*. London: Faber, 2003.

Cook, Pam. "Masculinity in Crisis? Tragedy in *Raging Bull*." *Screen* 23: 3/4 (1982), 39–46.

Cornea, Christine. *Science Fiction Cinema: Between Fantasy and Reality*. New Brunswick, N.J.: Rutgers University Press, 2007.

Darwin, Charles. *The Expression of the Emotions in Man and Animals*. 1872. Chicago: University of Chicago Press, 1965.

De Certeau, Michel. *The Practice of Everyday Life*. Trans. Steven Rendall. Berkeley: University of California Press, 1988.

Deer, Lesley. "Hal Hartley." In *Fifty Contemporary Filmmakers*, ed. Yvonne Tasker. London: Routledge, 2002. 161–69.

Deleuze, Gilles. *Cinema 2: The Time-Image*. Trans. Hugh Tomlinson and Robert Galeta. Minneapolis: University of Minnesota Press, 1989.

———. *Francis Bacon: The Logic of Sensation*. Trans. Daniel W. Smith. Minneapolis: University of Minnesota Press, 2004.

Deleuze, Gilles, and Félix Guattari. *What Is Philosophy?* Trans. Hugh Tomlinson and Graham Burchell. New York: Columbia University Press, 1994.

Doherty, Thomas. *Pre-Code Hollywood: Sex, Immorality, and Insurrection in American Cinema 1930–1934*. New York: Columbia University Press, 1999.

Du Maurier, Daphne. *Don't Look Now*. New York: Doubleday, 1971.

Dyer, Richard. *Only Entertainment*. 2nd ed. London: Routledge, 2002.

Farrell, Kirby. *Berserk Style in American Culture*. New York: Palgrave Macmillan, 2011.

Feaster, Patrick. "'The Following Record': Making Sense of Phonographic Performance." Ph.D. dissertation, Indiana University, 2007.

Feder, Chris Welles. *In My Father's Shadow: A Daughter Remembers Orson Welles*. Chapel Hill, N.C.: Algonquin, 2009.

Freud, Sigmund. *Jokes and Their Relation to the Unconscious*. Trans. James Strachey. 1963. London: Penguin, 1983.

Frodon, Jean-Michel, ed. *Cinema and the Shoah: An Art Confronts the Tragedy of the Twentieth Century*. Albany: State University of New York Press, 2010.

Frye, Northrop. *A Natural Perspective: The Development of Shakespearean Comedy and Romance*. New York: Harcourt, Brace and World, 1965.

Gemünden, Gerd. *A Foreign Affair: Billy Wilder's American Films*. New York: Berghahn, 2008.

Goffman, Erving. *The Presentation of Self in Everyday Life*. London: Allen Lane/Penguin, 1969.

Goodman, Paul. *Speaking and Language: Defence of Poetry*. New York: Random House, 1971.

Gordon, Rae Beth. *Why the French Love Jerry Lewis: From Cabaret to Early Cinema*. Stanford, Calif.: Stanford University Press, 2001.

Gould, Stephen Jay. *I Have Landed: The End of a Beginning in Natural History*. New York: Three Rivers Press, 2003.

Grant, Barry Keith. "Science Fiction Double Feature: Ideology in the Cult Film." In *The Cult Film Experience*, ed. J. P. Telotte. Austin: University of Texas Press, 1991. 122–37.

Halliwell, Stephen. *Greek Laughter: A Study of Cultural Psychology from Homer to Early Christianity*. Cambridge: Cambridge University Press, 2008.

Hammett, Dashiell. *The Complete Novels*. New York: Library of America, 1999.

"Hands Are Even More Dramatic Than Eyes Are." *Laugh, Clown, Laugh* pressbook. *Cinema Pressbooks from the Original Studio Collections*, reel 17. Woodbridge, Conn.: Primary Source Microfilm, 2001. (Available at the Billy Rose Theatre Division, New York Public Library for the Performing Arts.)

Hanich, Julian. *Cinematic Emotion in Horror Films and Thrillers: The Aesthetic Paradox of Pleasurable Fear*. New York: Palgrave Macmillan, 2010.

Harries, Dan. *Film Parody*. London: British Film Institute, 2000.

Hartley, Hal. "Responding to Nature: Hal Hartley in Conversation with Graham Fuller." In Hal Hartley, *Henry Fool*. London: Faber and Faber, 1998. vii–xxv.

———. *True Fiction Pictures and Possible Films*. Berkeley: Soft Skull Press, 2008.

Hazlitt, William. "On Wit and Humour." In *Selected Essays of William Hazlitt 1778 to 1830*, ed. William Hazlitt and Geoffrey Keynes. Whitefish, Mont.: Kessinger, 2004. 410–45.

Hesse, Hermann. *Steppenwolf*. 1931. Trans. Thomas Wayne. New York: Algora, 2010.

Heuman, Josh, and Richard Burt. "Suggested for Mature Readers? Deconstructing Shakespearean Value in Comic Books." In *Shakespeare after Mass Media*, ed. Richard Burt. New York: Palgrave, 2002. 151–72.

Hewitt, Joseph William. "Homeric Laughter." *The Classical Journal* 23: 6 (1928), 436–47.

Hirsch, Foster. *The Dark Side of the Screen: Film Noir*. San Diego: Barnes, 1981.

Hobbes, Thomas. *The Elements of Law, Natural and Politic*. Cambridge: Cambridge University Press, 1928.

———. *Leviathan*. New York: Penguin Classics, 1982.

Holston, Kim. *Richard Widmark: A Bio-Bibliography*. Westport, Conn.: Greenwood Press, 1990.

Hutcheon, Linda. *A Theory of Adaptation*. London: Routledge, 2006.

———. *A Theory of Parody: The Teachings of the Twentieth-Century Art Forms*. Urbana: University of Illinois Press, 2000.

Jenkins, Bruce. "Explosion in a Film Factory: The Cinema of Bruce Conner." In *2000 BC: The Bruce Conner Story Part II*, ed. Michelle Piranio. Minneapolis: Walker Art Center, 1999. 184–223.

Kafka, Franz. *The Trial*. 1925. Trans. Breon Mitchell. New York: Schocken, 1998.

Kaminsky, Stuart M. "Don Siegel on the Pod Society." In *Science Fiction Films*, ed. Thomas R. Atkins. New York: Simon and Schuster, 1976. 73–82. Reprinted in LaValley 153–57.

Kant, Immanuel. *Critique of Judgement*. 1790. Trans. James Creed Meredith. Oxford: Oxford University Press, 2007.

Karpf, Stephen Louis. *The Gangster Film: Emergence, Variation and Decay of a Genre 1930–1940*. New York: Arno, 1973.

Kiernan, Thomas. *The Roman Polanski Story*. New York: Grove Press, 1980.

King, Geoff. *Film Comedy*. London: Wallflower, 2002.

Kirby, Thomas A. "*The Pardoner's Tale* and *The Treasure of the Sierra Madre*." *Modern Language Notes* 66: 4 (April 1951), 269–70.

Kleinhans, Chuck. "Taking Out the Trash: Camp and the Politics of Parody." In *The Politics and Poetics of Camp*, ed. Moe Meyer. New York: Routledge, 1994. 182–201.

Klinger, Barbara. *Melodrama and Meaning: History, Culture, and the Films of Douglas Sirk*. Bloomington: Indiana University Press, 1994.

Kristeva, Julia. *Powers of Horror: An Essay on Abjection*. New York: Columbia University Press, 1982.

Lanza, Joseph. *Fragile Geometry: The Films, Philosophy and Misadventures of Nicolas Roeg*. New York: PAJ, 1989.

LaValley, Al. *Invasion of the Body Snatchers*. New Brunswick, N.J.: Rutgers University Press, 1989.

Leitch, Thomas. "Twice-Told Tales: Disavowal and the Rhetoric of the Remake." In *Dead Ringers: The Remake in Theory and Practice*, ed. Jennifer Forrest and Leonard Koos. Albany: State University of New York Press, 2001. 37–62.

Macdonald, Dwight. *On Movies*. Englewood Cliffs, N.J.: Prentice-Hall, 1969.

MacDonald, Scott. "Bruce Conner." In *A Critical Cinema: Interviews with Independent Filmmakers*. Berkeley: University of California Press, 1987. 244–56.

Macnab, Geoffrey. "Henry Fool." *Sight and Sound* 11: 8 (1998), 53–54.

Magny, Joël. "Tod Browning inconnu." *Cahiers du cinéma* 436 (October 1990), 76–77.

Mahar, William J. *Behind the Burnt Cork Mask: Early Blackface Minstrelsy and Antebellum American Popular Culture*. Urbana: University of Illinois Press, 1999.

May, Lary. *The Big Tomorrow: Hollywood and the Politics of the American Way*. Chicago: University of Chicago Press, 2000.

McBride, Joseph. *Hawks on Hawks*. Berkeley: University of California Press, 1992.

———. *Steven Spielberg: A Biography*. 2nd ed. Jackson: University Press of Mississippi, 2010.

McCabe, John. *Cagney*. New York: Knopf, 1997.

McDonald, Frances. "Laughing Away The Human: The Threat of Cyber-Laughter in Science Fiction." Paper presented at the conference "Visions of Humanity in Cyberculture, Cyberspace and Science Fiction," Mansfield College, Oxford, July 12–14, 2011; archived at www.inter-disciplinary.net/wp-content/uploads/2011/06/mcdonaldvhpaper.pdf.

McLean, Adrienne L. *Dying Swans and Madmen: Ballet, the Body, and Narrative Cinema*. New Brunswick, N.J.: Rutgers University Press, 2008.

McWilliams, Carey. *Southern California: An Island on the Land*. Salt Lake City: Peregrine Smith, 1973.

Messenger, Chris. *The Godfather and American Culture: How the Corleones Became "Our Gang."* Albany: State University of New York Press, 2002.

Meyer, Moe. "Reclaiming the Discourse of Camp." In *The Politics and Poetics of Camp*. New York: Routledge, 1994. 1–22.

Miller, Frank, and David Mazzucchelli. *Batman: Year One*. London: Titan, 2005.

Miller, Stephen. *Conversation: A History of a Declining Art*. New Haven, Conn.: Yale University Press, 2006.

Moore, Alan, and Brian Bolland. *The Killing Joke: The Deluxe Edition*. New York: DC Comics, 2008.

Morreall, John. *Comic Relief: A Comprehensive Philosophy of Humor.* Malden, Mass.: Wiley-Blackwell, 2009.

———. *Taking Laughter Seriously.* Albany: State University of New York Press, 1982.

Morrison, Grant, and Dave McKean. *Arkham Asylum: A Serious House on Serious Earth.* New York: DC Comics, 2004.

"Muscular Make-Up New to Hollywood." *The Man Who Laughs* pressbook. *Cinema Pressbooks from the Original Studio Collections,* reel 18. Woodbridge, Conn.: Primary Source Microfilm, 2001. (Available at Billy Rose Theatre Division, New York Public Library for the Performing Arts.)

Musser, Charles. *Before the Nickelodeon: Edwin S. Porter and the Edison Manufacturing Company.* Berkeley: University of California Press, 1991.

Nagel, Thomas. *Mortal Questions.* Cambridge: Cambridge University Press, 1979.

Naremore, James. *More than Night: Film Noir in Its Contexts.* 2nd ed. Berkeley: University of California Press, 2008.

Neale, Steve. *Genre and Hollywood.* London: Routledge, 2000.

Negra, Diane. "'Queen of the Indies': Parker Posey's Niche Stardom and the Taste Cultures of Independent Film." In *Contemporary American Independent Film: From the Margins to the Mainstream,* ed. Chris Holmlund and Justin Wyatt. New York: Routledge, 2005. 71–88.

Nochimson, Martha. *Dying to Belong: Gangster Movies in Hollywood and Hong Kong.* Malden, Mass.: Blackwell, 2007.

Oring, Elliott. *Engaging Humor.* Urbana: University of Illinois Press, 2003.

Pascal, Blaise. *Pensées.* London, 1950.

Paul, William. *Laughing Screaming: Modern Hollywood Horror and Comedy.* New York: Columbia University Press, 1994.

Perkowitz, Sidney. *Hollywood Science: Movies, Science, and the End of the World.* New York: Columbia University Press, 2010.

Pfister, Manfred. "Introduction: A History of English Laughter?" In *A History of English Laughter: Laughter from Beowulf to Beckett and Beyond.* Amsterdam: Rodopi, 2002. v–x.

Plato. *The Republic.* Trans. Robin Waterfield. Oxford: Oxford University Press, 2008.

Polan, Dana. In *The Cinema of Roman Polanski: Dark Spaces of the World,* ed. John Orr and Elzbieta Ostrowska. London: Wallflower, 2006. 108–20.

Pomerance, Murray. "Digesting Steven Spielberg." *Film International* 32 (April 2008), 24–37.

———, ed. *Enfant Terrible! Jerry Lewis in American Film.* New York: New York University Press, 2002.

Pruitt, John. "Jonas Mekas: A European Critic in America." In *To Free the Cinema: Jonas Mekas & the New York Underground,* ed. David E. James. Princeton, N.J.: Princeton University Press, 1992. 51–61.

Robinson Locke scrapbooks. New York Public Library for the Performing Arts.

Rosenthal, Stuart. "Tod Browning." In *The Hollywood Professionals*, vol. 4. London: Tantivy Press, 1975. 7–66.

Sanderson, Mark. *Don't Look Now*. London: British Film Institute, 1996.

Schickel, Richard. *James Cagney: A Celebration*. New York: Applause, 1999.

Schopenhauer, Arthur. *The World as Will and Idea*. Vol. 1. Trans. R. B. Haldane and J. Kemp. Boston: Ticknor and Company, 1888.

Schrader, Paul. "Notes on Film Noir." In *Film Noir Reader*, ed. Alain Silver and James Ursini. New York: Limelight, 1996. 53–63.

Schwager, Jeff. "The Past Rewritten." *Film Comment* 27: 1 (January–February 1991), 12–17.

Sconce, Jeffrey. "Irony, Nihilism and the New American 'Smart' Film." *Screen* 43: 4 (2002), 349–69.

———. "Trashing the Academy: Taste, Excess and an Emerging Politics of Cinematic Style." In *The Cult Film Reader*, ed. Ernest Mathijs and Xavier Mendik. New York: Open University Press, 2008. 100–118.

Shadoian, Jack. *Dreams and Dead Ends: The American Gangster Film*. 2nd ed. New York: Oxford University Press, 2003.

Short, Sue. *Cyborg Cinema*. London: Palgrave Macmillan, 2011.

Siskel, Gene. "Rerunning Widmark: The Cackling Killer's Quiet Now." *Chicago Tribune* (10 June 1973), 6: 3.

Sitney, P. Adams. *Visionary Film: The American Avant-Garde, 1943–2000*. 3rd ed. Oxford: Oxford University Press, 2002.

Smith, Jacob. *Vocal Tracks: Performance and Sound Media*. Berkeley: University of California Press, 2008.

Spencer, Stephanie. *O. G. Rejlander: Photography as Art*. Ann Arbor, Mich.: UMI, 1985.

Spurgeon, Brad. *Colin Wilson: Philosopher of Optimism*. Manchester: Michael Butterworth, 2006.

Staiger, Janet. *Media Reception Studies*. New York: New York University Press, 2005.

Stewart, Jacqueline Najuma. *Migrating to the Movies: Cinema and Black Urban Modernity*. Berkeley: University of California Press, 2005.

Toll, Robert C. *Blacking Up: The Minstrel Show in Nineteenth-Century America*. London: Oxford University Press, 1974.

Traven, B. *The Treasure of the Sierra Madre*. 1935. New York: Farrar, Strauss and Giroux, 1963.

Treverton, Edward N. *B. Traven: A Bibliography*. Lanham, Md.: Scarecrow Press, 1999.

Trilling, Lionel. *The Experience of Literature* [Briefer Version]. New York: Holt, Rinehart and Winston, 1969.

Tynan, Kenneth. "Fifteen Years of the Salto Mortale (Johnny Carson)." In *Life Stories: Profiles from the New Yorker*, ed. David Remnick. New York: Modern Library, 2001. 310–54.

Warshow, Robert. *The Immediate Experience: Movies, Comics, Theatre and Other Aspects of Popular Culture*. New York: Atheneum, 1975.

Wartenberg, Thomas E. *Unlikely Couples: Movie Romance as Social Criticism*. Boulder: Westview Press, 1999.

Welsford, Enid. *The Fool: His Social and Literary History*. London: Faber and Faber, 1935.

Wiles, David. *Shakespeare's Clown: Actor and Text in the Elizabethan Playhouse*. Cambridge: Cambridge University Press, 1987.

Williams, Linda Ruth. "The Tears of Henry Thomas." *Screen* 53:4 (2012), 457–62.

Wilson, Emma. *Cinema's Missing Children*. London: Wallflower, 2003.

Wilson, Eric G. *The Melancholy Android: On the Psychology of Sacred Machines*. New York: State University of New York Press, 2006.

Wood, Jason. *Hal Hartley*. Harpenden: Pocket Essentials, 2003.

Wood, Michael. *Literature and the Taste for Knowledge*. Cambridge: Cambridge University Press, 2008.

———. *The Road to Delphi: Scenes from the History of Oracles*. New York: Farrar, Straus and Giroux, 2003.

Wood, Robin. "An Introduction to the American Horror Film." In *The American Nightmare: Essays on the Horror Film*, ed. Andrew Britton, Richard Lippe, Tony Williams, and Robin Wood. Toronto: Festival of Festivals, 1979. 7–28.

Woolrich, Cornell. *Phantom Lady*. 1942. New York: Ballantine, 1982.

Wyatt, Justin, and Hal Hartley. "The Particularity and Peculiarity of Hal Hartley: An Interview." *Film Quarterly* 52: 1 (1998), 2–6.

Yumibe, Joshua. *Moving Color: Early Film, Mass Culture, Modernism*. New Brunswick, N.J.: Rutgers University Press, 2012.

Index

Hazlitt, William, 210, 214, 219
Heat (Michael Mann, 1995), 204
Hedaya, Dan, 64
Henry Fool (Hal Hartley, 1997), 11, 12, 163–76, *164*, *169*, *173*
Henry IV Part I and II (William Shakespeare), referenced in, 31, 32, 171
Henry V (William Shakespeare), 43
Hepburn, Katharine, 2
Hershey, Barbara, 147
Hesse, Hermann, 10, 108
Heuman, Josh, 197
Hewitt, William, 179
High Sierra (Raoul Walsh, 1941), 131
Hilberg, Raul, 54, 58n1
Hindenburg disaster (Passenger ship LZ 129), 97
Hirsch, Foster, 61
Hitchcock, Alfred, 4, 5, 39, 40, 136, 178; MacGuffin, 178
Hitchhiker's Guide to the Galaxy, The (Garth Jennings, 2005), 218
Hitler, Adolf, 48, 56
Hobbes, Thomas, 34, 80, 185, 186, 187, 214, 216
Hodgson, Joel, 88
Hodiak, John, 5
Hoffman, Dustin, 130
"Hoffman Tales," 161n3
Holden, William, 2
Holliday, Judy, 2
Hollywood cinema, 17, 54, 55, 60, 72, 75, 76, 77, 78, 83, 85, 87, 91, 101, 135, 137, 148, 177, 178, 197
Holmes, James, 207n3
Holmes, Oliver Wendell, 128
Holocaust, the, 8, 50ff
Holt, Tim, 4, 37, 178, *183*, *190*, *191*
Home Depot, 156
Homer, 12, 179, 180; Homeric laughter, 179, 181, 190, 192
"Honeymooners, The" (1955), 132
Hong Kong film, 139
Hook (Steven Spielberg, 1991), 222n3
Hornaday, Ann, 160–61n1
Horowitz, Gad, 203
Horton, Andrew, 6
Hubbard, L. Ron, 90
Hudson, Kate, 129
Hugo, Victor, 27, 29
Hurt, William, 51, 209
Huston, John, 140, 177, 178, 179, 180, 181, 182, 184, 187, 189, 190, 191, 192

Huston, Walter, 177, *183*, *190*, *191*
Hutcheon, Linda, 70

Iliad, The (Homer), 179
Internet, 89, 156
Invasion of the Body Snatchers (Don Siegel, 1956), 9, 79, 81, 91
Irish, William. *See* Woolrich, Cornell
Ispahan, 120, 121
It Conquered the World (Roger Corman, 1956), 80, 81
It's All True (Orson Welles, 1941–42), 33
It's a Wonderful Life (Frank Capra, 1946), 192

Jackson, Samuel L., 90
Jacobs, Ken, 99, 103–8
Japanese *onryo*, 106
Jaws (Steven Spielberg, 1975), 206n1
Jenkins, Bruce, 95
Jeremiah, 132
"Jerry Goes to Death Camp" (Bruce Handy), 52
Jerry Maguire (Cameron Crowe, 1996), 204
Jews, 51
Joffrey Ballet (Chicago), 152
Johnson, George Washington, 19

Kant, Immanuel, 9, 83, 102
Karloff, Boris, 218
Karpf, Stephen, 140
Kaufman, Sarah, 151
Keaton, Buster, 2, 116, 117, 145, 180
Keaton, Diane, 2
Keystone Cops, the, 78
Killers, The (Robert Siodmak, 1946), 60, *61*, 62, 63, 68
Killing, The (Stanley Kubrick, 1956), 62, 63
Killing Joke, The (Alan Moore and Brian Bolland), 197
King Kong (Merian C. Cooper and Ernest B. Schoedsack, 1933), 94
King Lear (William Shakespeare), 69
Kierkegaard, Søren, 102
Kirby, Bruno, 131
Kiss Me Deadly (Robert Aldrich, 1955), 9, 63
Kiss of Death (Henry Hathaway, 1947), 11, 62, 133–34, *134*, 135
Kleinhans, Chuck, 144, 150, 152, 153, 160
Klinger, Barbara, 77
Kristeva, Julia, 168
Kubrick, Stanley, 221, 222n9
Kunis, Mila, 145, 147

Universal Pictures, 27, 87
Urbaniak, James, 165, *169*

Valentine, Brandon, 197
Valentine, Paul, 63
"Vampire Show, The" (1954), 88
Van Dine, S.S., 71
Van Sant, Gus, 47
Variety, 78, 79, 80
Veidt, Conrad, 7, 16, 17, 25–29, *27*, 200
Vickers, Martha, 68
Victorian acting, 18
Vigo, Jean, 47

Wachberger, Nathan, 51
Walcott, Gregory, 84
Walker, Robert, 127
"Walking Woman" Project (Michael Snow),
 100, 108n2
Wall Street Journal, 195
Wallich, George Charles, 18
Wallis, Hal, 131
Walsh, M. Emmet, 64, *64*
Walsh, Raoul, 137
Wanger, Walter, 79
Warner Bros., 137
Warrick, Ruth, 35
Warshow, Robert, 60
Washington, Denzel, 90
Washington Post, The, 151, 157
Waterloo Bridge (Mervyn LeRoy, 1940), 11,
 152, 153, 154
Waterworld (Kevin Reynolds, 1995), 90
Wavelength (Michael Snow, 1967), 10, 93,
 98–103, 108n1
Weerasethakul, Apichatpong, 47
Welles, Orson, 8, 31–46, *44*, 129
West, Mae, 145

White, Michael Jai, 198
White Heat (Raoul Walsh, 1949), 11, 131, 136,
 137
"Why Superhero Movies Get Snubbed"
 (David Bentley), 196
Widmark, Richard, 2, 11, 133, *134*
"Wild Swans, The" (Hans Christian
 Andersen), 148. *See also* Swan Lake
Wild West. *See* American West
Wilde, Oscar, 180
Wilder, Billy, 138
Williams, Adam, 4
Williams, Linda Ruth, 13
Williams, Robin, 51
Williams, Sharon, *116*
Willis, Dennis, 90
Wilson, Colin, 139
Wilson, Don, 62
Wilson, Eric, 217, 218
Wilson, Owen, 129
Windsor, Marie, 66
Wise Blood (John Huston, 1979), 178
Wolcott, James, 156
Woman in the Window, The (Fritz Lang,
 1944), 64
Wood, Ed, Jr., 82, 84, 85
Wood, Robin, 202
Woolf, Virginia, 38
Woolrich, Cornell, 65
World War II, 105
Wrestler, The (Darren Aronofsky, 2008), 153
Wuthering Heights (William Wyler, 1939),
 37

You, Me and Dupree (Anthony Russo and Joe
 Russo, 2006), 129
Young, Loretta, 22
Young Frankenstein (Mel Brooks, 1974), 87